LIVERPOOL

LIVERPOOL

THE RISE, FALL AND RENAISSANCE OF A WORLD-CLASS CITY

Ken Pye

AMBERLEY

First published 2014

Amberley Publishing
The Hill, Stroud
Gloucestershire, GL5 4EP

www.amberley-books.com

British Library Cataloguing in Publication Data.
A catalogue record for this book is available from the British Library.

ISBN 978 1 4456 3757 0 (paperback)
ISBN 978 1 4456 3771 6 (ebook)

Typeset in 10pt on 12pt Sabon.
Typesetting and Origination by Amberley Publishing.
Printed in the UK.

Contents

Introduction

This book tells the remarkable story of how a previously unknown little fishing hamlet, nestling on the banks of an obscure river in the north-west of England, would grow, in the space of just 500 years, to become the most significant city and port in the British Empire outside London.

This is a tale too of a place that stands with its face to the world and of how its waterfront directly connected it and its people with every nation on earth. The town of Liverpool would trade in all kinds of commodities, manufactured goods and raw materials, but it would also lead trade in human bondage, exploitation and suffering.

Itself a victim of invasions, sieges, plagues and wartime devastation, the town would nevertheless thrive and evolve and become home to innovators, pioneers and entrepreneurs. The story of Liverpool is also one of a crucible of ideas and energy and of a diverse and often tribal community of peoples. In a remarkable variety of ways, they would all play a part in driving the city forward to reshape the destiny of the world. And this is no exaggeration; the inventions, passions and culture of Liverpool would influence people across the globe and its music would become the pulse of a generation.

This is also the story of how the 'Crossroads of the World' became a conduit for people moving from one side of the planet to the other as, with hope in their hearts, they left the 'old' world for the 'new' and the past for the future.

But then the story shifts to that of Liverpool's loss of its 250-year global supremacy. It tells of the city's descent into a period of catastrophic economic collapse, protracted industrial unrest, violent rioting and political extremism. It also tells of how Liverpool barely avoided bankruptcy, complete social breakdown and death by deliberate governmental neglect.

Nevertheless, this is also a tale of a people of resilience, fortitude and courage, who have a belligerent independence that always drives them to resist defeat. Their self-belief and determination to overcome all obstacles would see one of the most remarkable renaissances of modern times. In a story of inspiration and optimism,

often put rigorously to the test, Liverpool would become a twenty-first-century European Capital of Culture and a UNESCO World Heritage City and Port.

But this is only the beginning of Liverpool's rebirth, because this now becomes a story of creative dreams and bold ambitions. These will see Liverpool once again flourish as the home of an outstanding people, as it resumes its rightful place as A World-Class City.

Ken Pye
Liverpool, 2014

1
In The Beginning ...

The Land Before Time

When dinosaurs roamed the earth they did so across the prehistoric landscape that would become Merseyside. Their footprints have been found in the sandstone rocks on the shore at Crosby to the north of the modern city and across the River Mersey in the ancient quarries of Storeton on the Wirral peninsula.

Dug to a depth of 200 feet, these quarries are now disused and overgrown with woodlands, but the Romans first excavated here to find stone for their buildings. The diggings were in use well into the twentieth century, as was an original nineteenth-century tramway. Carts were hauled along the metal tracks by men and horses to transport stone throughout the area and to the docks at Bromborough Pool on the shore of the River Mersey.

It was in 1838 that Victorian quarrymen first discovered fossilised animal tracks in the slabs of stone they were cutting. Palaeontologists later identified these as belonging to the prehistoric creature *Cheirotherium*, which means 'Hand Beast', because of the five-fingered shape of its footprints.

In the Triassic period, which was the start of the age of the dinosaurs, around 250 million years ago, prehistoric Merseyside was prowled by this very large lizard. It measured about 2.5 metres long, stood around 1.5 metres tall and had a slim body with a long tail. The original stone slabs bearing these very ancient footprints, together with a life-size model of *Cheirotherium*, are now on display in the World Museum Liverpool.

But there was also *Rhyncosaurus*, which means 'Snouted Lizard'. This creature was a herbivore and it had a long, hooked beak for grubbing up roots. It also had powerful jaws and strong teeth for tearing down and chewing tough plants. These creatures were also large, standing at about 1 metre high and 2 metres long. They too were obviously heavy enough to make deep impressions in the mud through which they plodded. Unfortunately for *Rhyncosaurus* it was the main food supply of *Cheirotherium*.

In prehistory, the area upon which the great city of Liverpool would eventually become established was largely a landscape of forests and open heathland. This spread across seven hills, which we now know as Walton Hill, the Everton Ridge or Brow, the Toxteth Ridge and High Park, Mossley Hill, Childwall Hill, the Wavertree Ridge and Olive Mount, and the Woolton Ridge, including Camp Hill. Edge Hill, contrary to popular opinion, is not a hill, but actually the end of the long Everton Ridge, hence the 'edge' of the 'hill'. These hills surround a broad basin of land with a rising promontory to the west that still overlooks the modern waterfront of the River Mersey. It is on and around this high, broad sandstone outcrop that modern Liverpool sits.

This whole area was well watered with brooks and streams; some quite broad, including one that, as we shall see, would become the reason for Liverpool's existence. This watercourse rose from near the southern end of the Everton Ridge, in what was once a large area of marshland known as Moss Lake Fields. This is now the district around Abercromby and Falkner Squares in Liverpool's historic Georgian Quarter. From this source, what quickly widened into a broad stream ran north-west, to pass from the high hills through land now covered by the modern University Quarter and Pembroke Place.

Widening further, the stream then changed course to flow south-west along what are now Byrom Street and the end of Dale Street. By this point, the broad stream had widened significantly into a fast-flowing creek. This would eventually form the eastern boundary of the town of Liverpool and would need a rowed ferryboat to get across it. From here, the wide watercourse followed the line of today's Old Haymarket and Whitechapel, just past its modern junction at Lord Street where, again, a ferry would be needed to cross it.

Roughly at today's junction of School Lane and Paradise Street, what had now become a tidal river flowed into the wide, deep inlet or 'Pool', which opened directly onto the River Mersey. On this site now sit Merseyside Police Headquarters, Paradise Bus Station, Chavasse Park and the entire Liverpool ONE retail and leisure complex. This brook, creek and river still exist and, though long since culverted along its full length, it follows its winding course from the high hills above Liverpool down to the Mersey.

The northern edge of the pool formed a sharply rising embankment up to the rock promontory, which then stood at a height of around 50 feet. This is now the modern city centre area of Derby Square and Castle Street. To the north from this point, at the end of what is now Old Hall Street, once stood the Kirkdale Forest. In the opposite direction, across the southern borders of the pool stood the Stochestede Forest, which covered an area of at least 3,000 acres. This has also now long gone and has been replaced by the modern, urban district of Toxteth.

The first people to settle on the banks of the River Mersey were probably primitive coastal dwellers, during the Neolithic (or new Stone Age) period, which began around 9500 BC. These were boat people, who fished in the Mersey around what would become Rock Ferry, Woodside, Birkenhead and Wallasey, as well as in and around the Pool of Liverpool. These people may well have been the very

first to sail on the river and fish in it, as well as to ferry themselves across it, using hollowed-out logs and, later, coracles.

However, the earliest direct evidence of human activity in the Liverpool area is from the late Mesolithic period, about 6,000 years ago. Some 550 flint tools were found, but no structures, 7 miles to the north-east of the pool at a site in what is now Croxteth Park. This would eventually become the estate of the Earls of Sefton. This site was probably an encampment of hunter-gatherers who, in small family groups, would have hunted the wild boar and deer that roamed the vast forests that once covered the whole area. While doing so, these very first 'Liverpudlians' would have had to keep a wary eye out for the wolves and bears that also shared the territory with them.

Around 5000 BC, small communities of Stone Age peoples began to settle inland, in the areas now known as Childwall, Toxteth, Woolton and at West Derby, where stone axe heads and arrowheads were discovered. Also, Neolithic burial urns containing human remains were discovered in what is now the Liverpool suburb of Wavertree. These peoples had developed sophisticated social and community structures and hierarchies, as well as complex theologies and forms of worship to explain the great mysteries of their existence and environment.

The heavily forested, well-watered and extremely fertile lands, which were to evolve into Merseyside and Liverpool, soon became a well-established region of

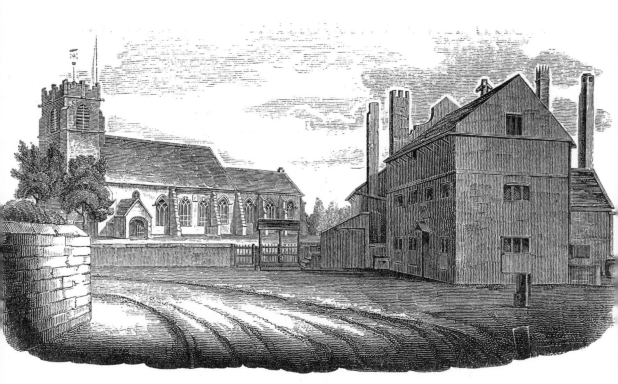

St Mary's, Walton-on-the-Hill.

developing, settled, human habitation and agriculture. As with the rest of ancient Britain though, greedy invaders and imperialists from overseas now set their sights on these rich prizes.

Veni, Vidi, Vici

At the end of the Iron Age, the formidable Roman General Julius Caesar (100–44 BC) first attempted to invade Britain in 55 BC. His targets were the rich resources of the country, including wheat, copper, tin, lead, silver, gold and slaves. Caesar attacked the Kent coast with ninety-eight ships and two Legions, each of 20,000 men. To his surprise though, the response from the native Britons was severe and brutal and he was soon repelled. He returned the following year, but this time with 800 ships, 50,000 soldiers and 2,000 cavalry. Now, he easily conquered the Celtic tribes of the south-east, but for reasons that are unclear, he left again three months later with his entire army.

Almost 100 years later, in AD 43, the Romans were back; this time under the command of the Emperor Claudius (10 BC – AD 54). He was absolutely determined to completely subjugate the country and its wild, Celtic warrior inhabitants, no matter what the cost in time or men. And it took decades because the tribespeople put up a brutal defence. In fact, it was not until around AD 70–79 that the Emperor got to the north-west of England – hacking, slashing, spearing, mutilating, impaling and beheading, every step of the way. He left the heads of beaten Celtic Chieftains stuck on pikes as a warning to others.

In the first century AD, as well as making their way north overland, the Romans landed their galleys at various points on the Lancashire coast. The invaders established themselves at Bremetennacum, which is now modern Ribchester, between Blackburn and Preston. From this fortified outpost they regularly marched to and from their larger and more strategically located settlement at Deva, which is now modern Chester.

En route, they passed through what would become the suburban riverside Liverpool districts of Garston, Woolton and Speke. Indeed, in the mid-nineteenth century, during road excavations in Garston, the remains of a Roman pavement were discovered below the roadway, as well as some coins. Other Roman coins have also been found outside the city centre, in places such as Toxteth, West Derby, Wavertree, Speke and Tarbock.

Also, in the early 2000s, when the foundations were being excavated of the new city-centre retail complex 'Liverpool ONE', the remnants of a Roman boat were discovered, along with copper coins dated AD 320, on the site of the original tidal pool. Also, a coin of Antoninus Pius (AD 138–161) was found near North John Street on the south side of Harrington Street. The Roman invaders also landed on the Wirral peninsula, at Meols, which was already a significant port. From here, they also marched southwards, as well as sailing down the River Mersey and the River Dee, again to Deva.

These were times of magic and mystery in ancient Britain, and of a human relationship with the earth, the skies, the waters and the natural world that has long since vanished. Even today, legends abound of the mysterious Druids, the priestly cult that seems to have been at the very pinnacle of Celtic society in those dark and bloodthirsty times. For many years these stories were suspected to have been only Roman propaganda, but recent archaeological finds now lead scientists to believe that perhaps the Druids really did exist and were indeed a bloodthirsty sect.

Tales are still told of bearded, white-robed mystics, harvesting mistletoe with golden sickles to use in strange rites; and of naked dances, held under the moon and stars in groves of sacred oak trees. Stories abound too of mass human executions inside the dreaded 'Wicker Man'.

Julius Caesar himself described how hapless victims would be imprisoned in these gigantic wooden cages, fashioned out of woven branches to look like human figures. Fires would be lit at the feet of these wicker men and the agonised screams of the men, women and children, as they slowly roasted alive, would soon be extinguished by the black smoke, raging heat and sheets of orange and red flames. Sometimes, live cattle and other animals would be burned with the people, only adding to the horror of the ritual.

Yarns persist too of ceremonial human sacrifice on great carved slabs set in circles of standing stones. Such tales circulated in the late nineteenth century, in what are now the southern suburbs of Liverpool, near Woolton Village. This was when, in 1866, a Scottish Victorian antiquarian and physician by the name of Sir James Young Simpson (1811–1870) came to the district to investigate six large, irregularly shaped sandstone standing monoliths. For generations, these had been known by local people as the 'Calder Stones' and the doctor declared them to be remnants of a 'Druidical Stone Circle'. This was reinforced by the fact that the word 'Calder' is derived from the Anglo-Saxon 'Galdar' or 'Wizard', so Simpson believed that bloody sacrifices had been carried out in ancient Liverpool.

Druids may well have practised their ceremonies here, but the Calder Stones are now known to have been the remnants of a chambered tomb that was part of a long-vanished Neolithic Chief's Tumulus. This had originally been erected around 4800 BC, therefore making it older even than Stonehenge, which had been constructed around 3100 BC. This remarkable pagan centre of religion and astrology is itself older than the first pyramids of Egypt, which were begun around 2600 BC. As the Calder Stones tomb predates both of these ancient sites, it is clear that Liverpudlians have been around for a very long time.

The Iron Age Britons fiercely defended their homes, communities and lands, especially in the region that was to become Liverpool and Merseyside. There is some evidence of this at the top of the 250-foot-high Camp Hill, which is also close to Woolton Village. In 1948, during the demolition of some buildings at the top of the hill, remnants of a fortified Iron Age encampment were found. This discovery proved what local people had believed for centuries; that the ancient

Britons had constructed a defensive outpost here to protect their surrounding farms and fields. This also explained how the hill had long before been given the name of 'Camp Hill'.

Before the Romans first came to Britain, perhaps as early as 150 BC, the hill had been the home of the local Celtic tribespeople, the Brigantes. This confederation of largely independent communities controlled the largest section of what would become northern England, as well as a significant part of the north Midlands. Their Camp Hill fortification was about 80 yards in diameter, with ramparts between 10 feet and 15 feet high, and was probably encircled by sharpened, defensive wooden stakes.

From the top of Camp Hill, even today, the views of the surrounding lands – the River Mersey, the Wirral peninsula, and the far mountains of North Wales – are spectacular, so this was an ideal location for the competitive local Celts. They would have challenged other local tribes for power and territory from here and defended themselves against the Romans when they came.

The Brigantean hill fort would have been a prime target for the invading Romans and it is also probable that they would have mounted at least one attack against its determined defenders. It is believed that Gnaeus Julius Agricola (Governor of Britain from AD 78 to 84) led major attacks against the Brigantes, although it took many years to finally conquer them, because even early Liverpudlians were taken on at peril.

The Romans reported too that their Celtic enemies often fought entirely naked, with their bodies painted all over, or in swirling patterns, with blue woad extracted from plants. I can imagine the Romans, in their smart uniforms and burnished armour, ready with their spears and broadswords, lined up at the base of the rise in serried and orderly ranks.

I can visualise too the daunting spectacle of hundreds of naked, powerful, angry, hairy blue men (and often the women as well) gathered at the top of Camp Hill. Also heavily armed with fearsome, long, slender slashing swords and vicious spears, they would charge screaming down the hill, proudly brandishing everything they had. Throwing themselves against the enemy in furious abandon, the effect that these rampant early Liverpudlians had on the invaders can only be imagined. However, the Romans were not the only ruthless invaders that the early people of Liverpool had to contend with.

The Great Northern Terror

In AD 410, the Emperor Honorius (AD 384–423) withdrew all Romans from Britain, telling the country that they now had to fend for themselves. In fact, Britain was a 'sitting duck' and, from around AD 430, northern European Saxons attacked from across the North Sea, as did the Angles from southern Denmark, eventually giving their name to East Anglia and therefore becoming known as 'The English'. In AD 441, Picts attacked from the north and Scots

invaded the west from Ireland. Around the same time, Jutes came from the area now known as the European Lowlands to occupy our eastern lands. Also, more Saxons invaded from what is now France, to assail the south and the east of the country. This all added to the cultural mix that was to evolve into Anglo-Saxon Britain.

Nevertheless, things became so bad that, in AD 446, Britain appealed to Rome for help, but this was refused and the country lay completely exposed to the ravages of warlords, tribal chieftains and opportunist adventurers: the Dark Ages had begun. But then, from the ninth century onwards, a race of new, seafaring aggressors began to invade our shores, this time from Scandinavia.

These were the 'Norsemen'; the Vikings, from Sweden, Denmark and Norway. Their first attack on Britain came in the year AD 793, when they sacked the Northumbrian monastery at Lindisfarne, sending a wave of shock, outrage and fear across the Christian west. These determined warriors now regarded the rest of Britain as a legitimate target for plunder, pillage and rape. The first raid by the Vikings on mainland England was recorded in Wessex, in AD 855, but then they also targeted Ireland, Scotland, Wales and Cornwall. However, the Danes specifically set their sights on north-east and north-west England. They were the race who exploited and subjugated the Liverpool and Merseyside areas of that time.

Their first landing points in the region were at what are now Crosby, just north of modern Liverpool and, like their Latin predecessors, at Meols. A wide variety of Norse artefacts continue to be discovered at both of these coastal locations, and Meols remains one of Britain's most important archaeological sites.

The Vikings voyaged far from their cold and often hostile homelands in the north, being driven by a lack of good farmlands, to seek new lands to plunder and then to settle. Even though, over the next 100 years, their attacks became more frequent and widespread throughout the British Isles, like the Saxons before them, the Vikings were really only looking for new places in which to set up home. Like the Romans, the Norsemen sailed their longboats up the River Mersey and the River Dee, as well as the River Ribble and the River Alt.

Coming here in fleets of longships, driven by sails, oars, and a bloodthirsty determination to conquer, Norse warriors such as 'Eric Bloodaxe', 'Ivar the Boneless' and 'Thorfinn Skullsplitter' would write the next chapter in the bloody history of ancient Merseyside.

Strong, proud and relentless, and with as many as 100 men in each vessel, the Vikings sailed across the icy and treacherous North Sea. Seated on benches on open decks, they were completely exposed to the elements; these raiders were fearsome indeed. Their wooden warships were steered by a single oar at the rear and could be up to 36 metres in length. Their prows and sterns were surmounted by awesome figureheads carved in the form of great dragons and monsters, designed to strike terror in their enemies as they approached the land. Travelling at up to ten or eleven knots, these were intimidating and powerful vessels.

The ships' narrow beams and shallow draughts meant that they could sail far inland up British rivers and broader streams. They could also plough directly onto shale and sand shorelines, or anchor very close inshore – right in the very heart of the settlements and communities that were their target.

When their objective was in sight, be it monastery, village, farm, or manor, the invaders would leap ashore over the shield-decorated sides of their ships and immediately go into frenzied and bloodthirsty attacks. Armed with saxes (single-edged swords); bows and arrows; spears; halberds (long blades mounted on short poles); and great battle-axes, when the Norsemen engaged with their victims, they were ruthless.

Any person was fair game, regardless of sex, age, or social standing. Monks and nuns could expect no leniency either and murder, mutilation, rape and plunder were the frequent outcome of a Viking attack. All could expect to fall victim to these terrifying and vicious warriors – only the lucky few escaped to tell the tale and spread news of the horror.

Even though for decades the Norse invaders had come to England as warriors and pillagers, they too preferred a settled and domestic life that was based on agriculture, fishing and local trade. Consequently, large numbers of them stayed, settled down (often marrying local women) and became farmers and artisans.

Queen Aethelflaed (*c.* AD 864–918), who was the powerful land-owning daughter of the Saxon king Alfred the Great, had led a successful campaign against the invaders in AD 911 and had expelled them from her Mercian kingdom. Mercia was a vast territory that included within its boundaries what we now know as north Cheshire, Merseyside and Lancashire.

However, within a decade or so, Aethelflaed granted land on both sides of the River Mersey to the Vikings, which they then began to settle as they also intermarried with the local population. The evidence of their influence on the local area and language still exists in some of the place names, such as Toxteth, Croxteth, Kirkby and Kirkdale. Indeed, some of the local Saxon place names that predate the Viking invasion also survive, as Fazakerley, Garston, Hale and Knowsley.

That there were significant Viking and Anglo-Saxon settlements in Liverpool is also clear from some of our other place names, including Walton, Aigburth and Aintree. Even the name 'Mersey' or 'Mersea' derives from the Anglo-Saxon name 'Meres-ig', which means 'sea-island', although 'lake-island' or 'pool-island' is probably a more accurate translation from the Old Saxon dialect.

The Soldiers for Christ

During the Anglo-Saxon era, which lasted from around AD 410, until the Norman Conquest of England, in 1066, the country had been divided into large administrative areas. Generally attributed to Alfred the Great (AD 849–899), these were the forerunners of our modern 'Shires' and were known as 'Hundreds'.

It is believed that a Hundred was an area that could raise an army of 100 fighting men and, as the population was so thinly spread, this meant that such areas frequently encompassed very large territories.

The Hundred that Liverpool would fall under was the 'West Derby Hundred'. This covered an area of around 40 square miles, which spread from the shores of the Mersey, through Ormskirk and across to Wigan. It also covered lands from the north of what is now Southport to the area south of modern Liverpool, and east to include Warrington.

At its political and administrative heart was the important township of West Derby itself, which was so named to distinguish it from the equally important township of Derby, in the Midlands. West Derby once had its own castle. This had probably evolved from a basic enclosed Celtic village compound, through a Norse fortified stronghold, and into a more formidable Norman motte and bailey stone structure. This bastion has long since vanished, leaving only its name, 'Castle Green', in an area of public parkland in what is now the suburban 'lost village' of West Derby on the eastern edge of Liverpool.

The religious centre for the Hundred of West Derby was Walton-on-the-Hill; now another suburban 'lost village' of Liverpool. This stands at the northern extremity of the modern city and was an Anglo-Saxon settlement. Its name derives from 'weald' and 'tun', or 'walled settlement'. Standing at the summit of one of Liverpool's seven hills, Walton was originally also an ancient and important centre of Pagan worship.

It is believed that a standing-stone circle once dominated the hill, but this was destroyed by militant monks from Lindisfarne, who came to this part of the north during the Dark Ages. They were on a mission to forcibly supplant the indigenous faiths with Christianity. In its place, they erected the first Christian church in the Hundred. This was a small building constructed of wattle and daub, with a thatched roof. These 'Soldiers for Christ' were often as determined as the previous military invaders had been and were frequently just as bloodthirsty.

By this time, there were already significant pockets of Christianity in the country, which had first been brought over by the later Roman invaders and settlers, but Anglo-Saxon Britain was still largely a pagan land. Indeed, Christianity only really began to take hold fully at the end of the sixth century AD, after the new religion had received official sanction.

This came about when, in the year AD 596, Pope Gregory the Great (c. AD 540–604), was passing through the market in Rome. Here, he saw some beautiful British slave boys being offered for sale and, asking where they had come from, he was told, 'Anglia'. He responded, 'Niente Angles, per Angeli', which translates as, 'not Angles but angels'. In the following year, the Pope then sent his Bishop, Augustine (d. AD 604) to lead a Roman mission to convert all of England to the worship of Jesus Christ.

'If such a land can produce such angels,' he also said, 'then they should hear the word of the Lord.' The Pope's ambassadorial prelate landed in Kent, converted King Ethelbert (c. AD 560–616) to Christianity and founded the archdiocese of

Canterbury. The first Christian missionary to Britain was subsequently canonised by the Church, as St Augustine of Canterbury.

The site of the church at Walton is old enough to have also been specifically recorded in William the Conqueror's Domesday Book, produced in the late eleventh century. It also became the location of an early Christian abbey that was founded by the Benedictine order of monks, who came here just after the Norman Conquest, in 1066.

The first stone church on the hill was not erected until 1362, but very little of this now remains, because it has been rebuilt and restored many times over the centuries. Even so, the parish church of St Mary the Virgin, Walton-on-the-Hill, is certainly the oldest church site within the area of the old Hundred of West Derby. This became the parish church for the originally tiny community of 'Leverpul', as well as the nearby townships of Bootle-with-Linacre, Everton, Fazakerley, Kirkdale, Everton, Kirkby and West Derby. It also had the isolated coastal township of Formby, the Royal Park of Simonswood, and the Royal Hunting Reserve of Toxteth Park within its boundaries.

The present church building at Walton is a stunning structure that dominates the skyline for many miles around. Its original Saxon font survives, as does a large ancient Saxon cross; both in very good condition. The graveyard that surrounds the church has many remnants from its historic and significant past, and is an attractive, if somewhat eerie place to wander through. Shrouded by the long branches and enveloping leaves of a number of very ancient trees, some of the tombstones have interesting inscriptions. One of the more recent tombstones identifies the final resting place of Hannah Wall, from West Derby; part of its inscription reads, 'who departed this life on the 2 August, 1938, at the extraordinary age of 111 years'.

In the corner of the burial ground is an attractive building with mullioned windows. This was the old Tudor Grammar School for the poor boys of Walton. Probably older that its date stone, which reads '1548', this remained a schoolhouse until the 1820s. From that time it became the parish rooms and Sunday school, and it now houses a day nursery and crèche facility, thus maintaining the educational traditions of the delightful building.

All of this attests to the significance played in the history of Liverpool and the Hundred by St Mary's Walton-on-the-Hill.

'William the Bastard'

From the time of the Romans, the lands around the Mersey became the target of violent, opportunistic armies of aggressors. Each of these foreign assaults played their part in the reshaping of the local people, their communities and their way of life. However, in terms of how catastrophic and irrevocable the impact of these successive invasions had been, none was as complete as that of the Normans.

In 1066, Duke William of Normandy (*c.* 1028–1087) became the latest, though not the last, alien dictator who was determined to conquer and subdue the English. Of course, he succeeded, consequently becoming known to posterity as 'William the Conqueror'. He was also known as 'William the Bastard'; more because of his questionable parentage than his personality, although both qualified him for the title.

The Normans were descended from a band of Viking warriors who settled in what is now northern France, near the town of Rouen. They soon came to dominate the territory and developed political and territorial ambitions. When they occupied England, it was William's objective to completely subjugate the Anglo-Saxons. Now, all land in his conquered territory fell nominally into William's direct ownership. To consolidate this authority, he seized the throne of England as his own, assuming the title of King William I. He now became one of a long line of Norman monarchs.

In 1086, William ordered a great national assessment to be taken of the value of his new kingdom. The finished report – the Domesday Book – hand-written in a form of abbreviated language, was luxuriously bound. Still preserved as an important national treasure, this records who owned every castle and house; every manorial estate; and every field, forest, river or stream. It lists who held title to every forge, water mill and windmill; every plough and every fishing net. It names the owners of every farm, every ox, horse, cow and pig.

The Book also forms a Medieval directory of 13,000 individual towns and villages (many whose names had been written down for the first time), as well as all the property contained within them. Once title to such property was entered in the Book, it was deemed to be irrevocable. In fact, it was the people of England who named William's great survey 'Domesday'. This was because they said that the records it held would last until the final judgement of God, on the last day of the world – on doomsday.

The great ledger also shows that, within twenty years of the Conquest, the vast majority of land and property owners were now Normans, not the original Anglo-Saxon people who had held everything at the time of William's invasion. Indeed, of the baronial landowners in England at the time of Domesday, only thirteen were English and the rest were French. The Conqueror took half the economic value of England for himself and gave a quarter to the Church, to appease the Papacy. He then divided the remainder among 190 Norman Knights and Barons. Their descendants still own at least one-fifth of the modern United Kingdom.

The Domesday Book, of course, was also a means for William to place a value on everything. This was essential, as he now knew how much to tax the people of England and thus generate much needed revenue. It was also an instrument in the king's ongoing plan to completely substitute everything Anglo-Saxon, everything English, with the Norman way of life. By replacing native social structures, laws, language, traditions, religious ceremonies, markets and trading customs with the rigid hierarchy of the feudal system, William virtually obliterated England's

traditional way of life and culture, thus guaranteeing the subjugation of the country and its communities.

As mentioned previously, while many outlying communities, such as Everton, Wavertree and Childwall, are recorded in that great survey, there is no mention of Liverpool. Clearly, it had no value or significance at that time, although it is believed to have been one of six unnamed berewicks (barley farms) that are recorded as being part of the much more important Manor of West Derby. However, this was about to change irrevocably when, 141 years after the arrival of the French, previously insignificant 'Leverpul' suddenly became strategically very important indeed.

2
The Belligerent Monarch

English life under successive Norman monarchs of the Plantagenet dynasty was harsh and brutal, not least of all under King John (1167–1216). He was the youngest and favourite son of King Henry II (1133–1189) but, on the death of the king, it was Henry's eldest son Richard (b. 1157) who inherited the throne. Even though John was granted important titles, vast tracts of land, large amounts of money and continuous revenue, the twenty-two-year-old prince was far from satisfied.

When his brother was killed, in 1199, at Châlus in France, John became King of England, but he was neither a competent nor popular monarch. In fact, he had a major disagreement with Pope Innocent III (1161–1216), about who should be the Archbishop of Canterbury. So, in 1208, the entire country was placed under a Papal Interdict for five years. This meant that no religious services could be conducted in England and no baptisms, marriages, or burials either. King John himself was also excommunicated by the Pope.

Said to have been a selfish, spoilt, sullen and vindictive man who was given to childish tantrums, he has passed into popular history as 'Bad King John'. Greedy, ruthless and most certainly not to be trusted, John even murdered young hostages he was holding prisoner. These included his twenty-year-old nephew Duke Arthur of Brittany (1187–c.1203), whom he had kept in a deep dungeon until, in a drunken rage, the king tied rocks to the young man and pushed him into a river to drown.

In 1210, King John captured Maud de Braose and her eldest son William. They were transported to Windsor Castle in cages and later moved to Corfe Castle. Here, John had them walled up alive in a dungeon to starve to death. In 1212, the belligerent monarch hanged twenty-eight hostage sons of Welsh princes and lords, including 'an excellent boy not yet seven years old'.

Also among his many shortcomings, John was seldom successful in battle, earning for himself the nickname of 'Softsword', which did not only belittle his prowess on a battlefield. When he came to the throne, in 1199, he had inherited a

vast empire in France. However, by the time of his death, he had lost most of this, earning himself another nickname, that of 'John Lackland'.

The people and the aristocracy were no longer prepared to put up with this, so the barons rebelled. To keep his crown, the king had to sign away many of the traditional rights and privileges of monarchy. This major event took place in 1215, at Runnymede near Windsor and his signature at the bottom of the Magna Carta (Latin for 'Great Charter') laid the foundation for many of the modern civil liberties that we now take for granted.

John died from dysentery, in 1216, with very little mourning. But he had done at least one remarkable thing – in 1207 he had founded Liverpool – 'Leverpul' as it was then known.

King John and the Birth of a Town

When John became King of England he also took the title of Lord of Ireland. However, the native Irish were not too happy about this and rebelled against his claim. This was another in a long line of humiliations for the king so, in 1207, he planned to send campaigns of conquest against the land across the Irish Sea. However, to do so, he needed a deep-water west-coast port from which to launch his invasion fleets. Milford Haven in Wales was an obvious choice, but the local tribes were too hostile. The second option, Chester, was too strictly controlled by the dominant local landowner, Earl Ranulf of Chester (1170–1232). He was a petty monarch in his own right and certainly no friend to John.

In the year 1206, John had visited the north of England. Records show that on 26 February he stayed at Lancaster and on 28 February he was at Chester. While there is no evidence that he passed through what was then the insignificant fishing hamlet of 'Leverpul', in the light of his subsequent actions, it seems very likely that he did so. It is certain that he knew of the place and of its sheltered tidal pool and creek.

He was obviously already aware that this was broad, deep and large enough to harbour a large fleet of ships. Also, as this was far enough away from the influence of Ranulf, Leverpul seemed ideal for his military purposes. On 23 August 1207, the king claimed control of the area for the Crown from the then Lord of the Manor, Henry Fitzwarine. Five days later he awarded the previously obscure community his 'Letters Patent' or 'Charter', creating a new town and borough that was to steadily evolve into modern Liverpool.

King John's Charter is carefully preserved and is on public display in Liverpool's Central Library, but it comes as a surprise when people see it for the first time. This is because this very important piece of parchment is only just over seven inches long. It is three inches wide at the left end and two inches on the right. A thin strip of the parchment is partially detached from the main document and it is at the end of this that the king's seal was presumably affixed; it has since become detached, but is also on display.

Nevertheless, this tiny document unlocked something extremely powerful. This was because, to boost his new town and port and to generate the economy necessary to fund the building, equipping and resourcing of his invasion fleet, John offered land and certain privileges to all who would settle here. These entitlements were known as 'Burgages', which gave 'Burgage Holders', or 'Burgesses', the right to build and own property, farm land and operate trades and business with special tax advantages.

Costing an annual rent of 1 shilling (5p), it is likely that he offered an initial 168 Burgages, which also came with an allocation of enough land to build a house fronting a street, with space for a long garden behind. This shows just how far back our traditional housing layout actually goes and why 'a home and garden' is so very English. Many of these first houses would have been erected fronting the narrow lanes of the seven original streets of the town. As well as the Burgage Holders there were around 840 other residents living on and around the seven streets.

It is not until the reign of Edward III (1312–1377) that we find any written reference to the names of Liverpool's first streets, although it is generally accepted that they were laid out on the orders of King John. This was in an 'H' pattern with an extended crossbar and they have all survived in to modern times. The streets have all been widened many times over subsequent centuries of course, but they are Old Hall Street (formerly Whiteacre Street); Tithebarn Street (formerly Moore Street); High Street, on which the town hall stands (previously Juggler Street); Water Street (originally Banke Street, as it led to the bank of the river); and Chapel Street, Dale Street and Castle Street, which retain their original names. Burgesses were allowed to run business from their homes if they wished, creating Liverpool's first shops and manufactories.

The vast acres of fertile land that surrounded the pool would produce livestock and crops to feed the growing community and so the king ensured that a Burgage also included title to two strips of farming or grazing land, in what were designated the common fields of the town. Burgages also came with a range of advantageous universal legal civil liberties, such as the right to gather fuel. Also, the holder of a Burgage would have had other privileges, including exemptions from certain taxes, levies and obligations. This was a very good deal indeed, in medieval England.

The great forest of Stochestede (Toxteth), just to the south of the pool, was another attraction for the king. This was because its ranks of sturdy oak trees would provide all the timber necessary to construct his invasion fleets, as well as the homes and buildings of the new town. The forest stretched southward, from what is now Parliament Street to Aigburth and Otterspool, and eastward from the banks of the Mersey to the Manor of Esmedune (Smithdown), on the edges of Wavertree.

Also, the forest was home to a variety of game, including boar, deer, rabbits and game birds. So, John declared this to now be his own private Royal Hunting Forest and he surrounded it with a high wall, built lodges to guard its entrances

and installed game-keepers, wardens, huntsmen, stables and hounds. The fact that he went to such lengths to secure and develop the area and spent such time, money and resources on his forest makes it almost certain that John did indeed come to Liverpool, on probably more than one occasion.

John also granted authority for his town to hold annual markets, thus establishing it as a significant centre of trade and enterprise. Little did he know that this would begin Liverpool's development into a centre of global commerce. Additionally, the small port on the Mersey was destined to connect directly, across the 'Seven Seas', with the ports, cities and nations of the entire world.

And so it was from 1207 that the story of Liverpool's rise began, although its initial evolution, over the next 500 years, would be slow. Nevertheless, there were to be some powerful landmarks on that journey, which we shall look at in the next

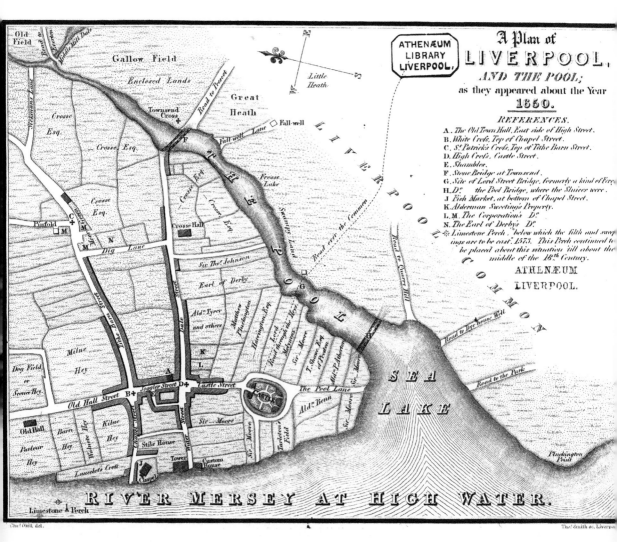

Seven streets of Liverpool.

chapters. But, before we do, we shall see how the town's medieval origins have left their mark in the twenty-first-century city.

A Medieval Legacy

Since the founding of Liverpool, many changes have taken place to the layout and fabric of the town and its port over the centuries. While Liverpool's first seven streets survive in their original locations, there are very few physical relics left of those early medieval times. Of course, there is other evidence of our ancient origins that is not made of stone or brick and the most important of these is the city's name.

No one can say definitively how the name 'Liverpool' originated, but theories suggest that it could have Anglo-Saxon origins in the word 'livered', translating as 'thick or muddy' and so 'muddy pool'. It could also simply mean 'place on the pool', because of the wide tidal inlet that formed its natural haven. Another theory is that seaweed, known as 'laver', was found in the area and that the name Liverpool means 'pool of laver'.

Because very few people could read and write at that time, how the name of the town was spelt varied significantly. This is why, in early documents and records, we see it written as 'Liuerpul', 'Litherpoole', 'Liderpole', 'Liferpole' and 'Lithepool' for example. In fact, one of the earliest versions is as 'Leverpul', which appears in the King's Charter. This was formally presented, by John, to the then Lord of the Manor, Henry Fitzwarren, on 28 August 1207. The document translates as:

> John, by the grace of God, King of England, Lord of Ireland, Duke of Normandy and Aquitaine, Count of Anjou, to all his faithful people who have desired to have Burgages in the township of Leverpul, greeting.
>
> Know ye that we have granted to all our faithful people who have taken Burgages in Leverpul that they may have all the liberties and free customs in the township of Leverpul which any Free Borough on the sea has in our land.
>
> And therefore we command you that securely and in our peace you come there to receive and inhabit our Burgages.
>
> And in witness hereof we transmit to you these our Letters Patent.
>
> Witness Simon de Pateshill at Winchester on the twenty-eighth day of August in the ninth year of our reign.

While the original language of the Charter is Latin, Liverpool marine pilot and Honorary Research Assistant in the Department of French at the University of Liverpool, John Curry, observed that the name of the town, as written in the document, was actually derived from simple Anglo-Norman French words. 'Li' is the definite article 'the'; 'ver' is the adjective 'springtime'; and 'pul' is shortened from the Latin noun 'pulvinarium', meaning 'anchorage'. Hence, 'Leverpul', or 'the springtime anchorage'. This is plausible, because the best time of year to use Liverpool as a safe haven, especially before the age of steam, was in the spring

and summer. The Mersey during the winter was, and remains, treacherous and gale-driven, with high tides and a forceful tidal flow in both directions and with at least a 10-metre tidal height range, which is the fourth highest in the world.

Another possible source might be from the Norse 'Hlithar-pollr', which translates as, 'the pool of the slopes'. As we have seen, the community grew up around the promontory of rock, surrounded by the gently rising slopes of the Seven Hills. So, which source you decide to accept as being the actual origin of the name of the town is entirely up to you.

The internationally famous symbol of the city, the Liver Bird, is another medieval survivor and it can be seen in many forms, in many places, all over Liverpool. There are varying opinions about the origins of the city's most recognisable emblem, but it is obviously a mythical creature.

One view is that it is based on the cormorant that once fed and nested around the old pool and its creek. They would eat the seaweed (again, 'laver') that once grew here; hence 'Laver Bird' or 'Liver Bird'. This is why the bird is always depicted with an apparent piece of the weed in its beak. However, the most generally accepted origin of the emblem is somewhat different.

In tribute to King John for granting Liverpool its charter, the now growing town decided to adopt the crest of the monarch as its own heraldic symbol. This was the image of the Eagle of St John the Evangelist and when the official town seal was first engraved the eagle formed the central image. It was shown carrying foliage in its beak and, rather than this being seaweed, it was more likely to have originally been broom, or the *planta genista* of the Plantagenet family, to which the king belonged.

However, Liverpool has had some turbulent and violent times in its fascinating history and in 1644 the town seal was lost. As shall be seen later in this book, this was during the English Civil War (1642–1651), when the Roundhead-held town was besieged by Royalist forces. Most of Liverpool's defenders were massacred, its buildings razed by fire and its bullion and treasures looted, including the seal.

In 1655, this was replaced by a new seal, but, because of the apparent ineptitude of the artist, the image looked more like a seagull than an eagle. Over time and subsequent redrawings, the bird came to be regarded as a cormorant. On the seal, inscribed around the bird, are the words, *Sigillum Commune Burgenium Leverp*, which translates simply as, 'The Seal of the Burgess Community of Liverpool'.

In terms of the physical remnants of our past though, the 'Sanctuary Stone' is the oldest surviving medieval relic in the town centre of Liverpool. The first written reference to this dates from 1292, although it is likely to be older than this.

The Sanctuary Stone sits embedded in the pavement of Castle Street; one of the most important of the Seven Streets. The stone is flat, circular and about 18 inches in diameter. It is made from green volcanic rock and has four deep parallel score marks across its surface. This was originally one of a pair and its partner was once embedded in the roadway on Dale Street, near the corner of Stanley Street, but this stone has long since vanished.

For almost eight centuries the surviving stone always sat in the same position on Castle Street, until the road was completely refurbished and, in 2013, it was repositioned. It has not moved far, only a few feet, and it now sits in the pavement outside the Natwest Bank. The 'Right of Sanctuary' had been established in early Anglo-Saxon times and it provided fugitives and ordinary people seeking justice too, with a temporary guarantee of safety from prosecution in all churches and churchyards in England. They could claim such sanctuary for up to forty days.

But the town of Liverpool was so important that it had its own 'safety zone'. This was originally marked by the two sanctuary stones, which also set the boundaries of the ancient Liverpool Fairs. These were held each year, on 25 July and 11 November. For ten days before and after these events 'Sanctuary' could be claimed within the precincts of the fair. This was mainly for debtors who would otherwise have been thrown into prison. However, this ancient tradition was abolished by Henry VIII (1491–1547) during the Reformation, so it's no use trying to claim 'sanctuary' today.

The only other significant relic of the distant past is a long tunnel, big enough, it was said, to accommodate a man riding on horseback. This ran from the base of the moat of Liverpool Castle, down to the riverfront at the bottom of what is now James Street. While this tunnel still exists intact, now running from the deep cellar of nineteenth-century Castle Moat House, in Derby Square, the great bastion it once served has long since been swept away.

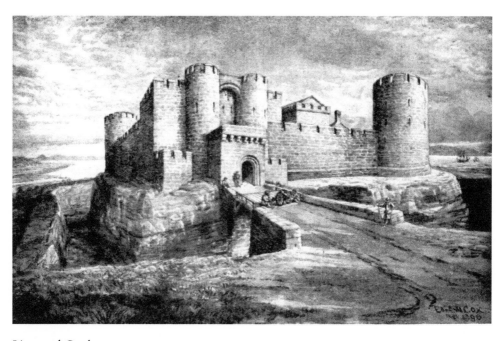

Liverpool Castle.

In the early decades of the thirteenth century, the Lordship of the town was bought from the Crown by William De Ferrers (1193–1254), who was the sheriff of Lancaster and one of the earlier holders of the first Earldom of Derby. Recognising the strategic importance of the town and its commanding position on the sandstone outcrop overlooking the river, the pool and the creek, William erected this impressive stone fortress on the high bluff. This was probably between 1232 and 1237 and is likely to have been built on the previous instructions of King John, or his successor, King Henry III (1207–1272). Some early records suggest that the fortress may well have been constructed on the site of an existing, much older manor house or hunting lodge.

In this excellent strategic position, where Derby Square now stands and at least 20 feet higher than the present ground level, Liverpool Castle was constructed out of great sandstone blocks and surrounded by a moat hewn out of the solid rock. This was about 15 to 16 yards wide and 22 feet deep. Liverpool Castle was rectangular, with tall, broad, circular towers at three of its corners and a large gatehouse, barbican and portcullis at its fourth, facing towards Castle Street.

This was the main entrance, which was also guarded by a drawbridge, set into a causeway across the moat. The castle towers and barbican were connected by high curtain walls topped by battlements, which enclosed a large courtyard. This was a building that was designed to be self-sufficient in times of siege. Consequently, the castle had its own forge, armoury and stables, as well as a bakehouse, a kitchen, a brewhouse and a well. There were also quarters for a garrison of troops and deep dungeons and strongrooms.

An apple orchard on the west side of the fortress overlooked the pool and covered what is now Lord Street. A stone-built dovecot stood to the south, probably near where the modern Queen Elizabeth II Law Courts are situated. The castle soon developed into a residence, with accommodations for the De Ferrers family, their servants and their soldiers. In due course, the building became the town stronghold of the powerful Molyneux family, who were also hereditary Constables of Liverpool Castle.

The huge building dominated the centre of the town for centuries but, during the Civil War, it was badly damaged and subsequently neglected. From 1709, the castle was demolished in stages and various sitting tenants were forcibly evicted, but it was not completely cleared away until 1726. Nothing now remains, above ground, to say that a castle ever stood there, except a plaque noting the fact, mounted on the side of a large memorial statue of Queen Victoria (1819–1901).

At its foundation, the town fell within the parish of St Mary's, Walton-on-the-Hill. But, as this was quite a distance away from the tiny port, Liverpool had its own Chapel of Ease, which is a sort of sub-church. This was the Chapel of St Mary del Quay, later the Church of Our Lady and St Nicholas, which still stands at the bottom of Chapel Street. While the present building is almost entirely twentieth century, this church is one more direct link with Liverpool's origins.

The street on which the church stands was named for the building, indicating that it stood before the founding of the town. Indeed, records dating from 1206,

refer to this being an Anglo-Saxon chapel made of wattle and daub, which already seems to have been a place of pilgrimage. The first chapel was initially dedicated to St Mary, in acknowledgement to its mother church at Walton. The suffix, 'del Quay', referred to its location directly at the river's edge, overlooking the harbour of the original fishing hamlet. When the castle was being erected, it is likely that the chapel was improved around the same time, confirming the important status of the new town.

In the years 1355–1361, a new church, dedicated now to St Mary and St Nicholas (the patron saint of sailors), was built on land granted to 'the Burgesses of the town' by the then Duke of Lancaster, John of Gaunt (1340–1399). This was constructed just a little further back from the river, so that there were then two places of worship on the site. The new and much larger building consisted of a chancel, a nave, a western tower and a large aisle. John of Gaunt knew the chapel well and he paid for the building of a chantry, adjacent to the main altar. A chantry was a special chapel, maintained by an endowment, in which masses were chanted for the soul of its founder, or for somebody named by the founder.

Our Lady and St Nicholas Church remained as a local place of worship until the Reformation and, in 1673, it was described as being 'a place of great antiquity'. Around this time, the original waterside chapel of St Mary del Quay was bought by the Liverpool Corporation, for the sum of twenty shillings. The ancient building was then variously used as a town warehouse, a school, a private house, a boathouse and eventually a tavern; but it was finally demolished in 1814.

In 1699, when the population of the town had risen to about 5,000 people, Liverpool was created an independent parish in its own right, so now it would have another, newly built church. Our Lady and St Nicholas, by then often called the 'Old Church' or simply 'St Nicholas', now became the Chapel of Ease for the new parish church, which was dedicated to St Peter. This had been built on a new street that was appropriately named Church Street.

'St Nick's', as the old church also later became affectionately known, remained the church that seafarers prayed and worshipped in before setting sail on perilous sea voyages. It is still the place of worship and prayer for the families and friends of sailors at sea while separated from their loved ones. This is also where seafarers and their families come to give thanks, following a safe return from a long voyage.

The church once had its own burial ground, which is now a beautifully kept lawn and garden to the south of the building. However, beneath the turf and flowers still lie thousands of corpses buried there over the centuries, including many victims of the plague. Burials ceased in 1849 and it was landscaped in 1891. Before the tombstones were removed, some of their inscriptions were recorded. One of these, to the memory of Richard Blore and dated 1789, read,

> This town's a Corporation full of crooked streets,
> Death's in the market place where people meets;
> If life like merchandise that men could buy,
> The rich would always live, the poor would always die.

Another, dated 1786, commemorates the tragic end that befell James Scanlion:

In the morning I rose up all right
And pursued my business until night,
When going to my Vessel's Stock,
Death plunged me in the Salthouse Dock.

Between 1673 and 1718, the building was added to and extended at various times and, in 1746, a spire was added to the tower. Then, in 1774, Our Lady and St Nicholas's Church was almost entirely rebuilt.

The church not only had a human significance, but also a strategic one. For, in 1759, a battery of fourteen guns was placed in the cemetery, where the gardens now stand, to protect the port from attacks by French privateers. This was still a time when the River Mersey washed right up to the wall of the church, before any of Liverpool's docks were built.

St Nick's continued to play an important role in the life of the waterfront and of the town but, despite the many new churches then being built in Liverpool, no opportunity was taken to replace the old and deteriorating building with a more up-to-date structure. There had been repeated warnings that the spire was unsafe and, on 11 February 1810, as people were assembling for Sunday morning service, the bells were being rung very vigorously, which caused the church steeple to suddenly collapse, crashing into the nave. Many people were severely injured and twenty-five people were killed. This included twenty-one girls aged under fifteen, who were mostly from the nearby Moorfields Charity School. Because of this tragedy, the Chester architect Thomas Harrison (1744–1829) was brought in to redesign and rebuild the tower. In 1815, the work was completed and the new, 120-foot-high tower, with spectacular flying buttresses, was built. This was surmounted by a beautiful and much more lightweight lantern spire, which still stands at a further 60 feet high. Since 1916, Our Lady and St Nicholas has been the Parish Church of Liverpool because, in 1922, St Peter's was deconsecrated and demolished.

The nave of St Nick's was destroyed by German bombing in 1940, during the Second World War, but the tower and spire survived. A new nave was built and was consecrated in 1952. It is in the churchyard here that one can find the 'Blitz Memorial', commemorating the catastrophic bombing of Liverpool during May 1941. We shall return to the wartime story of Liverpool later.

'St Nicks' remains not only an active and popular place of worship and the setting for many celebrations and special services, but also has a ceremonial function in the civic and communal life of the city. It is also a fully functioning parish church, which not only traditionally serves the business community of the town-centre, but also the local residential community.

In fact, the bells of the church have a special significance to local residents, in that, while everyone born within the city boundaries can claim to be a genuine 'Scouser', only those who are born within the sound of the church bells of Liverpool

Parish Church can be truly called 'Dicky Sams'. This is an old Lancashire term for a Liverpool man and it predates 'Scouser'. One explanation for the term says that it derives from the woollen muffler that Liverpudlian men, especially those working on the docks, traditionally used to wear around their necks.

Only one other building remains to directly connect with Liverpool's medieval past and that is Tower Buildings. This tall, modern office block overlooks the churchyard of Our Lady and St Nicholas. It was built in 1906, by the same architect who designed the famous Royal Liver Building, Walter Aubrey Thomas (1859–1934), and stands on the site of the original, and very grisly, Tower of Liverpool.

From around 1250, here stood a large mansion house built directly on the waterfront shoreline. Constructed in large blocks of local sandstone, by the year 1369, records show that this had become the property of Sir Robert de Lathom (1209–1290), who was a very wealthy and powerful local aristocrat. Then, in the reign of King Henry IV (1366–1413), the building passed into the hands of

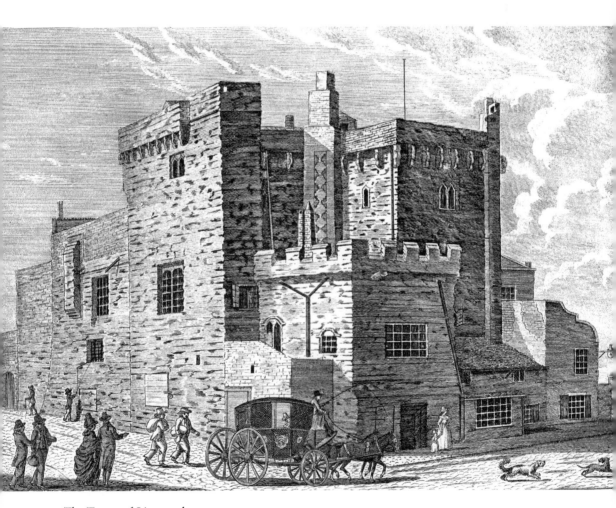

The Tower of Liverpool.

Sir John Stanley (1350–1414). He was a wealthy gentleman knight who owned estates throughout Lancashire and Cheshire and, in 1405, the king granted Sir John the Lordship of the Isle of Man.

Although he had an exceptionally large estate and hall at Lathom, 15 miles north of Liverpool near Ormskirk, and another vast estate and Hunting Lodge at Knowsley, 8 miles to the east of the town, in 1406, Sir John made an application to the king to be allowed to fortify his riverfront property. Henry gave his permission, so Sir John set about expanding and redesigning the large house and renamed it the 'Tower of Liverpool'. This was done to leave the local people in no doubt as to his status and authority.

By 1413, the powerful Stanley family had converted the old mansion into a military stronghold, which was permanently garrisoned by their own troops. These men stood guard over the Stanley's embarkation point for the Isle of Man, at the foot of what was then still Bank Street. For 250 years the Tower remained the Stanley family headquarters in Liverpool. It was also the base from which they governed their 'Kingdom of Man', on the small island in the Irish Sea.

As well as its high walls and turrets, its battlements, and a formidable, impregnable gateway, the Tower also had armouries and other facilities for the soldiers. Also, like the castle, there were dungeons and cells. On the upper floors, however, were much more comfortable apartments for Sir John and his family.

In due course, the Stanleys became the Earls of Derby and grew even more in power and wealth. By 1717 though, the family no longer had any need for the Tower and so they sold it. This was fortunate for their reputation because, by 1737, it was being leased from its new owner by Liverpool Corporation. They soon began to employ its noisome cellars and dungeons as an increasingly notorious town gaol, while the upper floors of the ancient fortification were used as assembly rooms for dancing, gaming and other entertainments.

Conditions in the prison soon became foul beyond belief for the unfortunate people who found themselves incarcerated there. Men, women, boys and girls were all herded together with no discrimination and in often violent, gross and indecent circumstances. Strong prisoners bullied the weak, while the jailers bullied everyone and extorted money from the prisoners. Cruelty, brutality, filth and starvation became facts of life in the Tower dungeons.

There were seven cells, each around 6 feet square and all well below ground level. At least three prisoners could be confined in each of these, with the only light and air entering through a tiny grill above each cell door. There was no water supply or sanitation so sickness and death were common from what was called 'jail fever'. What food was provided was of appalling quality and far from regular. This meant that starving prisoners were often reduced to catching and eating rats, mice and cockroaches to survive.

The excrement and mud that accumulated could often be ankle-deep and would only be removed (by the prisoners under close guard) when the happy revellers in the Assembly Rooms above could no longer stand the stench. This became especially bad in hot weather. Even then, it would only be taken into the centre of

one of the Tower's two courtyards, where it was piled up in a huge midden that was only removed once a month. These sewage-covered yards were also the only places where the prisoners could get any exercise.

There was a larger cell in the Tower, on the ground floor. This was big enough to accommodate between ten and twelve people, but at one point, it was home to over forty men, women and children. This did have a high window, which faced out onto the street. Through this and depending on the charity and generosity of the public, the prisoners lowered gloves or bags, tied to strings suspended from sticks. They hoped that kindly passers-by would drop coins or food into these. Sadly, it was a favourite sport of the local boys to deposit stones, mud, or other nasty substances into the begging-bags.

The dreadful Tower of Liverpool was closed in 1811 and demolished soon afterwards. Replaced by warehouses and then an office block, the present Tower Buildings reveals nothing of the grim yet significant history of the ancient Tower that gave the present building its name. However, it is the final direct physical link to Liverpool's ancient past.

3

The Lords of Liverpool

At the time of the founding of the new town and borough, there were already a significant number of surrounding manors and estates. Some of these dated from the time of the Norse invaders, while others were even older, dating from the Anglo-Saxon period.

These estates included the Manors of Garston, Allerton, Speke, Fazakerley, Much Woolton, Little Woolton, Smithdown (or Esmedune), Childwall, Wavertree, Everton, Toxteth, Walton and the Manor of West Derby. After King John died, in 1216, his ownership of the Borough of Liverpool, of the hunting forests and of the Lordship of the town passed to his son, Henry III. It was this king who granted the lease of the Manor of Liverpool and other manors surrounding the town, to a number of baronial families: these were the next 'Lords of Liverpool'.

A number of such families established themselves successively in the town, with authority from the monarch to govern and take an income from the people and the land. They each exercised great power and the first of these was Earl Ranulf of Chester, to whom Henry granted the Manor of Liverpool in return for political support.

Ranulf was succeeded by his brother-in-law, William de Ferrers. Then, from 1266 to 1399, except for short periods, Liverpool and its surrounding lands were controlled by the Earls and Dukes of Lancaster, including John of Gaunt, who became Lord of Liverpool in 1393.

Throughout the later centuries of the Middle Ages, as the town began to grow beyond the small residential area of the original seven streets, prominent families from all over Lancashire and elsewhere saw profitable commercial opportunities, so they moved in to exploit them. These families were now leasing (and occasionally buying) land, estates, manors and income rights from the great baronial aristocrats and were themselves becoming a new breed of lesser landed gentry.

With family names such as Lathom, Norris, Blundell, de Liverpool, de Walton, Fazakerley, Ireland and Percival, they would be among the people who helped

establish Liverpool Town and Port as a powerhouse of international commerce. The fourteenth to seventeenth centuries would see real wealth being created on the shores of the River Mersey by these families, as well as by the ordinary citizens of Liverpool.

The Crosse Family – The First Benefactors

The Crosse family was one of the most significant dynasties in early Liverpool, first settling in the town around 1350. They came from the Wigan area where they already held significant property and estates. They succeeded to much of the land previously held by the de Liverpool family, who had ceased to be an influence in the area by the beginning of the fifteenth century. This now made the Crosses one of the wealthiest families in the Borough.

As with the other manorial and land-owning families, the Crosses also needed a local family seat, so around 1520, they built Crosse Hall in the town. This stood at the corner of Crosshall Street and Dale Street and they saw themselves as patriarchs and benefactors to the community. Consequently, in 1515, Reverend John Crosse (c. 1464–c. 1517) funded the building of the first town hall and exchange in Liverpool and this stood just over the road from the present town hall.

In 1552, Sir John Crosse (c. 1525–1575), who was also a priest, gave money for the establishment of a Grammar School, which was the first of its kind in the town. This also funded the appointment of a schoolmaster, 'to keep a grammar school and take his advantage from all the children except those whose names be Crosse and poor children who have no succour'.

Whether the benefactor had lots of relations or offspring (legitimate or otherwise) that he wanted to educate, records do not say. Nor is it known how many pupils attended the school, by the name of Crosse or any other. The school was established in the former Chapel of St Mary del Quay on the waterfront at Chapel Street as, by this time, the Church of Our Lady and St Nicholas had been built and so the original place of worship was available. In the early eighteenth century, the school was moved to a property in School Lane, after which that street was named. In 1565 and 1572, John also served as Mayor of Liverpool, as did a later John Crosse, in 1581.

With the equally important Moore family, the Crosses held the corn-grinding rights from the monarch, and a windmill stood at the creek end of Dale Street. This was known as the Townsend Mill and all the local people, by law, were compelled to grind their corn here, paying both families a fee for doing so and providing them with one of many sources of income.

From the early seventeenth century, the Crosse family began to increase their wealth from overseas sources, when they became one of the first merchants in Liverpool to invest in lucrative foreign trade, importing iron into the town from Spain.

The family lived in Crosse Hall until 1697, when they moved away from Liverpool to reside at Shaw Hall in Chorley. However, they kept ownership of the grand mansion and its estates until 1742, when their extensive holdings were sold off to a variety of buyers. Crosse Hall survived until sometime around 1750, when it was pulled down. Over the next sixty years or so, a variety of buildings occupied the site and, in 1810, it became the location of the Saracen's Head coaching inn. Liverpool's Municipal Building now stands there.

While the Crosse family were undoubtedly significant in the town, there was another landed merchant family who were even more influential.

The Moore Family – The First Grandees

Some 150 years before the Crosse family came to Liverpool, the Moores had moved into the Kirkdale area, just a mile or two north of the tiny town. When the Vikings had settled here, in the tenth century, this was a pretty little country vale with a brook running through it. Later, Christian Saxons built a church alongside the stream and named the district 'Churchedele', from which we obviously get the modern version of its name. When the church was actually built is uncertain, but it was listed in the Domesday Book.

At the time of the Norman invasion and occupation, this district and much of what is now Liverpool was then owned by a very powerful Saxon 'Thane' named Uctred (dates unknown). A Thane was the ancient equivalent of a Knight or Baron and Uctred owned lands from Kirkdale all the way south to ancient Speke and Garston. The Norman conquerors took ownership of the manor, which passed to Roger of Normandie, who then took the name Roger de Kirkedale (dates unknown). The ownership of Kirkdale then passed from Roger, via his wealthy daughter Quenilda (dates unknown), to the More family around 1280.

The Moores already wielded powerful influence in old Liverpool at this time and, in fact, by 1230, they had built a large family mansion with a great estate and farmlands, on the site of the modern City Exchange Building on what is now Old Hall Street.

Named More Hall (spelt 'Moore' from the seventeenth century), this grand house contained a hall, a parlour, a great chamber, a buttery, closet, dairy, kitchen, brewhouse, stable, garret, cheese chamber and a large outhouse with two spare beds. This whole complex was clearly just as significant as the family were and the Moores became a key influence within Liverpool for many centuries.

Records show that in 1246 Ranuf de Mora (More) was Liverpool's first recorded reeve, although the town had almost certainly had a reeve since its foundation in 1207. This official office dated from Anglo-Saxon times and a reeve was the representative of the monarch or the lord of the manor in a shire or district. He was responsible for managing the administrative affairs of the community and this is where the term 'sheriff' comes from, deriving from 'shire-reeve'.

In 1388, Thomas Moore built an even greater house for his family in Kirkdale, which they named 'Bank Hall'. The Moores then moved into this from More Hall, which then became known as the 'Old Hall'; hence Old Hall Street. This street, which until that time had led only to this building, was now extended north to their new family seat.

If More Hall had been impressive, this was nothing compared to Bank Hall, which they completely rebuilt and extended in 1582. Additional rooms were now added to the already splendid manor house, including a larger Great Hall. This was decorated with carvings, busts, shields and military trophies. In all, Bank Hall had forty rooms, including seventeen bedrooms, a chapel, a nursery, a ferret house, four stables, a study and a dining room.

The house was surrounded by extensive and beautifully landscaped grounds and gardens, complete with an artificial lake and a moat. These were fed by the stream that ran through Kirkdale, from the hills above the district at Everton and Walton, down to the Mersey. A bridge across the moat led to the entrance of the hall and passed between two tall obelisks. The gateway had a tower that was adorned with coats of arms carved in stone and this estate was to be the Moore's new family seat for 400 years.

However, the Old Hall did not stand empty. Indeed, it was still very much part of the family holdings and it remained occupied for many years as a Dower House (a building occupied by a widowed female relative, as in 'dowager').

Many members of this family played important roles in the town and, between 1292 and 1633, various Moores served Liverpool as Mayor, in all a total of twenty-nine times. Colonel John Moore (1599–1650) was a Parliamentarian

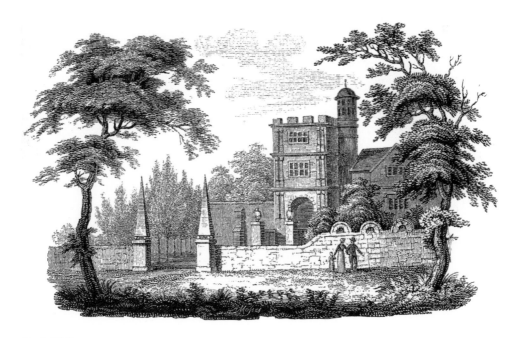

Bank Hall.

commander and Governor of Liverpool during the Civil War. He was also one of the signatories on the death warrant of King Charles I (1600–1649). Following the king's execution, John Moore went to Ireland as Governor of Dublin where, within a matter of months, he had contracted the plague and died.

Staunch supporters of parliament throughout this time, the Moores were respected by most people in the town, but not all. Indeed, a former clerk to the family and Royalist catholic described Colonel Moore's household as being 'a Hell upon earth as was most intolerable ... a pack of arrant thieves ... profane and bitter scoffers at piety'.

At his death, John left his estate in great disarray and in debt to the tune of almost £10,000 (around £1,250,000 today). His son, Sir Edward Moore (1634–1678), who became 1st Baronet in 1675, was unable to return it to solvency. Even so, he was the first Burgage Holder to begin the development of Liverpool beyond its original seven streets. He laid out many new roads and tracks, especially off the north side of Dale Street, including Hackins Hey and Hockenhall Alley. He also laid out Fenwick Street and Moor Street, between the castle and the river. Many of these streets survive today.

Unfortunately, Edward's son, Sir Cleave Moore (1663–1730), inherited the great family debt. Despite laying out Edmund and Union Streets, off Old Hall Street, as well as James Street, Sir Cleave was also incapable of reducing the debt. In fact, he soon increased it to around £12,650. So he decided to marry his way out his financial troubles by wedding a wealthy heiress from Hertfordshire. However, he did so without permission from his bride's father, who objected vehemently. In response and using false testimony from bribed servants, Sir Cleave successfully accused the country gentleman of 'lunacy'.

He had now secured an annual income for himself of £1,400 and had also separated from his wife. It was then that friends of his father-in-law successfully had the lunacy charge quashed and Sir Cleave had to repay the money he had already acquired. He also forfeited all claim to the income from his wife's estate. His reputation was irreparably damaged too and he retired to London in an attempt to escape local ignominy.

The only way Sir Cleave could now settle the crippling family debt was, in 1725, to sell his estates. These not only included those in Liverpool, but also the manors of Kirkdale and Bootle, as well as estates and property in Kirkby, West Derby, Fazakerley, Litherland, Little Crosby and Walton. The buyer was James Stanley, 10th Earl of Derby, who already owned much of Lancashire. This meant that the last of the Moores of Liverpool left the family name and estates in tatters.

Bank Hall was eventually demolished in 1772 and Bank Hall farmhouse was built on the site. The north Liverpool district of Bankhall now takes its name from this. The Old Hall survived largely intact until 1820, when part of it was taken down as, in due course, Old Hall Street was widened. By the end of the nineteenth century it had gone forever.

Despite the impact and influence of families like the Crosses and the Moores, the two most significant aristocratic dynasties, not just locally but nationally, were

those of the Stanley and Molyneux families, who became the Earls of Derby and Sefton, respectively.

The rank of Earl, though certainly a powerful position to hold in the British aristocratic pecking order, is third in order after the monarch, with Duke being the first rank and Marquess being the second. The Derby title was first adopted by Robert de Ferrers (*c.* 1062–1139), the 1st Earl, and had been awarded to him in 1139. It continued with the de Ferrers family until the 6th Earl forfeited his property toward the end of the reign of Henry III. Most of the de Ferrers property and, by a second creation in 1337, the Derby title, was then held by the family of Henry III. The title then became extinct upon Henry IV's accession to the throne. However, it would be created once again, some 150 years later, for the Stanley family.

For centuries, the Stanleys and Molyneuxs co-existed, if not always amicably, with their great estates located side by side to the east of Liverpool. Although neither family held large territorial properties within the early town, they were burgesses of Liverpool in their own right. This status, as we have seen, gave them significant political and economic privileges as landowners and licences to trade in a variety of commodities and services. However, their main sources of income came from the large estates that they held outside the town. Nevertheless, they also derived much of their wealth from their ownership of buildings in Liverpool, such as the castle and the Tower. They also took considerable and regularly increasing revenues from the vast surrounding forests and from fees for the operation of farms, mills, markets, fairs and ferries.

The Stanley Family – The Earls of Derby

Arguably, the most significant local landowning family remains the Stanley family of Knowsley. According to Stanley family tradition, their founding ancestor was Adam de Aldithley (b. *c.* 1005), who is said to have come to England with William the Conqueror. The story is that he was rewarded for his service with extensive estates and manors in Staffordshire. Although, the family certainly appear to hail from that county, it is likely that they invented their Norman heritage to give themselves status in Plantagenet England.

Whatever the truth is about their origins, early in the twelfth century, William de Aldithley (b. 1082) married Joan (b. *c.* 1071–d. unknown), daughter of Thomas de Stoneleigh (Stanley) (b. *c.* 1045), of Storeton on the Wirral. Thomas was a descendant of Anglo-Saxon thanes and so was a person of considerable rank and influence. Through his marriage to Joan, William acquired large estates and manors on the Wirral and throughout Cheshire. It was at this time that he also adopted the name of de Stanley.

In 1385, Sir John de Stanley (1340–1414) married Isabella de Lathom (1364–1414), who was a wealthy heiress from an extremely powerful South Lancashire family. This united both great houses and now made Sir John even richer too. The

marriage also brought him title to the lordship of much of the Hundred of West Derby, but not of the town itself. At that time, the Manor of Liverpool was still in the ownership of the king.

Although Isabella's family seat was at the magnificent and palatial Lathom Hall, 15 miles north of Liverpool, near Ormskirk, Sir John wanted to establish his own family estates, and so he and his new wife spent most of their time on his extensive Knowsley estate, at Knowsley Hall. It was from this time that Sir John adopted the motto, '*Sans Changer*', for his family, which translates as 'Without Change'.

Sir John became a Burgess in Liverpool in 1390 and was also very influential at the court of Henry IV. In 1400, the king appointed him as Lord Lieutenant of Ireland. The knight acquitted himself so well in this position and with such ruthless efficiency that Henry was delighted. However, the people of Ireland were far from pleased with the way in which he exploited them and their country and he was a much-hated man.

This ruthless approach suited the king however and so in 1406 he rewarded Sir John by granting him the hereditary title of 'King of Mann', directly representing the monarch on the tiny Isle of Mann (now 'Man'). This meant that Sir John was effectively ruling the island, which lies in the Irish Sea about halfway between Liverpool and Belfast. Although still subject to the British Crown, to this day the island retains nominal independence and it has a parliamentary structure that it inherited from its early Viking conquerors.

Sir John Stanley was as ruthless an overlord of the Manxmen as he was over the Irish and, when he died, rumours began to spread that this had been brought about by the pagan rites conducted by Irish Druid priests and poets. It was said that their vengeful curses had 'called down dark powers' to end his life. Nevertheless, the Stanleys continued to hold the title of King of Mann until the mid-eighteenth century, when the 10th Earl of Derby, saying 'It is better to be a great lord than a petty king', changed his title to 'Lord of Mann'.

As we saw in the previous chapter, the Stanley family stronghold in the heart of Liverpool Town was the Tower. Sir John Stanley had quite deliberately created this terrifying monstrosity of a structure to emphasise his authority over local people, but also as a direct challenge to his neighbours, the Molyneux family, who were also rapidly increasing their influence and wealth in Liverpool; as we shall see shortly.

These two great houses were to become serious rivals and both had large private armies of well-armed men to reinforce their respective points of view. These soldiers were always ready for action and in 1424, during one of the many Baronial arguments that took place during this period, Sir Richard Molyneux (1395–1454) and Sir Thomas Stanley (1405–1459), 1st Lord Stanley, were preparing to fight a serious battle against each other, right in the heart of Liverpool.

But, just before swords and spears could clash in the narrow streets of the town, the sheriff of Lancaster stepped in. He had been issued with a warrant by King Henry IV, which gave him authority to halt the argument and to arrest Sir Richard

and Sir Thomas. He sent two Justices of the Peace to the town, James Holt and Sir Ralph Radcliffe, to make the arrests. When they arrived, Sir Thomas was inside the Tower, ready with about 2,000 fully armed men and waiting for Sir Richard Molyneux to attack. Molyneux, meanwhile, was rapidly advancing towards the town with his own army of around 1,000 men, also heavily armed, armoured and ready to spill their rivals' blood.

Holt and Radcliffe immediately exercised their royal warrant and arrested both knights and forced Molyneux's men to withdraw back to his Croxteth estate at the nearby village of West Derby. Stanley was taken to Kenilworth Castle and Molyneux to Windsor Castle, but both men very quickly saw the error of their ways, relented and repented, and were released.

In an attempt to heal this rift, as well as in the hope of making a mutually beneficial alliance, the protagonists' children married. Whether or not the marriage was successful between Elizabeth Stanley (b. *c.* 1423) and young Richard Molyneux (1422–1459), the records do not say. Regardless, the rivalry between the families continued down the centuries, although they would never actually come to battle again. But, around sixty years later, the fortunes of the Stanleys would take a significant upward turn.

Richard Plantagenet, Duke of Gloucester (1452–1485), assumed the throne of England in 1483, on the death of his brother, King Edward IV (b. 1442). He was the eleventh monarch to do so since King John and this unlucky number reflects the nature of his very short reign. Richard was the last of the great Plantagenet ancestral line but, like his early predecessor, he has also passed into posterity with a very bad reputation. But, as the history of King John was largely written by the priests and churchmen whom he made his enemies, so King Richard's was written by the Tudors, who captured his throne from him – but only with the help of a cunning Liverpudlian. So perhaps we should not believe all we read in those medieval reports. Nevertheless, Richard was not a popular ruler.

Richard had been named Lord Protector of the new king, his twelve-year-old nephew Edward V (b. 1470). But, as the boy was making his way to London for his supposed coronation, his uncle met him and escorted him to the capital. Here, he was immediately placed in comfortable apartments in the Tower under close guard and he was soon joined by his younger brother, also named Richard (b. 1473). The two young boys were never seen again.

Rumours were rife then and suspicions persist to this day that the children's uncle had them murdered in the Tower. However, it is just as likely that someone else saw the advantage in removing these innocent obstacles to the crown of England: Lady Margaret Beaufort (1443–1509). She was the formidable Countess of Richmond and mother to a serious pretender to the throne, Henry Tudor (1457–1509), the Duke of Richmond. Also, she was the wife of one of King Richard's most trusted and powerful courtiers, Lord Thomas Stanley (1435–1504) of Knowsley. Even so, this complex situation would ultimately prove to be the making of the Stanley family (and of Henry Tudor).

In August 1485, Thomas Stanley's son-in-law, Henry Tudor, landed unopposed at Mill Bay in Pembrokeshire, close to his Welsh birthplace, with an army of 5,000 soldiers, mostly mercenaries. A direct descendant of the Welsh King Rhys ap Gruffydd (1132–1197), he was determined to seize the crown from Richard III.

Henry wanted to engage Richard as quickly as possible, before the king had the chance to raise too great an army. As it was, Henry knew he was likely to be outnumbered, so he rapidly made his way inland towards London. Richard's army, of between 8,000 and 10,000 men, was waiting for him near the small town of Market Bosworth in Leicestershire and the king had taken a commanding position on a hilltop.

It was 22 August 1485 and, as battle was joined, Richard was confident of victory because he had a superior force in numbers and armour. Salvos of canon fire criss-crossed the battlefield, wounding and killing hundreds of men on both sides. Then, wave after wave of arrows rained down on men who were inadequately protected against this deadly hail. Horses ran down foot soldiers, but were themselves impaled on spears and hacked by swords. Knights in full armour clashed together, slicing and slashing at all around them, as the ordinary soldiers fought more for their own lives than for the victory of their leaders. Bodies began to form mounds on the battlefield, which began to turn from verdant green to bloody crimson, as the noise and stench of death swept across the scene.

King Richard's army may have had the numbers, but they did not all have the will or the courage and some of his men deserted. The king now decided to take a major gamble. Seeing Henry Tudor across the battlefield, Richard and his knights left the main force and charged directly towards his enemy.

The king's position was now extremely vulnerable and the battle could have gone either way. But Richard believed his charge was a risk worth taking, because he had seen that there were troops ranged under his banner who had not yet fully engaged in the battle. These belonged to Lord Thomas Stanley and his brother, Sir William Stanley (1435–1495) and numbered around 5,000 men. Richard confidently expected the support of both Stanleys, but Lord Thomas was in a quandary. While he was a trusted friend and senior courtier of King Richard he was, of course, married to the mother of Henry Tudor and so was the pretender's stepfather. Like so many of his descendants would also prove to be, Lord Thomas was determined to be on the winning side.

Whatever subsequent chroniclers may have written about Richard III, his reckless courage in the battle was beyond doubt. The king knew he was facing defeat and that the battle was drawing to its end, so he made one last charge, at the head of a small body of knights in a final attempt to kill Henry Tudor. He galloped ahead with his sword poised ready to slay the pretender and he decimated Henry's bodyguard in the process. He also killed Henry's standard bearer with a single sword thrust.

The Stanley brothers had been deliberately waiting to see which way the battle was going before committing themselves to the fight. But then, William Stanley saw King Richard battling his way towards Henry Tudor and pulling ahead of

his knights as he did so. The king was now unprotected and exposed to personal assault. Between the armies was a marsh, which Henry purposely kept on his left so it would act as a barrier against any attack on his men from that direction. This also meant that he would have the sun at his back and in the faces of Richard's troops. This tactic allowed him to attack the right wing of the king's army.

Sir William, seeing where the king's troops were most vulnerable, now made his move and led his men to attack them from the rear. Meanwhile, Lord Thomas Stanley led his men forward too, but towards the king. Hacking their way through the monarch's now exhausted knights, Thomas closed in on Richard, who now realised his position and turned to face his new attacker.

But Richard and his knights were surrounded and massively outnumbered by Stanley's men, who now pressed them towards the marsh, where the king's horse became stuck in the mire. Tradition has it that Richard was unhorsed, crying out, 'Treachery, Treachery, Treachery,' when he realised how the Stanley brothers had betrayed him. And indeed there was treachery at the Battle of Bosworth Field, but there was also courage.

In this final skirmish, the king's banner-man, Sir Percival Thirlwall, had both of his legs hacked off. Even so, he remained in the saddle, holding the king's standard firmly aloft. But all was now lost for Richard, as his own men now deserted him. Surrounded and defeated, King Richard III was finally slain with a poleaxe, wielded by Sir Wyllyam Gardynyr.

William Shakespeare has the king desperately calling out in his last moments, 'A horse, a horse; my kingdom for a horse.' Tragically, the only horse he was given was the one over which his naked and mutilated corpse was then unceremoniously slung. Richard was to be the last English king to die in battle and the only king to do so on English soil since Harold II at the Battle of Hastings in 1066.

Chroniclers tell of Lord Thomas Stanley finding the crown of England lying in a thorn bush after the battle. Once victory was secured, he then led Henry's entourage to the nearest hill, originally named 'Garbrode Hill'. Here, Stanley dramatically placed the crown on Henry Tudor's head. From this time the hill became known by the name it retains today, 'Crown Hill', and also from this time, Thomas Stanley became known as the 'Kingmaker'. The image of a thorn bush now became part of Henry Tudor's heraldic symbolism.

Sir William Stanley received many rewards, but Lord Thomas was heaped with honours, titles and lands. The most important of these was the title of 1st Earl of Derby (in the third creation). Meanwhile, Richard's still naked body was brought to Leicester, where it was publicly displayed to prove his death. Two days later the mutilated corpse of the tragic monarch was buried in the nearby Franciscan Abbey. However, after the Dissolution of the Monasteries, between 1536 and 1540, the abbey was demolished. Over the centuries and as Leicester grew and expanded, the location of Richard's tomb was lost to history.

However, in 2012, after much research and analysis of maps and records, from under a car-park in the centre of Leicester, archaeologists unearthed the skeleton of a man with a partially deformed spine. These remains were

confirmed as being those of King Richard III, whose new resting place will be Leicester Cathedral.

Ten years after his victory at Bosworth, Henry Tudor, now King Henry VII, decided to pay his stepfather a visit at Knowsley. It was because of this that Earl Thomas built a new and much grander hall on his estate, which still stands today. From this time the Stanleys became increasingly rich and influential; indeed, their estates were once said to be the largest in England. However, they were to lose everything, 150 years later, after the Civil War.

During this protracted and bitter conflict, the Stanleys fought on the Royalist side in support of King Charles I (1600–1649). With the eventual victory of the Parliamentarians and Oliver Cromwell (1599–1658), the king was beheaded. Unfortunately, so was the then 7th Earl of Derby, James Stanley (b. 1607), at Bolton in 1651. The vast bulk of the Stanley family estates and properties were then confiscated. This left the surviving Stanleys eking out a much poorer lifestyle at their small Cheshire property of Bidston Hall on the Wirral.

But this was only a temporary setback, because, with the Restoration of the Monarchy in 1660, the Stanleys recovered most of their estates and holdings. Also, further strategic marriages continued to consolidate the family's wealth and influence.

Over the centuries, with the Stanleys holding the Tower of Liverpool and, as we shall see, the Molyneuxs as Constables of Liverpool Castle, the rivalry continued between these two great South Lancashire families. However, after many ups and downs in their respective dynastic histories and despite political and religious differences (the Molyneuxs had always been a Catholic family), they eventually began to grow more friendly towards each other.

Nevertheless, they were both inveterate gambling families, dedicated to horse racing and to card games. Consequently, during the late eighteenth and early nineteenth centuries, bits of land kept changing hands between the Stanleys and Molyneuxs, across green baize and green turf. In fact, the 12th Earl of Derby was very keen indeed on horse racing and in 1778, he founded a famous horse race, 'The Oaks', naming it after his house in Epsom. The Earl then went on in 1780 to establish what is arguably the world's most famous horse race, the Derby.

Following their sale of the Tower of Liverpool, to a private buyer, in 1717, the influence of the Stanley family in the town was to take a less military and more political and cultural form. The 13th Earl of Derby, who had assembled one of the finest natural history collections in the world at Knowsley, as well as a large private zoo, was President of the Zoological Society. On a visit to Regent's Park Zoo in London, he happened to notice a young Edward Lear (1838–1903) sketching the animals. The Earl was so impressed by the young man's ability and skill that, for five years, he employed him to paint the animals in his own menagerie at Knowsley Park. Also famous for his nonsense rhymes, it was while at Knowsley that Lear wrote the popular children's poem 'The Owl and The Pussycat'.

The tradition of keeping live animals at Knowsley Park is being maintained in Knowsley Safari Park, on the present Earl's estate. While the rest of Lord Derby's

land is closed to the public, the Safari Park is open all year round and it is one of the region's most popular visitor attractions.

The Stanley family continues to live at Knowsley Park, in the persons of the 19th Earl, Edward Stanley (b. 1962), his wife, Countess Caroline (b. 1963) and their children, Lady Henrietta Mary Rose (b. 1997), Edward John Robin, Lord Stanley (b. 1998) and Hon. Oliver Henry Hugh (b. 2002). This has ensured that the Earldom will continue through the male line of descent. A thriving community lives and works on the Knowsley Estate, maintaining and farming the land and its livestock, as well as serving the domestic, social and commercial needs of the Earl and his family.

The Molyneux Family – The Earls of Sefton

The second local aristocratic dynasty to weave their story into that of Liverpool, was the Molyneux family. Their motto, *Vivere Sat Vincere*, translates as, 'to live is enough to conquer' and, from medieval times through to the twentieth century, they were significant in politics and power, not just on Merseyside but throughout Britain. They were also close friends of many English monarchs.

The Molyneuxs were one of the oldest families in Britain, claiming descent from Guillaume De Molines (b. 1046). He was a knight who had come to England with William the Conqueror in 1066. Sometime just before 1100, they were first granted lands to the north and east of Liverpool by the powerful Norman Baron Roger de Poitou (1058–1123).

This included lands in and around the village of Sefton, where the Molyneuxs lived in Sefton Old Hall and established their family seat as Lords of the Manor. It was from here too, that they were eventually to take their title. The hall stood near the village church of Sefton, where family members were buried over the centuries. It is possible that this house already existed when they acquired the estate, but the family soon made it their own and kept their surrounding and extensive grounds well stocked with deer. The family were also granted lands at Thornton, Little Crosby, Litherland and at Warbreck Moor, which was near modern Aintree. However, Sefton Old Hall was pulled down sometime in the eighteenth century.

The Molyneuxs were also soldiers who fought in the Crusades and, because of the patronage of successive monarchs, they became wealthy and influential nobles. Members of the Molyneux family were among the first burgesses in King John's new town, where they established holdings from 1207.

In the fourteenth century, they bought the right to the tithe from Liverpool, which was payable to Shrewsbury Abbey. They then erected a stone tithe-barn at the outskirts of the medieval town, on what was to be named Tithebarn Street as a result. This meant that they took a cut from the income and goods passing through their hands on its way to the church hierarchy. This began the consolidation of their power over the townspeople and their fellow burgesses, which was to make them extremely unpopular in Liverpool.

The reigns of Kings Henry IV, V and VI marked the high point in the development of Molyneux power and, in 1446, Sir Richard Molyneux was granted the park of Croxteth. This estate still borders the former important township of West Derby, which is now a suburb of modern Liverpool. The name 'Croxteth' is thought to derive from 'Crocker's Staithe', or 'the landing place of Crocker'. This was probably a Viking chieftain who would have landed here from the River Alt, which still passes through the Croxteth estate, where it is now little more than a brook.

In the same year, the king also granted Sir Richard the hereditary offices of Steward of the Wapentake of West Derby and of Master Forester of West Derby. The word 'Wapentake' is Anglo-Saxon and translates as 'weapon-touch'. It describes a 'loyalty ceremony' that took place whenever the Lord of the Manor held court. He would stick his spear into the ground and his liege men would acknowledge his authority and their allegiance by touching the spear with their own weapons.

The year 1446 was certainly a very good one for the Molyneuxs, because they were then also awarded the hereditary office of Constable of Liverpool Castle. This made them direct representatives of the reigning monarch, who was still Lord of the Manor of Liverpool. This title gave them particular power in the town, because it meant that they were independent from the other burgesses and not answerable to other local jurisdictions and laws, as the rest of the townspeople were. This made them even less popular in Liverpool.

At Croxteth, the family took ownership of a large manor house that had been standing on the estate for some years. They divided their time between this house and Sefton Old Hall. Now, with their occupation of the castle, they had three bases from which to exercise their authority over the developing town of Liverpool. Not only were the burgesses increasingly resentful of the Molyneuxs' power and influence, especially at court, but so were the Stanley family. They felt challenged by the increasing success of their rivals and so the enmity between the two families became more intense. Now they fought each other in meetings of the burgesses and over parliamentary elections.

In 1575, a later Sir Richard Molyneux (1560–1622), 1st Baronet, demolished the original Croxteth Hall and replaced it with a much grander mansion. In 1602, he bought the Royal Hunting Park of Toxteth, to the south-east of Liverpool. At the same time, from William Stanley, 6th Earl of Derby (1561–1642), he also bought the forest of Simonswood, which itself was a huge deer forest stretching from West Derby to St Helens. Stanley was in the middle of a major legal battle with other members of his family, so was desperate to raise capital, even from his adversary. Also, it is likely that Molyneux was the only other aristocrat who could afford Stanley's asking price. But the acquisitiveness of the Molyneuxs did not stop there.

Since the time of King John, the Lordship of Liverpool had usually been held by the reigning monarch, but in 1628, King Charles I was short of cash and he broke this royal connection by selling the Manor of Liverpool to some merchants from

London. In the same year, Sir Richard's son, another Richard Molyneux (1594–1636), 2nd Baronet, was created the 1st Viscount Molyneux of Maryborough in the Irish Peerage. In 1635, the family bought the Lordship of Liverpool from the London merchants, for £400. They now held the true political and economic power in the town.

This now put them in direct opposition to the independently minded townspeople, but their reputation would soon sink to an absolute low. As we shall discover later, this would be because of the actions, during the English Civil War, of Sir Caryll Molyneux (1622–1699), the 3rd Viscount.

Following the Roundhead victory at the end of this war, much of the Molyneux lands and property were confiscated by Oliver Cromwell and this included the Manor of Liverpool. However, as with the Stanley family at Knowsley, these were returned to them at the Restoration. However, they were never to recover their reputation and, while the Stanleys would go from strength to strength, the opening decades of the eighteenth century began a protracted and steady decline for the Molyneuxs, despite their titles and property.

Throughout their ancestry, the family had remained staunchly Roman Catholic, which had added another element to their unpopularity in the town. This came to a head during the Jacobite Rebellions between 1688 and 1746, when attempts were made by members of the exiled Roman Catholic Stuart family to regain the English crown. The people of Liverpool and Lord Derby supported the Protestant Hanoverian succession of William III (1689–1702) and Mary II (1689–1694), but the Molyneuxs supported the rebel Catholic Stuart dynasty.

In 1694, Sir Caryll Molyneux made one of his many errors of judgement and, after using Liverpool Castle to store arms for the Catholic rebels, he was arrested on a charge of treason. With other Catholics in the town he was imprisoned in Liverpool Tower but, because much of the evidence against him could not be proven conclusively, he was very soon acquitted. However, the hereditary Constableship and occupation of the castle were permanently confiscated from his family.

In 1769, Isabella Stanhope (1748–1819), who was a renowned society beauty of the day, married Sir Charles William Molyneux (1748–1794), the 8th Viscount. Shortly afterwards, she sat for the painter Gainsborough at Bath and her portrait is considered to be one the artist's finest works. In 1768, it was she who persuaded her husband to renounce his Catholicism and conform to the Church of England, at least outwardly. In 1771, as a reward for this from the Protestant King George III (1738–1820), William was created the 1st Earl of Sefton in the Irish Peerage.

In 1831, Sir William Philip Molyneux (1772–1838), the 2nd Earl, was also created Baron Sefton in the English Peerage and this title now gave him even greater credibility within the ranks of the British aristocracy. He needed this, as his capital reserves were running low, so he was very much a man more of style than of substance. He was quite a character, becoming known as 'Lord Dashalong' because of his fondness for driving a carriage and four 'at breakneck speed'. Sir William was one of the founders of the Grand National Steeplechase, when it was

inaugurated at Aintree in 1839. The name for this form of horse race comes from earlier times, before specialised race-tracks were devised, when the horses would be raced across open country from church steeple to church steeple.

By the start of the nineteenth century, the fortunes of the Molyneux family were more obviously in decline. Although they were still friends with royalty and senior peers of the realm, and gave and attended many lavish house parties and hunting weekends, their finances were in dire straits. Parts of the Croxteth estate were sold off, possibly to redeem gambling debts, and other land at Great Crosby, Melling, Maghull, Lydiate and Aughton was also disposed of. Throughout the late nineteenth and early twentieth century, more of Croxteth Park was sold to generate income and to accommodate the expanding city of Liverpool.

Nevertheless, as far as the Molyneuxs were concerned, it seemed that their dynasty would continue forever and Sir William Philip Molyneux (1835–1897), the 4th Earl, constructed a purpose-built nursery wing at Croxteth Hall. Sadly however, illness and misfortune blighted the succeeding generations, none of whom ever again had large families. Indeed, Charles William Hylton Molyneux (1867–1901), the 5th Earl, had a racing accident while riding in the Grand National and never recovered from his injuries. The estate then passed to his brother, Osbert Cecil Molyneux (1871–1930) the 6th Earl. Tragically, two of Osbert's three children died as teenagers, leaving only Hugh William Osbert Molyneux (born in 1898) to inherit the title, as the 7th Earl of Sefton.

As if to presage the end of the family line, in 1952 a major fire completely destroyed the best rooms in the Queen Anne Wing of this once great house. It ruined several rooms on the ground floor and most of the second and third floors. Every fire engine in Liverpool came out to contain the blaze. The Earl decided not to restore the damaged rooms so he left them empty and stripped back to the original brick walls.

When Hugh Molyneux died in 1972, he was without children or heirs, except his widow, Countess Josephine (b. 1903). This meant that the Earldom died with him. On the death of the last Countess of Sefton in 1980, Croxteth Hall, and what remained of its grounds and estate, passed into the ownership of Liverpool City Council.

While all of these great baronial and aristocratic families did indeed hold considerable economic, cultural and political sway over the communities of South Lancashire and beyond, and especially in and around Liverpool, their status has not always been unassailable. At the end of the eighteenth century, the Molyneux family had been forced to sell the Lordship of the Manor of Liverpool to the corporation of the town. As we shall see, it was with that purchase that for the first time since the founding of the town and borough, the corporation and the people would become the true 'Lords of Liverpool'.

4

The 'Middling' Years

The Tudor Town

To continue to tell the story of how Liverpool first rose to glory and power we must return to the time of the Tudor and Stuart monarchs.

After his victory at the Battle of Bosworth, from the time of King Henry VII to that of Queen Elizabeth I (1533–1603), life in Liverpool was largely uneventful. Even by the beginning of the seventeenth century, the population of the town was no more than around 2,000 people. These were mostly still living in cottages constructed principally from wood and bricks and with clay or wattle-and-daub walls. However, as we have seen, the town was important enough to have a Grammar School, established by John Crosse in 1515. Also, Liverpool continued to steadily expand its inland trade and its population now began to increase as well. By the end of the Tudor era, the town had begun to enlarge its geography and a number of new cart tracks now led out of town. Also, smaller residential roads and alleys began to radiate off the original seven streets. Even so, the town remained a mainly rural community until the seventeenth century, when commerce and trade began to develop much more with the other towns and villages that surrounded Liverpool.

It was from this time too that the town first started to really use its pool harbour as a port. The town was becoming a hub for maritime trade and was able to take trade away from nearby Chester. This was because the River Dee, on which its rival town sat, had begun to silt up. Liverpool was then able to develop seaborne commerce with Wales and the Isle of Man. However, its principal trading partner was Ireland. It was from that country that hides, skins and cotton yarn were imported to be processed and sold in the town. Indeed in 1540, a visitor to Liverpool wrote, 'Irish merchants come much hither as to a good harbour ... There is good merchandise at Liverpool and much Irish yarn, that Manchester men buy there.'

Liverpool now began to export manufactured items, such as cloth, leather goods and knives, as well as raw materials, such as coal. Fishing was still an important trade at this time, both for home consumption and for limited export. The port also began to develop what would become another important source of local income: the servicing of soldiers and sailors billeted in the town. This was a period when Liverpool was a major point of embarkation for military campaigns, to Ireland and elsewhere and these temporary residents had money burning holes in their purses and pouches, which they were only too happy to spend in the local taverns and on the local wenches.

Throughout the Middle Ages though, a series of devastating plagues known as the 'Black Death' had intermittently ravaged South Lancashire, particularly between 1348 and 1361. This was a terrible contagion that had spread across Europe from Asia, killing an estimated 25 million people in its wake. This pestilence first came to Britain on ships entering the ports of Liverpool, Bristol and Weymouth. It was carried by fleas on the bodies of ship-board rats and mice. When vessels landed in port, so did these vermin and they spread the disease right across Britain; nobody was immune. The most vulnerable died first: the very young, the very old and the poorest. The disease was always fatal and its symptoms were appalling.

The Black Death, more formally known as 'Bubonic Plague', took its names from the effects on its victims as it destroyed their bodies. First, swellings called 'buboes' appeared in the armpits, legs, neck, or groin. These would be red at first, but would next turn purple, then black. The skin around these swellings would blacken also. Blood-letting was considered to be a legitimate form of treatment at the time, but when the buboes were lanced, the blood that oozed slowly out of the wounds was itself black. It was much thicker than normal and rippled with streaks of dark green; it also gave off a dreadful stink.

Liverpool and the surrounding districts were very badly stricken and plague pits were dug in outlying fields and in Walton and St Nicholas Churchyards to take the bodies of the victims. There were intermittent outbreaks of plague in subsequent centuries too. The sixteenth and seventeenth centuries saw the worst of these, especially in 1540 and 1548. Despite this series of catastrophes though, economic and political life in the town had to go on. In 1547, Liverpool was still influential enough to send two representatives to parliament in the persons of Nicholas Cutler and Gilbert Gerard. The town had not had such representatives since 1306, when Richard de la More and John de la More had been the voices of the burgesses.

Nevertheless, each of the massive epidemics that Liverpool experienced had decimated the population, which struggled to recover, only to be severely struck down again in 1558, when between 240 and 250 people died. This now had a ruinous effect on the local economy and, over the next decade, Liverpool went into a major decline. Things became so bad that in 1571, the burgesses sent a petition to Queen Elizabeth in which they described themselves as, 'her majesty's poor decayed Town of Liverpool' and asked for

relief from a tax being levied on them, which they thought themselves 'unable to bear'.

However, these were turbulent times for other reasons too. From the time of King Henry VIII until after the execution of King Charles I in 1649, the period of the Tudor and Stuart dynasties saw a number of catastrophic changes in the official religion of England. This produced many innocent martyrs of both the Protestant and Roman Catholic Christian doctrines and these religious divisions were one of the main causes of the Civil War. This was fought between the troops of aristocratic supporters of the Stuart monarchy, known as 'Royalists', and supporters of the common people, represented by the Puritan-dominated Parliamentarians, whose soldiers were known as 'Roundheads'.

Liverpool would play a pivotal role in these ferocious hostilities, which not only divided the country, but also divided families. It was often the case that fathers could find themselves facing their sons and sons facing their brothers, all as enemies across bloody battlefields. During this war, Liverpool Town and its pool harbour were to suffer three sieges, as they changed hands between the Parliamentarians and the Royalists.

Speke Hall, Liverpool's Grand Tudor House.

The 'Crows' Nest'

In July 1642, when civil war in Britain was becoming inevitable, in common with the rest of the country, the town of Liverpool was divided. The leading burgesses and corporation members were supporters of the king, Charles I. However, the vast majority of the townspeople were strongly in support of the Parliamentarians. It was also clear that the strategically positioned town would become a prime target for both sides in the coming conflict. This was because of its safe harbour commanding the major sea-routes and because of its fortified tower and great castle. The Royalist Mayor of Liverpool, John Walker, saw to the defences of the town, working closely with Lord Richard Molyneux (1619–1654), 2nd Viscount, and James Stanley (1607–1651), Lord Strange, the eldest son of the 6th Earl of Derby.

A large store of arms and gunpowder was lodged in the dungeons of the castle and a great defensive rampart was built around the town. However, only too aware of their unpopularity with the ordinary people of Liverpool (and with many of their fellow burgesses, including the Earls of Derby), the Molyneuxs saw this as an opportunity to secure their position. So, on 25 August 1642, when King Charles raised his standard at Nottingham and the war began in earnest, Lord Molyneux encouraged the Royalists to take control of Liverpool and its castle, which they did.

By September, Lord Strange had succeeded as the 7th Earl of Derby on the death of his father. A small group of his loyal retainers stayed in the Tower of Liverpool while he left the town to fight in support of the king. Meanwhile, Lord Richard Molyneux also left to defend nearby towns, such as Warrington and Wigan, but was pursued by Parliamentarian forces under the command of Colonel Ralph Assheton (1596–1650). This formidable soldier was Commander in Chief of all Parliamentarian forces in Lancashire.

In April 1643, while Lord Molyneux was now safely on the Wirral, Assheton attacked and besieged Liverpool with an army of 1,600 men. The Royalists in the town were under the command of Colonel Sir Thomas Tyldesley (1612–1651), who was very wealthy and a staunch Roman Catholic. He suddenly found his positions under a cannonade from the tower of the Church of Our Lady and St Nicholas. Parliamentarian soldiers had captured this after entering the town from the river, at the end of Chapel Street. Tyldesley soon proposed terms of surrender, but Colonel Asheton rejected these and immediately began an all-out assault on the defenders. He was victorious, driving Tyldesley and his Royalists out of the town, killing eighty of them and taking over 300 prisoners. He also captured ten cannon. This was at the loss of only seven Parliamentarian lives. And so, Royalist-held Liverpool now passed into the hands of the Parliamentarian forces.

However, some Royalist sympathisers escaped from Liverpool and made their way to other communities outside its boundaries. Many made their way to the Royalist stronghold at the nearby village of Everton, high above the town on Everton Ridge. A small handful of other supporters of the king stayed within

the town, including Lord Molyneux's younger brother, Caryll (1622–1699), who would become 3rd Viscount Molyneux. He stayed inside the castle with a small cohort of his personal supporters, who tried to draw as little attention to themselves as possible.

Liverpool was now garrisoned for Parliament under the command of Colonel John Moore, a member of the local Moore family of Bank Hall. The ordinary people of the town were now eager for the civil freedoms offered by the opponents of the monarch. Perhaps this was an early demonstration of the militancy of later generations of Liverpudlians. However, they knew only too well that an attempt to retake their town was inevitable and so many of them took this opportunity to leave with their families and belongings. This left around 1,000 people now preparing to fend off another siege and assault. It was only a matter of weeks before this began.

In May 1644, Prince Rupert of the Rhine (1619–1682), the twenty-four-year-old nephew of Charles I, marched his troops towards Liverpool to recapture it for the king. This was at the urging of Earl James Stanley and with the encouragement of the Molyneuxs. Arriving on the evening of the 1 June, the young German prince chose to plan his attack from Everton. This was not only because the high ridge afforded a magnificent overview of the town, but also because of its Royalist loyalties. It was also home to Catholic priests who had previously been expelled from Liverpool by the town's dominant Puritans.

Rupert was, by this time, an experienced and already successful military commander and he occupied a large cottage in the heart of the village. This was a long, low, stone building with a thatched roof. It had four rooms with clay floors and stood on an escarpment of rock just to the north of the village green, giving unobstructed views of the valley and the town of Liverpool below. The prince set up home here and established it as his command post. Afterwards, this was always known as 'Prince Rupert's Cottage', until its demolition in the eighteenth century.

With him, the Royalist Commander had brought his pet spaniel and his tame monkey on a jewelled lead; both animals accompanied him everywhere. However, Rupert had also brought with him an army of 10,000 soldiers and cavalry to attack the town, well supported by cannon and armaments. His men camped, with their horses, munitions and supplies, on land towards the rear of the broad ridge, on what is now Heyworth Street. The modern Campfield Pub, with its portrait of Prince Rupert as its signboard, commemorates this. The adjacent housing estate and modern school now stand on all that remained of what was once a broad expanse of open land.

By this time, news of the swathe of violence that Rupert had already cut through Lancashire had reached Liverpool, especially the vivid descriptions of his brutal massacre of the people of the town of Bolton. The arrival of Rupert's army on Everton Hill had therefore struck terror into the inhabitants of Liverpool. For safety, most of the women and children of the town had been immediately sent across the Mersey to Storeton Hill, on the Wirral, where there was an armed Parliamentarian camp to protect them.

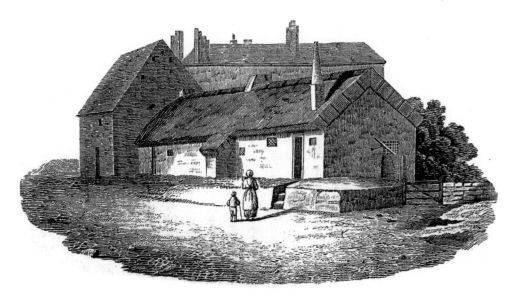

Prince Rupert's Cottage.

About to be besieged for the second time in the war, the town's defenders strengthened their defensive wall and, in places, they dug a deep ditch in front of it, 12 yards wide and 3 yards deep. They also placed batteries of mortars along the town side of the pool river, especially at the end of Dale Street. A number of cannon were also mounted on the castle towers and battlements. In addition, at the entrance to the pool harbour, they established another powerful battery of mortars.

Between 400 and 500 men and youths now remained in the town and they armed themselves fully with muskets and pikes, ready to die in defence of their homes. But all of this was known to Prince Rupert, because Caryll Molyneux's 'fifth column' inside the castle had been smuggling messages out to him.

Consequently, the rash young man believed that taking the town would be a simple matter. Indeed, he declared that Liverpool was 'nought but a crows' nest that a parcel of boys could take'. So, on 7 June, Prince Rupert began his siege. But he must have quickly regretted his initial brashness because his guns could not reach the town from Everton and so he had to reposition his batteries in trenches much nearer to his target, on the edge of 'The Great Heath' along the line of what is now Lime Street.

His cannon were arrayed from where the Wellington Column today dominates William Brown Street, to a point now occupied by the Adelphi Hotel. Firing over the broad creek to the south-east of the small town and above its outlying mills, farmsteads and cottages, Rupert bombarded Liverpool. Although subjecting the people to a virtually constant barrage of artillery that lasted for around ten days, he killed only around forty of the defenders. The arrogant German prince was soon to discover, to his cost, that the resistance mounted by the townspeople

was considerable and determined. In his continuous cannonade against the town, Rupert had been forced to use over 100 barrels of gunpowder. He had also lost 1,500 of his men in the returned fire from the embattled but fierce Liverpudlians.

However, this only stiffened Rupert's resolve and, on the 16 June 1644, he ordered a secret night-time attack that was aided by the Royalist sympathisers in the town, led by Caryll Molyneux. Molyneux's men had sneaked up Old Hall Street and in the dead of night, had treacherously breached the town's defensive walls from within. They took down the large woolpacks that made up the bulk of the rampart and used these to fill in the defensive ditch so that the troops could cross. Meanwhile, Rupert's army had silently made their way down from Everton Hill and were hiding under the eaves of the Kirkdale Forest, just a few hundred yards to the north of the town wall.

On getting a signal from the traitors and with Caryll Molyneux now at his side, Rupert led his troops through the wide gap in the wall and they poured into Liverpool. Their attack was swift and exceptionally brutal. In a bloody massacre, the prince's men put everyone they encountered to the sword. Colonel Moore had put up a serious defence but, when he realised that his defeat was inevitable, he escaped to sea from the pool.

Once the battle was over and all resistance had been quashed, Rupert ordered the complete sacking and burning of the town. It was plundered of all its gunpowder and shot, as well as its money, gold and treasures, and was left in smoking ruins. Liverpool Tower was untouched because it belonged to Lord Derby. The castle too, although it had sustained some damage from the bombardment, was not destroyed. This was not just out of consideration for the Molyneuxs, but also because it remained a strategic stronghold.

During the siege and the subsequent sacking of Liverpool, it is estimated that around 400 townsfolk lost their lives. The town records report that of these were 'some that had never borne arms ... yea, even one poor blind man'. The records of the Moore family describe how their Old Hall was ransacked and plundered for portable valuables. These also state that, 'the outhouses of the Old Hall were pulled down when Prince Rupert took Liverpool ... putting all to the sword for many hours, giving no quarter; where Caryll, that is now Lord Molyneux, killed seven or eight men with his own hands; good Lord, deliver us from the cruelty of blood-thirsty papists. Amen.'

It would be six months later before the surviving men and the returning women and children had finished properly burying their dead. A later entry in the town records, dated 20 January 1645, reads, 'We find that a great company of our inhabitants were murthered and slain by Prince Rupert's forces; the names of the murthered we cannot yet be certified of; any of them or their names.'

Following his victory, Rupert had taken up lodgings in the castle, but he only stayed in the town for nine nights before moving on to York, on the orders of the king. The prince left the town garrisoned by English and Irish troops under the command of Sir Robert Byron (dates unknown) and he joined Charles I in the

Battle of Marston Moor. Here, on 2 July 1644, the Royalists suffered a crushing defeat.

The war was not going well for the armies of the monarch locally either and, on 20 August, Royalist troops were defeated again, this time at nearby Ormskirk. They retreated in disarray to Liverpool, where they joined the existing Royalist occupiers. However, the Parliamentarians were in hot pursuit and, now under the leadership of Major-General Sir John Meldrum (d. 1645), the Roundheads soon laid siege to Liverpool from the north and east. Meanwhile, the previously defeated Parliamentarian governor of the town, Colonel Moore, attacked Liverpool from the river and the mouth of the pool.

What was now the third siege of Liverpool began immediately and lasted until 4 November. The Royalists had now all withdrawn to the relative protection of the castle and its adjacent buildings, but the old bastion became the main target of the relentless bombardment and it was soon severely damaged. Before long, the exhausted garrison could take no more and they mutinied against their officers, surrendering the town to the now victorious Parliamentarians. Fortunately for the defeated soldiers, the winning troops were more humane in their victory than the Royalists had been in theirs and the lives of the captured officers were spared. They were also allowed to retreat in safety to Ireland.

After this final assault, the war-ravaged town and its damaged castle remained in the hands of the Parliamentarians. Indeed, the damage to Liverpool was so significant that the following year, on 17 September 1645, the surviving townsfolk presented a petition to parliament, pleading for financial aid. The response was speedy and included an order for direct reparation to be made from the local estates of Royalist supporters. Part of the order decreed,

> that five hundred tons of timber be allowed unto the town of Leverpoole, for rebuilding the said town, in a great part destroyed and burnt down by the enemy; and that the said five hundred ton be felled in the grounds and woods of James Earl of Derby, Richard Lord Mollineux, William Norris, Robert Blundell, Robert Mollineux, Charles Gerard and Edward Scarisbrisk, esquires and that it be referred to the committee for Lancaster that are members of this house, to take order for the due and orderly felling of the said timber and for apportioning the quantities to be allowed to the persons that suffered by the burning of the said town and the rebuilding thereof.

In addition, the town received £10,000, also taken from the estates of the defeated Royalists, with a further £20 for 'the relief, if it be possible, for poor widows and fatherless children that had their husbands and fathers slain and their goods plundered and others in the town who are in distress and want'. Also, in 1646, the town records state 'that the castle bee repaired and fortified', showing that money had also been received to repair the considerable damage done to the building during Rupert's bombardment.

On 1 January 1649, King Charles I was put on trial by parliament, accused of being, 'a tyrant, traitor and murderer; and a public and implacable enemy to the Commonwealth of England'. It was also charged that he, 'out of a wicked design to erect and uphold in himself an unlimited and tyrannical power to rule according to his will and to overthrow the rights and liberties of the people of England'. Inevitably, he was found guilty and was publicly beheaded on 30 January 1649. In fact, Liverpool's former governor, Colonel John Moore, was one of the 'Regicides' – a signatory on the king's death warrant.

James Stanley, the 7th Earl of Derby, was also captured and was himself beheaded by the Puritans at Bolton, on 15 October 1651. He went to his death with great dignity and heroism, which began to soften the attitude of the Liverpool townsfolk towards his family. This meant that the Stanleys soon won their way back into favour in the town.

However, in the wake of the conflict, over half of Liverpool's population had been killed and many wounded or maimed. Following the massive loss and destruction of land and property, the people of Liverpool held the Molyneux family directly responsible for their tragic condition. The memory too, of the personal cruelty and treachery of Caryll Molyneux, lived long in the hearts of Liverpudlians and the family now quietly withdrew to their Croxteth estates, well to the east of the town.

The Civil War left social and political scars on Britain that would take decades, in some cases centuries, to heal. The loss of life had been catastrophic. Indeed, proportionally, more British people died in the Civil War than in any other conflict, including those of the twentieth century. In the seven years that the war lasted, one in ten British people were killed; 85,000 dying on the battlefields and another 100,000 dying of their wounds. In percentage of population terms, this was three times more than those killed in the First World War and five times more than those killed in the Second World War. Additionally, it is estimated that, after the English Civil War, the military campaigns waged in Ireland by the troops of Oliver Cromwell, to subjugate those people, resulted in around half the Irish population being wiped out.

But, for Liverpool, the destruction of their town was soon repaired, as former residents returned and as new people moved in. However, the events that had taken place during the war, in and around the town, were to play a significant role in the development of the unique psyche of Liverpool people. This is particularly true of their 'belligerent independence' and unwillingness to easily submit to authority or government. It was also the Civil War that fuelled the peculiar pride that Liverpudlians have, in being members of a close-knit community. To this day they remain fiercely determined to protect their civil and economic rights and autonomies.

This determination now fuelled Liverpool's post-war recovery. Trade, in a wide range of commodities, began to burgeon once again as the volume of shipping on the river rapidly increased. The tidal harbour of the Pool of Liverpool provided the anchorage that an increasing number of merchants needed, especially as

maritime commerce with the 'new world' of the Caribbean and the Americas also began to grow.

The burgesses of Liverpool had also realised, through their experiences during the war, just how strategic and significant their town truly was and how this was inevitably going to develop. The innate entrepreneurial nature of the people, their creative energy and a willingness to take risks, would soon fuel the most dramatic change and evolution of the town and port since Liverpool's creation in 1207.

5

'Long China Walls of Masonry'

The Old Dock

As the eighteenth century dawned, the steady increase in Liverpool's maritime trade was now propelling the port into global prominence and the need to accommodate an increasing number of heavily laden cargo ships in a safe harbour became more pressing.

Vessels seeking to load and unload could only do so when the tide was high in the pool. They anchored in the deep-water heart of the large harbour and their goods would be unloaded down their sides into waiting rowing boats. These were then sculled to the sloping beaches of the pool by strapping Liverpudlians, as there were no wharves. Cargoes were then exchanged at the shore and the reloaded boats would take the new consignments back out to the ships. However, the vessels had to quickly sail out into the river again as the tide ebbed, or risk being grounded. They would then have to wait until the tide turned again, so that they could return to the pool to finish transferring their cargoes.

Not only did this mean that it could take up to fourteen days to turn a ship around, but traffic jams were being caused on the Mersey, as vessels sailed into the port to join the ones already waiting off-shore. Collisions, beachings and capsizings were occurring with startling frequency and with often tragic results. So, around 1700, the town corporation decided that a dock had to be constructed to more efficiently manage cargo handling.

In 1708, Thomas Steers (1672–1750) was appointed to design and realise this concept. Born in Kent, Steers was already an accomplished and recognised civil engineer and the town wanted the best available man for the job. Steers was that man and he accepted the commission, proposing to convert the pool into a wet dock by reclaiming as much of its shoreline as possible. He told the corporation that he would then erect quays on three sides and river gates across its mouth, which would also form a pedestrian bridge. These would then keep vessels afloat during the ebb of the tides, in what would then be a much larger basin of deep

water. The flow of the creek into and out of the dock would be controlled by sluice gates, so that no flooding would occur even in heavy rains.

The concept of such a water-filled enclosure, unaffected by the fluctuating water levels, was a remarkably innovative one for the time, but its creation was going to be a very complex job. The site was largely composed of soft mud, into which brick-and-stone foundations had to be sunk to such a depth that they could be bedded onto solid rock. With an initial estimated expenditure of £6,000, Steers began work, in 1710, by building an embankment across the mouth of the pool. Soon, what would be the world's first enclosed commercial wet dock was well under construction.

Once completed, ships and water could enter the dock at high tide, and the gates would then be closed. This prevented the water running out of the dock even at low tide. The effect of this was that a ship could now unload and reload in one-and-a-half days, as opposed to the two weeks that it used to take. Also, previous cargo exchange had been at the mercy of any stormy conditions on the river and of the Mersey's dangerous tidal range. This is the fourth highest in the world at 33 feet (10 metres). These issues would now be much less of a concern in the modernised harbour.

Though the 'New Dock', as it was named, would not be finally completed until 1719, on 31 August 1715, the vessels *Mulbury*, *Bachelor* and *Robert* were the first to use it and were successfully turned around in a matter of hours. However, by this time the costs of construction had outstripped the initial estimate and further debts of £5,000 had been incurred. A quarter of the initial £6,000 had been borrowed from a resident of Westmoreland and other contributions had come from wealthy widows in the town. In January 1716, an Act of Parliament was now requested by Liverpool burgesses, to allow them to borrow a further £4,000. This was granted and the town was put at serious risk by borrowing against the security of the corporate seal and mortgaging the town heavily.

As this mammoth civil engineering project neared completion, it became clear that even more money was required to finish it. The boldness and determination of Liverpool Corporation saw them borrowing a further £12,000. This was, once again, secured on corporation lands, properties, leases and predicted ships' tonnage duties. Nevertheless, the entrepreneurial endeavour and massive gamble undertaken by the town of Liverpool was completely successful and all debts were repaid in full and with interest, in November 1729.

The New Dock was 200 yards long and covered 4 acres. It could accommodate around 100 ships at a time, as cargo vessels were very much smaller in the early eighteenth century. Between thirty and forty of these could be loaded and unloaded at one time, anchored around the quaysides. However, this process could only be carried out along planks, stretching from the wharf to the decks. This could still be a treacherous process, with goods and cargo handlers (Liverpool's first dockers) often falling into the water. In due course, cranes were installed to make unloading quicker and safer.

Daniel Defoe (c. 1660–1731), the writer of *Robinson Crusoe*, visited Liverpool in the year the dock was opened. He was so impressed that he wrote, 'This is of so great a benefit and its like is not to be seen anywhere in England.'

The national and international impact of the dock was immense. Chester, Bristol and London were among a number of British ports that soon lost significant amounts of trade to Liverpool. They simply did not have the same facilities that the port could now offer to the world's merchants. Indeed, London's first dock, the West India Dock, would not open until 1802.

Liverpool now took the lead in international maritime commerce but in 1751, the number of vessels using the dock reached 543, with a gross tonnage of 37,731. This was more than the basin could cope with efficiently and the corporation realised that this demand was only going to increase. Clearly, more docks were now needed and so in 1753 the South Dock was opened. This was so called because it was located just south of the original dock.

At this time, the anchorage at the foot of Water Street was still in use, but this could not help with the increasing demand. So in 1771, George's Dock was created on the site. Named after King George III and covering an area between James Street and Water Street, this was a much larger dock than the first two because the size of trading vessels was now increasing. Larger docks meant larger berths, which meant that more sizeable ships could be built, which could then carry even greater amounts of cargo. This meant that Liverpool was not only driving maritime commerce but now also ship design and construction.

By this time the New Dock was being called the 'Old Dock', as even more enclosed harbours began to be constructed along the Liverpool waterfront. These were being built with accompanying warehouses and processing facilities. This now made cargo handling and connecting transportation much more efficient and was another world first.

By 1788, the King's Dock had also opened, followed by Queen's Dock in 1796. The success of these and the trade that they generated, encouraged the reclamation of further stretches of Mersey riverbank and the building of scores of new docks and warehouses. By the end of the nineteenth and early decades of the twentieth century these stretched for just over 7 miles along the Liverpool waterfront. Liverpool had fifty main docks and, with additional basins and other quays, this made a total of eighty-seven docks, including graving docks. The total lineal quayage of the Liverpool docks was over 38 miles and their water area was 653 acres. Liverpool's docks system remains the only one in the world to be completely connected with an internal waterway. This allows goods and smaller vessels to travel safely from the extreme North Docks to the extreme South Docks, completely avoiding the tidal range and often dangerously inclement Mersey.

Designing For Destiny

It is no exaggeration to say that the construction of Liverpool's first dock shaped the destiny of the town and its people for the next 250 years. In fact, the town was so proud of its maritime success and of its five centuries of heritage that they celebrated this at every opportunity. Indeed, from 1715, it had become the custom

for every vessel entering the port to announce its arrival by firing a salute from its cannon. All merchant ships were then armed, of course, to protect them from attacks by the foreign ships of whichever country Britain happened to be at war with at the time. This was usually the French, but at certain periods the country was also in conflict with the Spanish, the Dutch and the Americans.

Naturally, when such a salute was fired the cannonballs would be removed from the guns first. However, in the summer of 1799, one ship neglected to remove its shot and two unsuspecting men, crossing the gates of the Old Dock, were struck by the cannonballs and killed outright; another man was severely wounded. The practice of gun salutes ceased immediately.

The development of the docks saw the establishment of many new shipping lines. These traded in particular commodities from particular parts of the world. Different docks became home for these companies and their vessels, or for the handling of specific cargoes. For example, the South Dock, which was also built by Steers, was first opened simply to relieve the pressure on the Old Dock and so took vessels and cargoes of all types. Before long though, its name was changed to the Salthouse Dock, because it began to receive shipments of salt from Cheshire and great salt storage warehouses were then built on its quaysides.

Georges Dock was first used for vessels trading around the coasts of Britain and with Ireland. It was later enlarged and became the centre for Mediterranean shipping and the fresh fruit trade. King's Dock was first built to handle Dutch vessels and consignments of timber, but it soon became the anchorage for fleets of whaling ships.

Around 1750, Liverpool had begun taking part in the lucrative whaling industry. Whale oil was a light, clear oil used in the manufacture of soap. It was also used to fuel lamps and to lubricate watch mechanisms and small machine parts. By 1788, twenty-one ships from the port were engaged in this trade. Indeed, this led to the foundation of 'Brocklebanks', the oldest shipping line in the world. Daniel Brocklebank was from New England in America and he came to Liverpool in 1775 to join his brother, who was a whaler. Daniel grew rich as a privateer (a government-sanctioned pirate or free-booter) and his sons went on to build ships and establish the international shipping company.

The Baltic Fleet pub, near Wapping Dock on the Liverpool waterfront, is named after one of the principal hunting grounds for Liverpool whalers. Baffin Island off the coast of Canada and the waters around Greenland were also destinations for hunting these great mammals. Nearby Greenland and Baffin Streets mark this. It was in Baffin Street that a whale fishery once flourished, where whale meat was processed and oil extracted from the blubber. Liverpool also began to build its own whaling ships, the first being launched in 1775, from Sutton's Shipyard in Mersey Street.

The Liverpool whaling trade reached a peak in 1788, when twenty-one ships sailed out of the port for the freezing northern waters. These vessels were huge for the time, weighing an average of 310 tons. But this was because they were more like floating factories, which had to capture, haul on-board, cut up,

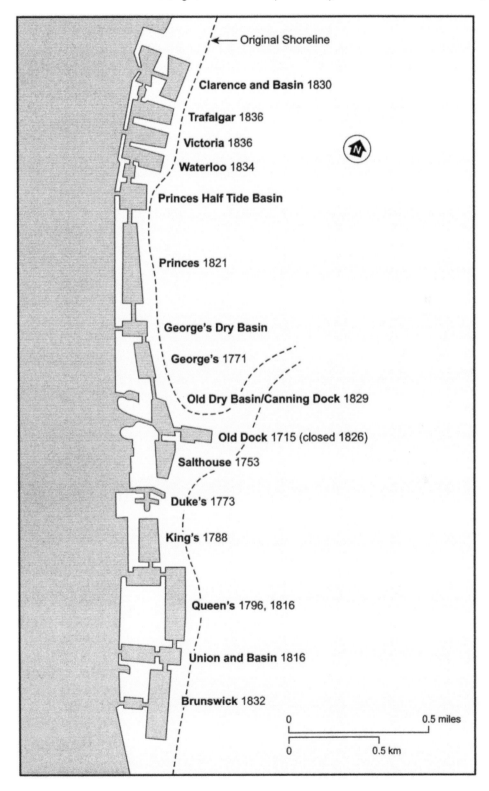

Docks development chart, 1715–1836.

store and process the largest creatures on earth. In 1789, seventeen whalers left Liverpool, and four of these were lost with their entire crews. This was a dangerous business and began to diminish in the port from this time. Even so, it continued to attract a particularly hardy and resilient kind of sailor, so typical of Liverpool seafarers. This was because whaling was full of adventure and also paid very well.

Men from all over Britain and the world came to the port to go whaling, including Captain William Scoresby (1789–1857), from Whitby in Yorkshire. He sailed *The Baffin* out of the port in the 1820s. In 1823, he published his *Journal of a Voyage to the Northern Whale-Fishery, Including Researches and Discoveries on the Eastern Coast of West Greenland, Made in the Summer of 1822, in the Ship Baffin of Liverpool*. This was an astounding title for a remarkable work, written by an accomplished sailor. It was this book that attracted another young seaman to Liverpool and to whaling.

In 1839, twenty-year-old American, Herman Melville (1819–1891), sailed into Liverpool from New York as a ship's boy, aboard the *Highlander*. He wanted to see the great Port of Liverpool for himself and sign on-board a whaler. He fulfilled both ambitions and in 1859 he would draw on his experiences to write the great novel *Moby Dick*. This is as much a whaler's manual as it is the story of one man's relentless pursuit of his nemesis in the shape of the 'Great White Whale'. Melville spent six weeks in Liverpool before sailing out of the port and he explored the Town thoroughly. He was so impressed by the docks and the great walls that surrounded them that he wrote,

> I beheld long China walls of masonry; vast piers of stone; and a succession of granite-rimmed docks completely enclosed. The extent and solidity of these structures seemed equal to what I have read of the pyramids of Egypt. For miles you may walk along the riverside, passing dock after dock like a chain of immense fortresses.

As the British Empire expanded during the eighteenth and nineteenth centuries and especially as trading opportunities opened up with a newly independent and dynamic America, the full length of the town's waterfront was a continuous landscape of docks, each filled with ships. The quaysides and warehouses were at work twenty-four hours a day and tens of thousands of people worked in and around these and on the dock road that served them. What had begun as mechanical processes driven by human muscle or horsepower, were soon driven by steam engines. These powered capstans, cranes, pulleys, conveyors and hoists and speeded up cargo handling. The volume of goods and raw materials being handled increased exponentially too.

The next dock to open was Princes Dock in 1821, at the end of Chapel Street. Next was Clarence Dock, which opened in 1830, to take the new steamers that would eventually spell the end of sailing ships. This was located some distance northwards, to avoid the risk of fire to the sails and rigging of any adjacent wooden vessels. This was followed by Waterloo Dock, which opened in 1834.

From the opening of the Old Dock, the Liverpool Town Corporation managed the whole estate of docks along the Liverpool waterfront but, as more docks were built, this became an ever more complex responsibility. Between 1845 and 1847, permanent subcommittees were established to manage the finances and day-to-day operation of the growing docks system. However, this was cumbersome and inefficient and the government, dock users and competitors from Manchester all put the Liverpool Corporation under increasing pressure to give up control.

Eventually, in 1858 it was decided that a single body was needed to oversee the port and so the Mersey Docks & Harbour Board (MDHB) was created. This comprised several committees and it employed senior paid officials, including a harbour master, a marine surveyor and a water bailiff, who were all responsible for managing not only Liverpool Docks but also the developing docks at Birkenhead and Wallasey, across the River Mersey. It was the corporation and then the Harbour Board who also employed Liverpool's succession of dock engineers.

Credit for helping to set Liverpool on its path to greatness certainly goes to Thomas Steers. He stayed in Liverpool, became a freeman in 1713 and was elected to the town council in 1717. He also served as mayor in 1739. When he died in 1750, he was buried in St Peter's Churchyard, in Church Street. However, he was only the first of the port's outstanding dock engineers, who all played their part in creating Liverpool's ever expanding harbour network.

However, from 1824 and for thirty-six years, Jesse Hartley (1780–1860) would dominate the development of Liverpool's waterfront and he would dominate his workforce too. Originally from Yorkshire, Hartley was a large and powerfully built man who had a personality to match. The overall design style of the dock estate and of its supporting buildings and architectural features are largely due to his grand vision and taste. A combination of architect, engineer, designer and artist, it was he who chose granite as his principal building material, partnered with great sandstone blocks and red brick.

Hartley was the first full-time professional dock engineer in the world and he was so highly valued by the Liverpool Dock Trustees (the forerunner of the MDHB), that his salary in 1825 was £1,000 per annum. This would be worth about £50,000 at today's value and was an exceptional figure for the time. In 1845, Hartley's salary rose to £3,500, worth around £180,000 today.

Hartley's output was beyond prodigious and he was recognised in the town and within his profession as being a complete workaholic. Perhaps he was first in the world at this too. Regardless, he had genuine skill and a style of man-management and productivity that was unique. First, instead of employing outside contractors, which was the norm at that time, Hartley set up what he called 'The Dock Yard' and employed specialist craftsmen and labourers to carry out all the work in-house. He also devised a new system of monitoring and administering the ordering and use of work, time, labour and materials. He also fully understood the concept of cost-effective efficiency, and of time and motion.

As well as directing the maintenance of the entire dock network, Hartley modernised all of the docks that had predated his appointment apart from the

Jesse Hartley.

Old Dock, which was filled in in 1826. Because of Hartley's energy and capacity, from 1830 the building of new docks was prolific. He was responsible for the construction of:

Clarence Dock	opened 1830
Brunswick Dock	opened 1832
Waterloo Dock	opened 1834
Victoria Dock	opened 1836
Trafalgar Dock	opened 1836
Albert Dock	opened by the Prince Consort in 1846
Salisbury Dock	opened 1848
Collingwood Dock	opened 1848
Stanley Dock	opened 1848
Nelson Dock	opened 1848
Bramley-Moore Dock	opened 1848
Sandon Dock	opened 1849
Wapping Dock	opened 1850
Wellington Dock	opened 1851
Huskisson Dock	opened 1852
Canada Dock	opened 1859

He also built graving docks and basins, as well as many of the warehouses, slipways, dock walls, gateways, lodges, dock-masters' houses and the great sea walls that went with them. His designs incorporated much that was pioneering and innovative and were soon being copied around the world, including:

The construction of dockside warehousing, first at Duke's Dock in 1783.
The internal linking of dock systems via canals, locks and tidal gates.
The construction of fireproof warehouses, as at Albert Dock in 1846.
The installation of hydraulic cargo-handling machinery in 1847.
The sophisticated design and engineering of retaining wall construction, to resist tidal pressures and weathering.

Jesse Hartley died in post on 29 August 1860, but his outstanding legacy survives for the world to continue to marvel at.

With the exception of the original Old Dock and the later Stanley Dock, opened in 1848, all of Liverpool's docks were built out from the waterfront. They were then surrounded by wharves, quaysides and other structures on what is reclaimed land. This is why the main road that runs along the riverfront between the modern town centre and the dock estate is named 'The Strand': it was once, quite literally, a strand of sand, shale and shingle.

The range of raw materials and products that were imported and exported through Liverpool's docks was considerable. In 1736, 1,000 tons of cheese were exported through the Old Dock. Tobacco had begun to arrive in the town in 1648,

from North America. Its import grew to 8,400 tons by 1810, mainly coming in through Stanley Dock. In 1770, 48,000 tons of salt were exported through Salthouse Dock, mainly to Ireland and America. Imports of sugar from the Americas came in through Canning Dock and, by 1810, were averaging 46,000 tons a year. In the 1840s, new transit sheds and a dock wall were built at Princes Dock to protect spices imported from Asia. In 1853, 500 tons of silk arrived from Italy, France, India and China. By 1900, Liverpool would also have 250 clock and watchmakers, who would be exporting their goods across the globe.

From the opening of the Old Dock, Liverpool was regularly importing huge consignments of particular commodities, the most significant being grain, sugar, tobacco, rum and, in particular, cotton. The port received its first cargo of cotton in 1709 and this commodity was to provide Liverpool with its most lucrative source of income by far. This was because cotton, together with the other plantation-grown crops, was the product of a trade that would also be the source of Liverpool's greatest shame.

6
The Triangular Trade

By 1700, there were twenty-eight streets in Liverpool and the population had risen to 5,714. This fuelled a major expansion of commercial growth and by 1708 there were thirty-six streets. The number of ships registered to the town in that year was 102, with a total tonnage of 8,619.

Many of the new immigrants to Liverpool, especially those from London, brought with them existing businesses and overseas interests. The year 1667 was that of the Great Fire of London and of a resulting major influx of new people into Liverpool, especially entrepreneurs. Sir Edward Moore of Bank Hall recorded his sale of a piece of his land to 'one Mr Smith, a great sugar baker at London, a man as report says, worth £40,000'. This land was on the north side of Dale Street, between the present Moorfields (named after his family) and Cheapside. Of his transaction with Mr Smith, Edward goes on to record that

> according to agreement, he is to build all the front 27 yards, a stately house of good hewn stone 4 stories high and then go through the same building with a large entry; and there on the back side, to erect a house for boiling and drying sugar, otherwise called a sugar baker's house. The pile of building must be 40 feet square and 4 stories high, all of hewn stone. If this be once done it will bring a trade of at least £40,000 a year from the Barbadoes, which formerly this town never knew.

It was the arrival of merchants like Mr Smith and many others which prompted the existing burgesses to begin investing in the importation of not only sugar but also other plantation-grown crops. These were produced on the slave-worked estates of the West Indies and the southern states of America, like Virginia. What became known as the 'Triangular Trade' fuelled most of the rapid economic growth of Liverpool at the end of the seventeenth century and throughout the eighteenth century. This was so named because the trade was based on the very profitable sale of three types of cargo, conducted on a three-way ocean voyage.

The first part of this triangular voyage was the shipment of goods used for barter. These would be packed into the capacious holds of specifically designed and equipped ships anchored at Liverpool's quaysides. These goods came from all over Britain and included muskets and pistols from Scotland; cutlasses, knives and axes from Sheffield; pottery and earthenware from Stoke and Staffordshire; cheap jewellery from Lancashire towns; cotton and linen from Manchester; woollen goods from Leeds and Bradford; and mirrors and glassware from St Helens. This meant that many other British towns, cities and individuals were complicit in the dreadful Triangular Trade.

Next, these laden vessels would sail to the coast of West Africa. Here, the goods would be exchanged with Arab and African slave traders for African men, women and children, who had been brutally abducted from their homes. These terrified people, generally kept naked and roped together at the neck or wrists from the time of their capture, would often have already been marched hundreds of miles to the coast. They were then shackled together in the now empty holds of the same Liverpool ships and transported to American and Caribbean plantations. This was the notorious 'Middle Passage' across the Atlantic, on a journey that could take between fifty to sixty days and often in appalling weather conditions. This was the second and most horrific part of the Triangular Trade.

With the sexes and ages often randomly mixed and families forced apart, these men, women and children were packed tightly together, naked, on racks of hard, wooden shelves. They were manacled and chained with no room to move.

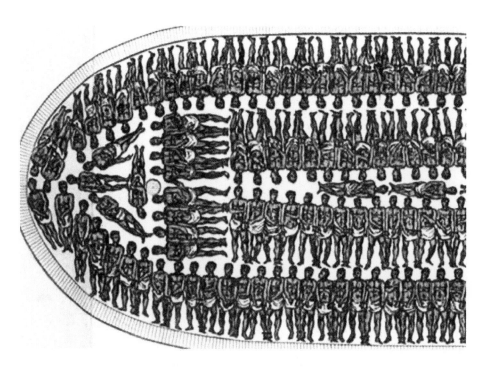

Slaves packed like sardines in the hold.

Afflicted by seasickness, dysentery, despair and humiliation and with no way to relieve themselves other than where they lay, the decks and holds would soon be awash with excrement, urine and vomit. The conditions were foul beyond belief and slave ships stank so much that even on the high seas, other vessels would steer clear of them and they would also be avoided as much as possible when anchored in port.

In an attempt to minimise the death rate to maximise profits, if the weather was calm, every few days the slaves would be brought up on deck to be washed, fed and exercised. They were still chained together to prevent them from jumping overboard, which many of them attempted. The captives were generally fed only on thin gruel, but sometimes they were given a watery broth made of dried shrimps, mixed with flour and palm oil, seasoned with salt.

Those people who fell ill but were deemed 'salvageable' were given a thicker soup made from mutton, goats' flesh and fowl. Otherwise, the sick were simply cast alive over the side of the ship, as 'disposable waste cargo'. Many thousands of people did not survive the Atlantic crossing. Indeed, 20 per cent of all slaves died on the Middle Passage and only 60 per cent of those who did make land survived for more than a year in captivity. Of these, most only lived into their early thirties.

Once unloaded from the now filthy and stinking holds, those people who had survived the crossing would be exchanged for consignments of sugar, rum, cotton and tobacco. These commodities were then shipped back to Liverpool, on what was the third and final part of the triangle. In the town the goods would be unloaded from the ships' holds, to then be processed and sold onwards to the rest of Britain and its expanding empire. Because the trade generated so much income for the town and its merchants, Liverpool actively encouraged this traffic in human bondage and misery.

The first recorded slaving ship to set sail from Liverpool had been *The Liverpool Merchant*, which sold a cargo of 220 slaves in Barbados in 1700. In 1709, a single Liverpool barque of 30 tons carried fifteen slaves across the Atlantic. Nothing more was done for the next twenty-one years, but in 1730, fifteen much larger slave ships left the port, each of 75 tons. Then, from 1737, Liverpool began to seriously increase its involvement in slavery. That year saw thirty-three slavers setting sail from the Old Dock. In 1751, fifty-three slave ships left Liverpool.

In fact, in 1771, 105 ships sailed from Liverpool to West Africa and from there transported 28,200 slaves to the West Indies. During the town's involvement in the trade, Liverpool-owned slave ships transported 1,360,000 African people in over 5,000 voyages. More than half of all slaves sold by English traders were the property of Liverpool merchants and, by the end of the eighteenth century, the town had 70 per cent of Britain's total trade in slaves.

Small numbers of slaves, of both sexes and all ages, were brought to Liverpool and were occasionally sold at local auctions. These people were mostly used as maids, footmen, grooms, or stable-hands, by the more wealthy families in the town. Black domestic servants in great houses were seen as a conspicuous sign

of wealth and status at that time and, while some were paid wages and could move about the town relatively unhindered, others were treated just as items of property.

Naturally, runaway slaves were quite common at this time, and on 8 September 1758 the following appeared in *Williamson's Liverpool Advertiser*, a local Liverpool newspaper:

> Run away from Dent, in Yorkshire, on Monday the 28th August last, Thomas Anson, a negro man about 5 feet 6 inches high, aged 20 years and upwards and broadset. Whoever will bring the said man back to Dent, or give any information that he may be had again, shall receive a handsome reward, from Mr Edmund Sill, of Dent; or Mr David Kenyon, merchant in Liverpool.

Local slaves were also bought and sold in the town and in 1765, the following also appeared in *Williamson's Liverpool Advertiser*:

> To be sold by auction at George's Coffee-house, betwixt the hours of six and eight o'clock, a very fine negro girl about eight years of age, very healthy and hath been some time from the coast. Any person willing to purchase the same may apply to Capt. Robert Syers, at Mr Bartley Hodgett's, Mercer and Draper near the Exchange, where she may be seen till the time of sale.

And the following year, in the same journal, was printed,

> To be sold at the Exchange Coffee House in Water Street, this day the 12th inst. September, at one o'clock precisely, Eleven negroes Imported per the Angola.

Amazing Grace

Most of Liverpool's merchants and wealthier citizens, including many of its mayors, owned or invested in slave ships or slave plantations, or both, or they traded in the crops produced. Indeed, several of the town's MPs also invested in the trade and spoke strongly in its favour in parliament. Vast fortunes were being made by many Liverpool shipowners, merchants and speculators.

One of the most enthusiastic slave ship captains was London-born John Newton (1725–1807) who, as a young man, was the captain of two Liverpool slave ships. John had first gone to sea at the age of eleven, with his father, but in 1744, at the age of nineteen, he was press-ganged (forcibly abducted) into the Royal Navy. He then served for a year on-board HMS *Harwich*, but managed to get a transfer to a slave ship.

He found this to be a very lucrative profession and buried any qualms he might have had about the nature of the trade. He immersed himself in his chosen career, living a dissolute life of debauchery and drunkenness in the process. Although,

as he matured, John began to change his personal lifestyle – he began to read the Bible and became much more respectable – he nevertheless remained an active participant in the Triangular Trade, which of course was then a perfectly acceptable occupation for a young man to be engaged in. He soon became well respected among other slave traders and rose quickly in his profession.

In August 1750 and now at the age of twenty-five, John Newton sailed out of Liverpool as captain of the 140-ton slave ship the *Duke of Argyll*. By this time, however, he had reflected on his life to such an extent that he had converted to Christianity. The message of brotherly love preached by his new faith would hang on him like a shroud on this particular voyage.

John's crew was made up of a second mate, a boatswain, cooper, gunner, steward, cook, tailor and a fiddler. There were also eleven able seamen plus some ordinary seamen and apprentices. This gave him a ship's complement of thirty men and he planned to collect a cargo of 200 slaves once the ship reached Africa. The *Duke of Argyll* arrived off Sierra Leone in West Africa on 23 October, when Newton entered in his log that 'the passage from England has not been the shortest, but remarkably pleasant and free from disaster'.

On 25 October, John went ashore to meet with local slave traders, who showed him seven slaves. After rejecting the older women, he picked two men and a young woman. The *Duke of Argyll* spent the next few months sailing the coast of West Africa looking for slaves for sale. He anchored offshore and landed his longboats on the beaches, as well as sailing them deep up the rivers, always in search of slave traders with whom to do business.

John, in common with other slave ship captains, did not record the names of any of his captives; he simply numbered them. He also showed no particular concern if any of his slaves became sick or died, largely because this happened to so many of them. Again in common with other slavers, he bought many more slaves than he needed, in the expectation of the deaths of so many of them as they sailed across the North Atlantic Ocean.

Olaudah Equiano (*c.* 1745–1797) was an African who had been born in what is now southern Nigeria. At around the age of eleven, he and his younger sister had been kidnapped from home and sold into slavery. The children were separated and Olaudah was shipped across the Atlantic to work on plantations in Barbados and then Virginia. Later in his life, he was taught to read and write by one of his masters and these skills eventually enabled him to buy his freedom. In due course, he came to England to support the very active Slavery Abolitionist Movement. As part of this campaign, Olaudah wrote his life story, vividly describing conditions on-board such vessels as those captained by John Newton:

[The ship] was so crowded that each had scarcely room to turn himself. This produced copious perspirations, so that the air soon became unfit for respiration, from a variety of loathsome smells and brought on a sickness among the slaves. This wretched situation was ... aggravated by the galling of the chains, now become unsupportable and the filth of the necessary tubs, into which the children often fell

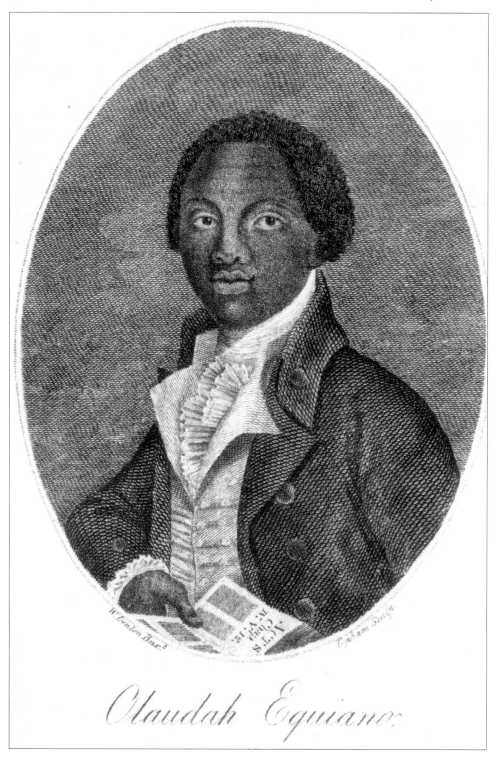

Olaudah Equiano.

and were almost suffocated. The shrieks of the women and the groans of the dying, rendered ... a scene of horror almost inconceivable.

After six weeks at sea on the Middle Passage, on 3 July 1751, John's ship arrived in the West Indies. Here, he exchanged his human cargo for one of sugar and set sail back to England. John anchored in Liverpool on 7 October, after a round trip of more than a year, and entered in the ship's log that the *Duke of Argyll* had been 'very full and lumbered' with her freight on her return to his home port.

Throughout this voyage John had reflected deeply on the trade in suffering and humiliation that he was participating in so thoroughly and his strengthening Christianity conflicted with this. He increasingly began to question the morality of what he was doing. Through successive voyages he began to see the slaves he was transporting less as commodities and more as human beings; as men, women and, especially, as children. He continued to make trips in the Triangular Trade, but the guilt and anguish that now overwhelmed him soon became intolerable. John began to empathise with the suffering and degradation of his captives. He also recognised that, by default, he and his crew were also being degraded by perpetrating this tragic abuse of his fellow creatures.

Then, in 1754, John Newton finally left the sea and the slave trade. With considerable remorse, he completely surrendered to the charitable doctrines of his faith and in 1764, he was ordained as an Anglican minister. John now began to work closely with William Wilberforce (1759–1833) and Olaudah Equiano and other members of the Abolitionist Movement, determined to stop forever the heinous trade.

In 1764, John Newton became the curate at the Church of Saints Peter and Paul, at Olney in Buckinghamshire, where he wrote the *Olney Hymns*. These included 'Glorious Things of Thee Are Spoken' and 'How Sweet the Name of Jesus Sounds', but the most famous of his hymns is 'Amazing Grace', which was the anthem of the anti-slavery movement:

Amazing Grace, how sweet the sound,
That saved a wretch like me.
I once was lost but now am found,
Was blind, but now I see.

Tragically though, the Triangular Trade continued, with Liverpool still at its centre. On 6 September 1781, the Liverpool slave ship *Zong*, outward bound from Africa and under the command of Captain Luke Collingwood, was massively over-packed with its human cargo. So many slaves had already died because of the appalling conditions on-board that Collingwood decided to throw a further 132 of them overboard, alive, so that he could claim compensation and cover his already significant financial losses. His claim was denied, but the actual murder of the slaves was not an issue during his subsequent trial – only the Captain's attempted fraud.

While slavery was encouraged in the towns and cities that benefited from it, this was not the general case in the rest of Britain. The abolitionists were getting increasing support in their campaign, not just from across the country but also in parliament. As the century drew to a close, Liverpool's national reputation was fast becoming tarnished. This was demonstrated when George F. Cooke (1756–1812), a famous actor of the day, appeared in the town. He was known to be an abolitionist and so his performance was booed. Undaunted, he rebuked the audience, stating, 'I have not come here to be insulted by a set of wretches, every brick of whose infernal town is cemented with an African's blood.'

Matters were coming to a head and in 1787 a petition for the suppression of the slave trade was handed to parliament by some members of the Society of Friends (Quakers). This had also been signed by many wealthy and influential people from Liverpool, including the highly respected merchant, scholar and radical reformer William Roscoe (1753–1831). Because of this increasingly potent protest in 1788, Liverpool Corporation formally declared its opposition to abolition and a local song began to do the rounds of the taverns:

If our Slave Trade be gone, there's an end to our lives;
Beggars all we must be, our children and our wives;
No ships from our port their proud sails would spread,
And our streets grown with grass, where cows might be fed.

In 1788, John Newton published a campaigning pamphlet entitled *Thoughts upon the African Slave Trade*. This began with a heartfelt apology for his role in slavery and then described in detail the grotesque realities of what this had truly meant to the African people. The first edition sold out very quickly and he sent copies of the second edition to every member of parliament.

It is important to note also that many women in Liverpool openly supported abolition, applying pressure on their men-folk to join their campaigns. Many could be seen wearing hairpins, bracelets and brooches, each bearing the image of a kneeling slave in chains, pleading for freedom under the words, 'Am I not a man and a brother?' But the slave merchants of Liverpool held on to the bitter end and the last slave ship to sail from the port was the *Kitty Amelia*. This vessel left on the final voyage of the Triangular Trade in July 1807.

Eventually, following years of public meetings and acrimonious debate, despite protectionism and downright ignorance from vested commercial and political interests throughout Britain, in 1807 an 'Act for the Abolition of The Transatlantic Slave Trade' was carried through parliament. Thanks to the relentless campaigns of people such as Wilberforce, Equiano and John Newton, this outlawed the transportation of slaves by British ships. Thus began the end of the Triangular Trade, which was finally stopped by the 'Slavery Abolition Act', of 1833.

Despite the loss of this highly lucrative source of revenue and the doom-laden predictions of the supporters of slavery, the Port of Liverpool and its maritime

trade continued to thrive. This was because of shipowners and merchants such as the Rathbones, Holts, Rankins and Bibbys, who were a new breed of entrepreneur, trading in a variety of goods other than in the exploitation of their fellow human beings. Such prominent individuals laid the foundation for Liverpool's massive expansion and more wholesome economic success during the nineteenth and early twentieth centuries. But what of Afro-Caribbean people in Liverpool?

There are stories prevalent in the modern city of slave shackles and iron rings still to be found in the walls of old dock buildings and warehouses in Liverpool, but these tales have no basis in fact. If any enslaved people had been brought to England after 1772, they would have immediately been set free, as a law had been passed to ensure this.

John Newton, the reformed slave ship captain, served as rector of the Church of St Mary Woolnoth in Lombard Street in London from 1780 to 1807. Here, he devoted himself to working with the poor and needy in the community and he won the love of local people and the respect of the Church establishment. He died in December 1807, only nine months after the parliamentary vote to abolish slavery had been passed. However, at least he had lived long enough to see his campaigns fulfilled and to achieve a personal redemption.

Soon after this and in the town that had profited so much from the slave trade, Liverpool paid tribute to John. The long street that still runs alongside the University of Liverpool's buildings and which connects Brownlow Hill with London Road was renamed as 'Great Newton Street'.

Yea, when this flesh and heart shall fail,
And mortal life shall cease,
I shall possess within the veil,
A Life of joy and peace.

7

The Cultural Revolution

With slavery at its core throughout the eighteenth century, the economy of Liverpool and the wealth of its leading citizens really began to grow. In 1700 the population of Liverpool had stood at 5,715, but within only forty years and after the opening the Old Dock, this had increased to 18,000 people. Within a further thirty years this had doubled and by 1801 it had reached a figure of 78,000. There was an increasingly plentiful supply of cheap if unskilled labour and so business opportunities began to increase rapidly as demand responded to supply. As well as shipping and cargo handling and all the trades associated with these, manufacturing began to increase in the town. A number of potteries became established and rope making, sail making and watch making also became significant trades.

But even as early as 1708, as fast as the new streets were being laid out on the Great Heath, they were becoming as overcrowded, dirty and thoroughly unpleasant as those in the older parts of town. There were no sewage or plumbing systems and water was still either being drawn from wells around the town or sold from travelling water-carts, the purity of which could never be guaranteed. With all the other basic hygiene limitations of a still primitive community (by modern standards), sickness, disease, disability and premature death, were rife and commonplace.

Throughout the first half of the century, Liverpool's commercial success made many of its citizens extremely wealthy indeed. These were professionals who were servicing the economic growth of the town in trades other than slavery. They were doctors, lawyers, insurance brokers, shipping agents, engineers, architects, proprietors of growing factories and businesses, newspaper editors and owners and landlords of buildings accommodating the poorer classes.

These were the rising middle classes of Liverpool and they were establishing themselves as the town's new political, economic and cultural elite. These men and their wives were very proud and conscious of their status and had increasing social aspirations. However and to their considerable discomfiture, the rich had to rub

shoulders, often quite literally, with their poorer, dirtier and smellier neighbours. As they made their way around the town they would also have to avoid stepping, or even falling, into the middens and mounds of rubbish and excrement that were common on the streets and pavements of all English towns of this period. A contemporary report on street conditions in Liverpool stated,

> The streets are generally well cleaned by scavengers, who are regular and diligent in their duty; but in the execution of their business, while they remove one evil they never fail to create a greater. The soil, instead of being immediately carted away, as in London and other places, is raked into heaps around 12 feet wide and 2 feet deep.
>
> These Cloacenian repositories are common in every part of the town and remain eight or ten days and sometimes longer before they are carted away, whereby passengers in a dark night and often in the day, tread in them to the mid-leg and children are sometimes nearly suffocated by falling into them.
>
> The exhalations in summer, by reason of these assemblages of soil being exposed many days to the sun, have a most pungent effect on the olfactory nerves of the passenger, nor are the inhabitants of those houses which are situated near them insensible of the pernicious effects of their effluvia on their health and constitution.

The New Florence

Fortunately for the middle classes, they could now afford to move away from the squalid areas of Liverpool and establish more comfortable lifestyles for themselves and their families. By the mid-1800s they were moving to new houses in the very desirable districts becoming established on the fringes of the town centre. Locations such as Everton, on the high ridge and its flanks; further afield, in what were to eventually become the suburbs of Liverpool, such as Crosby, Wavertree, Mossley Hill and Childwall; and into the developing district now known as Liverpool's 'Georgian Quarter'. This was so named because the distinctive, classical and symmetrical style of architecture of the time became popular under the reigns of King George II (1683–1760) and King George III.

From around 1720, peaking around 1770, this area of residential development was constructed, stage by stage, by speculative property developers on land reclaimed from the marshes of Moss Lake Fields. It was to this district that successful entrepreneurs, shipowners and merchants moved their households into new terraces of spacious homes. These had been built on land that, by 1809, had been successfully and finally drained by an underground tunnel that had been cut out of solid rock. Each of these new properties also provided accommodation for live-in servants and stabling at the rear for horses and the carriages that they drew. These areas were regarded as being 'out in the country', even though the new roads were no more than half a mile outside the town.

This highly desirable area included streets such as Upper Parliament Street, Huskisson Street, Canning Street, Grove Street, Myrtle Street, Hope Street, Rodney

Street, Bold Street and Hanover Street. There were also residential squares, such as Abercromby and Falkner Squares, with their private, central, gated gardens. Indeed, in 1809, William Ewart Gladstone (1809–1898), the future Liberal Prime Minister, was born in Rodney Street. His father, John Gladstone (1764–1851) was the owner of about 1,500 slaves and the family became very affluent as a consequence. The number of new streets now being laid out beyond the heart of the original old town was increasing so rapidly that in 1773 they were first formally named with wall plaques and all the houses were officially numbered.

By this time too, the principal streets in the town centre were far too narrow to cope with the volume of goods and carriage traffic now using them. Many were crooked, mud-and-manure-caked tracks that were overhung by ill-built structures. Thoroughfares such as Castle, Dale, Old Hall and Water Streets still had their original medieval dimensions and were no more than 6 yards wide – 'not enough for two carriages to pass each other'. Between 1786 and 1857, the corporation of wealthy Liverpool spent £1,197,977 on street improvements and widening, all without needing to impose any charges or rates on the townspeople.

As well as the new middle class of Liverpool, there was also a much wealthier class of person emerging in the town. These were individuals of such considerable personal wealth that they regarded themselves as the 'New Aristocracy'. Not for them were terraced properties, as attractive as these undoubtedly were (and remain); they wanted to become genuinely landed gentry with their own stately homes set in the centre of extensive and landscaped estates. These were the nouveau riche bankers, shipowners, leading merchants and the owners of the larger companies and organisations, including people such as William Roscoe, the Rathbone family, the Bibbys, the Hardmans, the Earles, the Brocklebanks, the Harrisons and the Fletchers. They sought to emulate the old money and lifestyle of the likes of the Stanleys, the Molyneuxs, the Norrises and the Gascoignes.

Having bought large parcels of land from Lancashire's more ancient families and from the lords of Liverpool's surrounding manors, they created new estates at places like Calderstones, Allerton Hall, Allerton Manor, Allerton Tower, Greenbank Hall, Broadgreen Hall, Carnatic Hall, Woolton Hall and Gateacre Hall, to list only a few.

All of these members of the middle and upper echelons of Liverpool society sought the trappings and status that they felt went with their new wealth. They also wanted to reflect this in the town in which they lived. Indeed, some of the most significant and culturally aware of Liverpool's new merchant classes saw Liverpool as, potentially, a new Florence. They realised that they could elevate their own cultural credibility by becoming benefactors and patrons of social, artistic and cultural improvements in their town. They began working to make Liverpool a centre of national cultural and artistic excellence, which they would lead and maintain. As a result, the century saw a great expansion of cultural activities and social interaction, paid for and enjoyed by these emerging prosperous classes.

Any town of the period that had such intellectual ambitions (or pretentions to sophistication) needed a newspaper. This was not only for news, but to provide

business and political information and to act as social cement for these people of new wealth and position. The first daily newspaper in Liverpool was *The Liverpool Courant*, which was established in 1712 but soon closed. Another newspaper, *Williamson's Liverpool Advertiser and Mercantile Register*, appeared in 1756 and survived until 1856, although by that time it had been renamed as *The Liverpool Times and Billinge's Advertiser*. A direct competitor to this was the *Liverpool General Advertiser*, which was later renamed as *Gore's Liverpool General Advertiser* and survived until 1871.

Also, as a way of pursuing intellectual enlightenment and of establishing and preserving elite groups and communities, a number of private clubs and associations were formed. Many of these grew out of the coffee houses that were giving birth to the broadsheets and newspapers, as well as to companies and enterprise partnerships. Such institutions as The Lyceum Club, established in 1759, came from these roots. In its glorious building at the bottom of Bold Street (now retail and commercial premises), the members of the Lyceum had access to what was the first subscription library in Liverpool. Then, among a number of other private or specialised cultural establishments, came the Athenaeum in 1797. This established its own internationally renowned library and collections and it remains a significant institution in the intellectual life of modern Liverpool.

The Lyceum Club.

Art galleries, conversation societies and dining clubs were also founded and the Liverpool Medical Library was established in 1799. In 1802, so too were the Liverpool Botanical Gardens. The leading citizens of Liverpool were also conscious of their 'Christian obligations', though some responded to these in more significant and honest ways than others. Consequently, in 1718, in School Lane, the Bluecoat School and Orphanage was established. This was 'dedicated to the promotion of Christian charity and the training of poor boys in the principles of the Anglican Church', although destitute girls too were eventually accommodated there.

As a contribution towards improving the health of the poorer citizens, in 1778 a dispensary was established in Church Street to provide free medicines and medical care to the poor of the town. It was at this time too that the town's first charitable organisations, asylums and hospitals were founded. All of these social improvements were paid for by wealthy private individuals or groups.

The Play's the Thing

Public entertainment had always been popular in the town, especially among the poorer classes. Now, however, the new 'Liverpool Establishment' saw the building of theatres and concert halls designed to provide more elevated entertainments, as another way of demonstrating their cultural credentials. Of course, they would also provide venues for simply having a good time, which has always been an imperative in Liverpool.

The Cockpit Yard Theatre in Moor Street is thought to have been Liverpool's first playhouse. This was built as a place of public performance and drama in 1567, on the orders of the corporation. It stood on the site of the former town cockpit and had bench seating on either side of the stage. It measured 50 feet by 20 feet, had whitewashed walls and was lit by candles. Actors who failed to win the approval of their audience could be forcibly ejected as 'undesirables' from such theatres, so many performers preferred to appear in the taverns along Dale Street and Water Street.

However, during the Civil War and its subsequent decades, the Puritans under Oliver Cromwell banned all forms of public entertainment and theatres were closed down. Once this restrictive and miserable period in English history began to come to an end though, Liverpool Castle, the Tower, the town hall and certain churches, provided venues for a range of musical and theatrical entertainments.

Following the Restoration of the Monarchy in 1660, theatres once again began to appear in Liverpool. This included the reopening of the old Cockpit Yard playhouse, which was mostly for itinerant performers. However, it had no boxes or gallery and, following public demand for a larger and more suitable playhouse, Liverpool's first true theatre was built. Standing on an old track, which ran along the end of the Old Ropery parallel to Fenwick Street, this was opened in 1749 by dock designer Thomas Steers. He renamed the track 'Drury Lane' and his theatre

'The Drury Lane Theatre'. This was to deliberately emulate the famous road and theatre in London; if the capital could have a Drury Lane Theatre then so could Liverpool.

The great actor David Garrick (1717–1779) performed at Liverpool's Drury Lane Theatre to great public acclaim. However, another attraction was the theatre bar, which was advertised as being a source of libation where 'a young woman attends to accommodate the company with such refreshments as they require, on very moderate terms'. The Drury Lane Theatre remained in use until 1772 when the Theatre Royal was built in Williamson Square. After this the old theatre went into decline: it was used as a warehouse and fire engine shed until its demolition in 1786.

The music hall in Bold Street opened in 1786, but as a concert hall rather than as what we would understand a music hall to be. During the nineteenth century, and keeping pace with the massive growth in the population of the town, the establishment of more theatres, concert halls and other places of public entertainment became exponential. The first philharmonic hall opened in Hope Street in 1846 for orchestral concerts. This was followed in 1855 by St George's Hall on Lime Street. This opened for larger concerts and for civic functions and entertainments. But the late nineteenth century was the peak time for theatrical entertainment and, by the turn of the twentieth century, Liverpool would have twenty-six theatres and thirty-eight music halls, entertaining all classes of people.

Tea and Topiary

All the entertainment was not indoors, however. The eighteenth century also saw the emergence in Britain of private landscaped pleasure gardens. A forerunner to public parks, these thrived throughout the century and beyond and opened as private enterprises for a fee-paying public. The gardens were enclosed areas of formal lawns and flowerbeds, of planted trees and shrubberies, of man-made rustic bowers, of planned watercourses and walkways, and of cleanliness and fresh air.

Pleasure gardens were places of tasteful culture, where the new and highly fashionable beverage of tea could be imbibed; no alcohol was permitted. The first of these, naturally, opened in London, but soon major towns and cities across the country had their own such gardens; not least of all Liverpool. The town had the Spring Tea Gardens, near where the Anglican cathedral now stands; the Folly Gardens, where the Wellington Column today dominates William Brown Street; and the most popular of all, the Ranelagh Tea Gardens.

From 1722, a certain Mr Gibson owned and operated the Ranelagh Tea Gardens, which stood on the land between what are now Brownlow Hill and Copperas Hill, behind the White House Tavern, also sometimes known as Ranelagh House. This was inspired by Vauxhall Pleasure Gardens in London and named after the house of Lord Ranelagh in Chelsea.

Mr Gibson laid out, at considerable expense, landscaped gardens that were bounded by lush shrubberies. Also, the hedges were sculpted into shapes and patterns, demonstrating the skills of artists in topiary. From the centre of his new gardens, flowerbeds radiated out like spokes from a wheel and at its hub stood a tall, highly ornate Chinese temple. Inside this, an orchestra played delightful music to entertain and divert people who promenaded throughout the grounds.

Members of gentile society would meet at the Ranelagh Gardens; beautiful and graceful ladies in their finest gowns, with their hooped skirts, would seemingly glide along the pathways, their bonnets framing pale faces and delicate lace shawls keeping out the chill of the evening summer breezes. They would stroll along on the arms of their beaus, gentlemen immaculately turned out in their buckled shoes, brushed velvet breeches, neatly tailored frock-coats with double-breasted fronts, adorned by large buttons and topped by flawless silk cravats.

There was a large pond, stocked with a wide variety of fish, so tame that they would come to the surface to be fed by the visitors. Indeed, some of the carp were so fat that they were too large to swim. All these features, as well as the firework shows, strawberry gardens and rustic creations, provided the glitterati of Liverpool, as the handbills said, 'with entertainment and diversions so admirably adapted for the consumption of tea'.

The tea gardens were so successful that when a new road was laid out nearby in 1766, it was named Ranelagh Street. However, by 1790, these once popular and highly fashionable pleasure gardens had closed. In the early decades of the nineteenth century, a new development began on the site of the White House Tavern: the Adelphi Hotel.

A Temple to Civic Pride

On the top of the dome of Liverpool Town Hall, which has four clock faces flanked by lions and unicorns, sits the statue of the goddess Minerva, who was the Roman equivalent of the Greek goddess Athena. She sits in powerful and benevolent guardianship over the city and, as the goddess of wisdom, warfare, strength, science, magic, commerce, medicine, teaching, creativity, the arts and poetry, and as the inventor of spinning, weaving, numbers and music, she is a perfect symbol of Liverpool.

The town hall is a true temple to civic pride and is the third such building on this site. As we have seen, the first such civic building was given to the town in 1515 by Reverend John Crosse. This became Liverpool's first town hall and though probably only a very primitive structure, it became the principal civic building in the town. Known as 'The Exchange', this served as both a mercantile exchange and as the place for formal meetings of the town corporation and leading burgesses, although some of the merchants also built special exchanges for their own trades in various parts of the town, including a cotton exchange and a corn exchange. Little is known about The Exchange except that it was a small

thatched house, standing on the east side of Juggler Street (afterwards named High Street), but sadly no images of the building exist.

By 1673, the mayor James Jerome declared that the existing building was not grand enough for a town of Liverpool's importance and that a more modern exchange was needed. In 1674, the corporation ordered the demolition of the old building and construction of Liverpool's second town hall began. This was set back from where the original town hall had stood. When it was completed, the new building also became known as 'The Exchange', because the ground floor had an open colonnade, inside which local traders and merchants could conduct business.

This was a stone building, with upper rooms that were used for the town's formal and civic meetings. The eaves were embellished with decorative battlements and there was a square lantern tower in the centre. It also had a belfry with a fire bell at one corner. Although the town now had its 'grand new exchange', by 1740 it was in a dangerous state. The foundations were so unstable that some of the arches were sinking into the ground. With a view to relieving the 'pressure upon the other supports', the great turret was taken down. This failed to stop the gradual subsidence of The Exchange, so it was pulled down before it fell down. A new building was now needed.

In 1748, the town council commissioned John Wood the Elder (1704–1754), a prominent architect from Bath, to design and build Liverpool's third town hall.

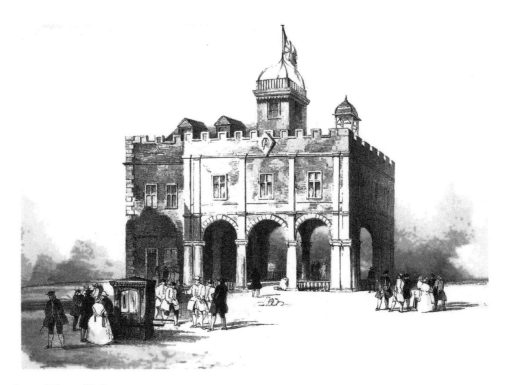

Second Town Hall.

The foundation stone was laid that same year, but on a much more solid base than its predecessor. This building was constructed of ashlar stone and it had a slate roof upon which stood a square tower with a lead dome. The new building was opened in 1754 amid great celebrations.

However, fifty years later in January 1795, a disastrous fire damaged the town hall. It proved impossible to extinguish the blaze because a severe frost had frozen the water pipes, and it was purely by chance that a great part of the building survived. The architect James Wyatt (1746–1813) was given the responsibility of restoring and reconstructing the town hall, which is the building that stands today, on the north side of Water Street, facing Castle Street.

Wyatt carried out the project to great effect, including the addition of a magnificent two-storey Corinthian portico. He also replaced the gutted roof with a large dome, which he supported on a new cylindrical tower. It is from this high position that the goddess Minerva continues to gaze out over the modern city. She is carved in terracotta and covered in 87,000 square inches of gold leaf. Work began in 1796 and took fifteen years to complete. The restored town hall was reopened in 1811 amid yet more enthusiastic public celebrations.

At the north end, to the rear of the building and overlooking the broad, open piazza of exchange flags, are statues of the Four Seasons. These originally came from the Irish houses of parliament in Dublin. Also overlooking this large courtyard is 'The Queen's Balcony'. It was from this vantage point in 1851, while observing the business being conducted there at the time, that Queen Victoria commented that she had 'never before seen together so large a number of well dressed gentlemen'.

Above the main entrance to the town hall and overlooking Castle Street is the South Balcony. It is from here that the lord mayor, visiting royalty, stars of stage and screen, and those individuals receiving the freedom of the city, all acknowledge the cheers of crowds below.

The interior of the town hall is magnificently decorated throughout. The two ballrooms and fine suites of civic rooms on the upper level make this one of the most significant town halls in the country. Indeed, on a visit to Liverpool in 1904, King Edward VII (1841–1910) compared the rooms in the town hall to those of the Tsar's Winter Palace in St Petersburg, remarking that they were 'the best-proportioned in all Europe'. At the heart of the building on the ground floor, Wyatt created a spacious, panelled, semi-circular council chamber and committee rooms. He also included the official residence of the lord mayor, making Liverpool the only city outside London to have a mayoral home.

Despite its contemporary use as a functions and events venue, until very recently the building did not hold its own drinks licence and events organisers had to apply to the city magistrates for special licences if they wanted to serve alcohol. The previous permanent alcohol licence was revoked in 1571 because the bar owed a debt of one shilling and fourpence. Also, the city's gentlemen were getting too drunk and 'falling about the hall floor in states of inebriation'.

Indeed, over the years some very famous people have had to be carried or dragged out of Liverpool Town Hall, somewhat the worse for wear. These have included Mark Twain (1813–1910), General Ulysses S. Grant (1822–1885), and a young William Ewart Gladstone. Indeed, Prince William, 2nd Duke of Gloucester (1776–1834), after attending a civic function in 1803, was quoted in the local press as saying, 'By the time of the 24th toast, the hall had lost count of the proceedings.'

Liverpool's town hall remains a symbol of how the town, from the middle decades of the eighteenth century, began to reinvent itself. No longer simply a port, it was now a centre of cultural life and of social and intellectual aspiration. Of course, this would have only a peripheral impact on the labouring classes of the town, although they did benefit from increased welfare, charitable, social and educational improvements. Some of these were deliberately aimed at improving their quality of life, but most simply trickled downwards, with few benefits reaching the very base of Liverpool's social pyramid.

Nevertheless, from 1750 it was clear that Liverpool was already the most significant town in Britain and therefore in the British Empire, discounting London. This is a title it had earned and one it would hold until well into the twentieth century.

8
The Hub of Britain

It was certainly the Port of Liverpool and its rapidly developing dock system that were the principal factors in making the town so critical in the economic growth of Britain and in its imperial development. But from 1750 to 1850, Liverpool would also become one of the country's most vital transportation hubs of raw materials, commodities and also of people. Over that 100-year period, every mode of transportation developed would both radiate from and converge on the town on the Mersey.

From Packhorse to Turnpike

By the closing decades of the 1600s, an increasing amount of raw materials and manufactured goods were being transported in and out of Liverpool by land. This was happening regionally to and from towns like Prescot, St Helens, Ormskirk and Manchester, but also with more distant places like the Midlands and the south of England. This was often in preference to transportation by sea, as overland travel was less hazardous, even though the quality of Britain's roads, until the middle of the eighteenth century, was extremely poor.

Until that time, most roads were little more than packhorse or cart tracks, created over centuries of common use and beaten flat by foot, hoof and wheel. Therefore, roads could rapidly become rutted through overuse, overgrown because of irregular use, full of potholes due to inadequate maintenance, even though parishes were legally responsible for their upkeep, or completely flooded or washed away in bad weather.

However, as well as the poor road surfaces making such journeys extremely uncomfortable, the routes were often infested with highwaymen. But commercial pressures create change and, with the increasing need to travel and to move goods further afield, the improvement of the roads became an urgent priority.

While coach travel had already developed in and out of London and in one or two other major cities, it came to Liverpool quite late. The town was small enough for people to walk to their local destinations and if they needed transport, they would hire a sedan chair. This was a chair inside a windowed cabin, big enough for one seated passenger only. It was carried by two porters, one in front and one at the rear, using wooden rails that passed through brackets in the sides of the cabin. Alternatively, during the first decades of the eighteenth century, there was a single hackney coach available for hire in the town. Again, this was only used for very local travel and the horse was led slowly along for safety. In fact, until the 1720s, few people had any reason to travel outside the town. If they did, then they would do so on horseback, with or without goods.

This would only be men of course, who would either ride alone or in small groups. No woman would ever travel alone by any method, as this was considered to be indecent. Families would travel by cart or by hired carriage if they had the money to pay for this service. The most important road out of Liverpool was then the packhorse route from nearby Prescot to the town, which was mainly used for the movement of coal. As this became busier and as other routes began to make their way out of town, something had to be done to enforce road maintenance and security. So in 1726 an Act of Parliament created the Liverpool to Prescot Turnpike Road.

'Turnpiked' meant that toll booths, toll gates, or toll houses were placed at various points along principal packhorse or travel routes. These would raise income from road users to pay for regular road maintenance. The word 'turnpike' was originally the name given to a gate-like frame, pivoting at one end on an upright post or 'pike'. These had first been used on tracks to block the passage of cattle and other animals, but the term eventually came to mean any gate by which the way was obstructed in order to take toll.

Such tolls were payable in addition to whatever other fares or costs were charged for any journey and were levied on demand at the toll gates. At this time the toll for wagons carrying coal was 6*d* (old pence) each; for carts carrying coals, 2*d*; for carts carrying other commodities or goods, 6*d*; for horses carrying coal, ½*d*; for other horses 1*d*; for coaches, 1 shilling; for cattle ½*d* per head; and for sheep, ¼*d* (one farthing) per head. The toll keepers were called 'Pikemen' and they wore a uniform that consisted of a tall black hat, black stockings and knee britches, and short aprons with deep pockets in which to hold the money. The wages for these men, and sometimes women, were poor, but at least they and their families could live rent free in the adjacent, purpose-built toll cottages.

By 1761, the new 'highway' to Prescot was extended further to connect with other major routes. It was now also regularly used to carry the mails, goods and news to and from Liverpool and Manchester and also to the Midlands, as well as, in due course, to London. The first mail coach to London left Liverpool on 25 July 1785. The journey took thirty hours and, as well as the coachman, there was a guard who was often armed in case of attacks by highwaymen. The fare was £3 13*s* 6*d*, which was expensive even for the times, so long-distance travel was then only for the wealthier citizen.

A major development was that the mails were being carried on passenger stagecoaches rather than the other way round. The wealthy travellers of that period, those who lived in the great houses that the mail coaches passed en route, were picked up at their gates. They were forewarned of the arrival of the post-carrying coach by the driver, who blew through a long horn to herald their approach, hence a 'post horn'. With the development of this delivery service, soon, people also began to travel on the coaches between Liverpool and all the local towns.

These vehicles were known as stagecoaches because horses could only haul their heavy loads for limited distances and so had to be changed at regular intervals. These changeovers took place at stages on the route, usually coaching inns with stables that would have fresh teams of horses available. The distances between these stages varied, depending on how flat or hilly the terrain of the route was.

On the Liverpool to London route, the first stop was after only a mile from Dale Street to Low Hill, which was a very steep climb. The next stage was at Old Swan where the route split. The next stages were then at Knotty Ash, on the Prescot and Manchester route, or at the Childwall Abbey Inn, on the Warrington route to the south and on to London. To warn a coaching inn that the coach was approaching, the coachman would blow his horn. In this way too, the innkeeper could ready his food and ales for the travellers and his bedrooms for those on long-distance journeys.

The Liverpool to London route became particularly important and lucrative and one of the most important coaching inns in Liverpool was the 'Saracen's Head'. This stood between 1810 and 1853 on the site currently occupied by the Liverpool City Council Headquarters at Municipal Buildings in Dale Street.

All this traffic increased the fortunes of the districts and communities through which it passed and encouraged the establishment of coaching inns, taverns and travellers' suppliers at significant points all along its length. As late as 1788, a train of seventy packhorses set out daily from Dale Street to Manchester. They travelled along the new highway and, together with the now regular passenger coaches, these created more trade for the town and increased the importance of Old Swan as a crossroads of major routes and of Knotty Ash, Roby, Huyton, Prescot, St Helens and Warrington as halts and as destinations.

As passenger numbers grew, Liverpool's first horse-drawn omnibus service was established on 12 May 1830. These buses ran regularly from Liverpool Town Hall to travel through Edge Hill and across the Great Heath and then via Old Swan to arrive at Turk's Head Inn in Knotty Ash Village. The journey took 1½ hours and the fares were 10d if you sat inside and 6d if you were prepared to brave the weather by sitting outside. In the colder weather, passengers seated inside had the luxury of straw around their feet and rugs across their knees and they could even hire binoculars to survey the passing countryside.

By the end of the eighteenth century, roads were now being built right across Britain as demand for the movement of goods and people increased. Roads now needed to be much better constructed to withstand the volume and weight of

Coaches give way to the railways.

the vehicles. In 1816, John MacAdam (1756–1836) was appointed as surveyor of Bristol's road network. He devised a system of road building that involved resurfacing them with gravel mixed with crushed stone. This was then pounded into the roadway to make a compacted and firm surface. He also built his roads with a camber, so that rainwater would run off into channels that he also cut alongside the road. This method was soon named after its inventor and 'Macadamising' was soon being used across Britain's roads.

Thomas Telford (1757–1834), another great engineer and road builder, helped in the development of a high-standard network of roads around the country. Because of this, there was no longer a need for turnpikes or tolls and these began to be phased out. From the beginning of the nineteenth century, the transportation of goods and people by road grew rapidly as it was now much safer and far quicker. However, this was still not enough for the commercial needs of Liverpool and additional methods of inland transportation had to be devised.

By Cut, Rail and River

An early solution to the problem of increasing demand for improved transportation was the development of existing inland waterways. The more important rivers were made navigable for moving goods by deepening them so that they could accommodate barges and narrow boats with large holds. These were often linked

together in waterborne trains and barges, which were horse-drawn by ropes using towpaths alongside the waterway. In 1720, long stretches of the rivers Mersey and Irwell were deepened for this purpose. It was after this that specially dug canal waterways were created and these revolutionised the bulk movement of commodities and of manufactured goods throughout the country.

The businessmen and entrepreneurs of Liverpool quickly recognised the importance of canals. Their exploitation of this revolutionary method of transportation began with the opening of the Sankey Brook Navigation in 1757, which had been constructed to carry barges of coal from the St Helens coalfields to connect with the River Mersey and then on to Liverpool.

This was the first man-made canal in England and the first commercial canal in the world. This waterway and all the subsequent ones that were soon being dug across the rapidly developing industrial landscape of Britain, were excavated only by manpower. The shifting of tons of earth using only spades, picks, shovels and muscle-power, demanded a new breed of manual worker. Because of their jobs, on what were referred to as 'navigations', these burly men became known as 'Navvies'.

However, Britain's first true canal, rather than a river navigation, was opened in 1761 as a business venture by Francis Egerton, 3rd Duke of Bridgewater (1736–1803). Named by him as the Bridgewater Canal, this is 39 miles long and connects Runcorn with Leigh. Then came the building of what is still the longest canal in Britain, the Leeds & Liverpool Canal system at 127¼ miles long. This gave the impetus for the construction of other major canal systems around Britain, including the Trent & Mersey Canal, which is 93½ miles long, connects the Trent and Mersey rivers, and opened in 1777.

Factories, warehouses, wharves and quays soon developed at strategic points alongside these canals, as did barge-repair workshops, stables for the horses and new communities of water-folk, the 'bargees' and their families. These people took a real pride in their skills as watermen and in their vessels, giving their barges romantic or evocative names, as well as painting and decorating them and their equipment with beautifully executed designs in vivid colours.

Of all of these canals, the most significant, at least as far as the expansion of commercial trade across England was concerned, was undoubtedly the Leeds & Liverpool. This formed a major link across the Pennines carrying goods from Liverpool across Lancashire and into Yorkshire. Construction began in 1770 with the first section from Liverpool to Wigan being opened in 1774. Built primarily to carry all kinds of goods, commodities and finished products to and from Liverpool, the full length of the canal was finally completed in 1816. At its peak of operation the Leeds & Liverpool was the most profitable canal in England. This was because it created a new commercial connection between the thriving Port of Liverpool and the equally flourishing town of Leeds, as well as with all the many other towns along the canal's length.

Coming into Liverpool through the Aintree, Vauxhall and Kirkdale districts, the new 'cut', as it was known locally, provided increased work opportunities for

that densely populated part of the town. It also became a great recreation centre for local children and young men, especially in sections passing factories such as the sugar refineries in Vauxhall and Kirkdale. These discharged hot water into the canal as part of their manufacturing process, turning the cut into a heated swimming pool. Making sure to dodge the barges, these 'water rats', as they became known, came to splash, swim and play in the cut from all over north Liverpool.

The canal originally ran parallel with Pall Mall to terminate at the appropriately named Leeds Street. This section closed many years ago, but in 1848 Jesse Hartley built a set of four stepped locks that still connect the canal with Stanley Dock Basin. This then connects beneath a stunning dock road bascule bridge, with Collingwood and Salisbury Docks and the rest of the network.

By the opening decades of the nineteenth century, the demand for even more efficient, more capacious and faster forms of transportation had continued to grow. It was to be in 1830 that Liverpool entrepreneurs took another huge gamble. Like the creation of the Old Dock, this too would be an outstanding success. Yet another engineering marvel would again totally transform life and business, not only in the town, but throughout Britain and beyond. Because it was in that year that Liverpool gave the world its first true inter-city passenger and goods railway.

The Industrial Revolution (*c.* 1760–*c.* 1830) irrevocably changed the face of Britain. As steam power transformed an agrarian nation into an industrialised nation and towns and cities into conurbations, Liverpool would be at the very heart of all of these social and economic changes. But the construction in the town of this new railway was another massive revolution.

In the early decades of the nineteenth century, there were already a number of railway lines in Britain, but these were mostly for very localised industrial purposes, such as hauling coal and other goods over short distances in collieries. Also, most of these railways were horse-drawn. However, this all changed when the great engineer George Stephenson (1781–1848) was invited to come to Liverpool by certain wealthy prominent industrialists and businessmen from the town and from nearby Manchester. These men were the directors of the newly created Liverpool & Manchester Railway Company (LMR) and they proposed to build a railway powered by some form of steam locomotive.

This would provide faster transport of raw materials and finished goods as well as passengers (although this was an afterthought) between the Port of Liverpool and the cotton mills of Manchester. Road and canal transport was no longer adequate for the ambitions of these men in this modern age. Also, they felt that such a direct link between the two great northern cities would be cheaper to run and more profitable. The railway would certainly make its investors richer and it would consolidate their continuing vision for Liverpool as the leading town and port in Britain and her Empire. These men knew that Stephenson and his son Robert (1803–1859) would be equal to this great commercial and technological challenge and in 1826 the engineers came to Liverpool and set to work.

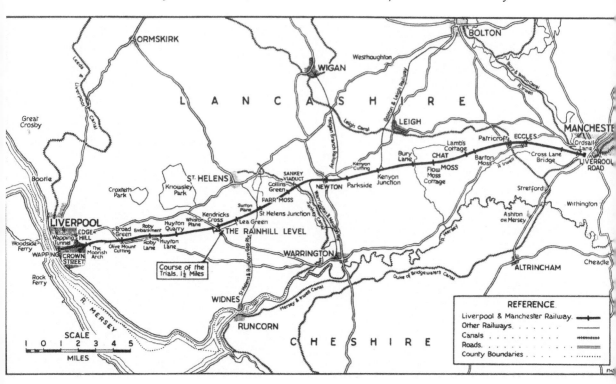

Liverpool & Manchester Railway route map.

The line would consist of two parallel tracks covering a distance of 35 miles, which would have to be laid over some very difficult terrain, including across the treacherous Chat Moss. This 12-square-mile expanse of soggy bog lies 5 miles west of Manchester, directly on the route between the two cities. Stephenson eventually decided to 'float' his line across it by distributing the load over a wide surface. He prepared the terrain by laying sand, earth and gravel, thickly coated with cinders, upon overlapping hurdles of branches, heather and brushwood. Modern trains still run over Stephenson's imaginative foundations.

However, this was not the only significant engineering problem that Stephenson had to overcome. The line began with a goods depot at Wapping Dock in Liverpool, then travelled through a 2,250-yard tunnel beneath Liverpool to Crown Street Station at Edge Hill, where passengers would board trains to and from Manchester (the construction of Lime Street Passenger Station in the centre of Liverpool did not begin until 1836). From Edge Hill, the line then ran through a 2-mile hand-hewn cutting through solid sandstone bedrock. At the Olive Mount section in Wavertree this was 70 feet deep.

Then a viaduct had to be crossed over the Sankey Brook Valley, supported by nine arches, each one 50 feet wide and around 70 feet high. Also, many more great embankments, cuttings and tunnels had to be constructed along the route, to make the track as level as possible across significantly variable gradients. All

of these magnificent feats of civil engineering were carried out using only muscle power by Stephenson's labourers, who were also known as 'Navvies', as many of these men had already dug many of Britain's canals.

In 1828, the LMR directors could not agree on how to power their new transportation system and so they decided to hold a series of competitive practical trials to choose the most effective form of locomotive. These had to take place quickly as work on the tracks was now well underway. So, beginning on 8 October 1829 at Rainhill just to the east of Liverpool, a number of steam locomotives were to compete against each other, not just for the contract, but for a prize of £500.

While George Stephenson was largely occupied in supervising the building of the railway line, he had every intention of winning the Rainhill Steam Trials and of using his locomotive on his railway tracks. Consequently, his son Robert, who was then only twenty-four years of age, concentrated on developing their entry for the competition. This was named *Rocket*, which was one of five shortlisted locomotives in the competition. The others were:

Novelty, built by Messrs Braithewaite and Ericsson of London.
Perseverance, built by Mr Burstall of Edinburgh.
Sans Pariel, built by Mr Hackworth of Darlington.
Cycloped, built by Dr Brandreth of Liverpool, but which was disqualified because it was powered by a tethered horse and jockey on a treadmill.

Competitors had to run their locomotives ten times in each direction over a 1½-mile-long course. After a break to take on water and fuel, another ten runs had to be completed, each of which were timed. George and Robert Stephenson won the rigorous trials in grand style, having attached a coach to their engine containing thirty passengers. They further impressed the judges, the spectators and no doubt their passengers by travelling at the impossible speed of between 24 and 30 miles an hour. This was twice the speed of even the fastest stagecoach and flying in the face of the common belief that people would not be able to breathe at such speeds. At the conclusion of the trials, *Rocket* was the only locomotive to have completed the course and so was declared the outright winner. The prize and contract were duly awarded to the Stephensons.

Not only was their engine the most scientifically advanced engine at that time, but it also looked good with its tall smokestack and brightly painted bodywork. Following the contest, the fame and popularity of the locomotive was almost universal and the impact of the Rainhill Trials and of George and Robert Stephenson cannot be underestimated. A year later, the rail link had been completed and 15 September 1830 was the date set for the inaugural run between Liverpool and Manchester.

This saw the *Rocket* as one of a cavalcade of eight new locomotives; the Stephensons' innovations had inspired many other engineers to follow suit. Each engine was drawing a train of passenger carriages laden with dignitaries and officials. Among these special guests were the Duke of Wellington (1769–1852),

who was Prime Minister, and the Liverpool MP William Huskisson (1770–1830), who was one of the promoters of the new railway.

The leading engine was *Northumbrian*, pulling the Prime Minister's carriage and an open car for the band. Next came *Phoenix* and *North Star*, followed by *Rocket*. After this came *Dart*, *Comet*, *Arrow* and *Meteor*. The track sides were thronged with cheering crowds, and passengers and spectators alike were in high party mood. Sadly though, the day was marred by a tragedy that took place halfway en route to Manchester.

The procession had stopped at Parkside near Newton-le-Willows for the locomotives to detach from their carriages to take on water. At this point some of the VIPs got out to stretch their legs and to socialise. William Huskisson thought that this might be a good time to go to Wellington's carriage for a conversation. After shaking the duke's hand while standing on the step of his carriage, the Liverpool MP realised that *Rocket* was advancing towards him on the parallel track, only 5 feet away from him. All the people who had been walking around very quickly began to scramble back aboard their own carriages, leaving Huskisson as the last person standing on the ground, with his hand on the open carriage door.

It was clear to observers that he was too close to the approaching locomotive and the engineer shouted out to him from *Rocket*. As Huskisson struggled to pull himself back into the duke's carriage, his strength failed and, already weakened by a recent illness, he lost control of the carriage door, which swung outwards, knocking him into the path of the oncoming locomotive. The unfortunate man was struck by the engine and he fell to the ground. As he did so, his left knee was thrown across the track in a bent position and the wheels of the engine crushed his thigh and leg, producing a loud 'crunching' sound according to eyewitnesses and 'squeezing it almost to a jelly'. The ill-fated MP died later of his injuries, becoming the world's first railway fatality.

Every day, without realising it, hundreds of passengers on modern trains pass the site of Huskisson's accident at Parkside. A memorial was placed here at the time and it still stands bearing an inscription, part of which reads,

> The accident changed a moment
> of the noblest exultation and triumph
> that science and genius had ever achieved
> into one of desolation and mourning ...

The Liverpool & Manchester Railway was the first to carry passengers and goods on a regular basis and to a timetable. The passenger service proved immensely popular and was soon transporting over 2,000 people each day. In the first year of operation, the railway also carried over 40,000 tons of goods and by 1835, this had increased more than five times. In the same period, the amount of coal being carried, literally fuelling the Industrial Revolution, increased from 11,000 tons to 116,000 tons per year.

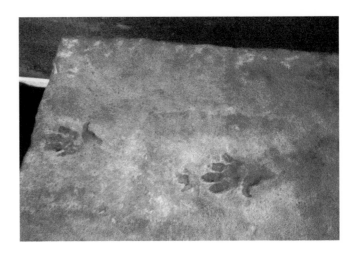

1. *Cheirotherium* footprints.

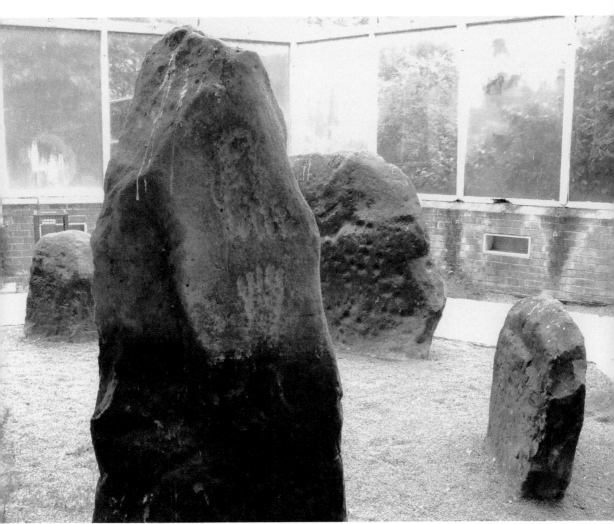

2. The Calder Stones.

3. Map of the Hundred of West Derby.

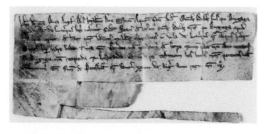

4. King John's Charter of 1207, creating the town and borough of 'Leverpul'.

5. Lord Thomas Stanley, 1st Earl of Derby.

6. William Phillip Molyneux (or Lord Dashalong), 2nd Earl Sefton.

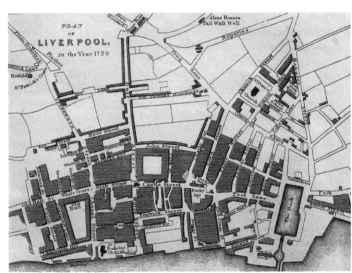

7. Liverpool's first dock and the developing town.

8. Some of Jesse Hartley's dock walls that survived Hitler.

9. The Athenaeum Club.

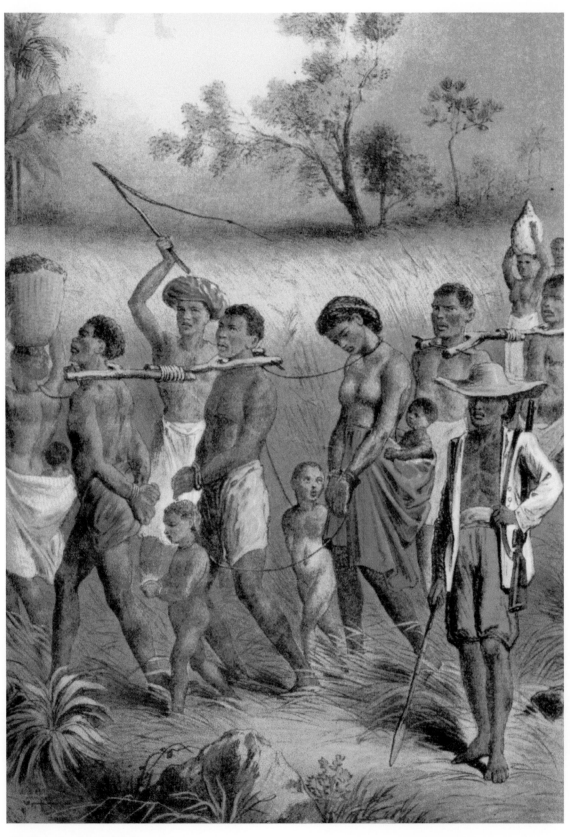

10. Slave caravan in Africa.

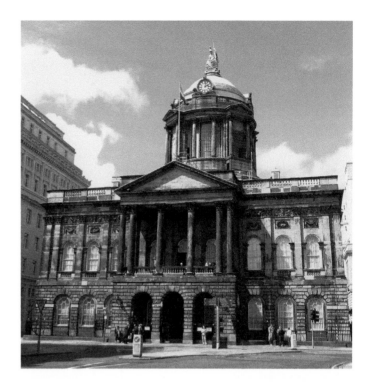

11. The Town Hall today.

12. Leeds–Liverpool Canal extension at the Pier Head.

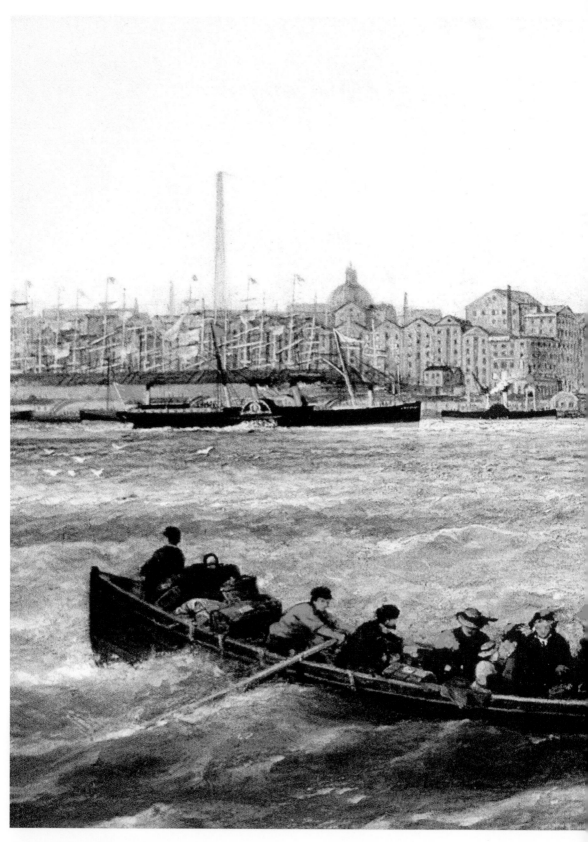

13. Ferries by muscle and steam power.

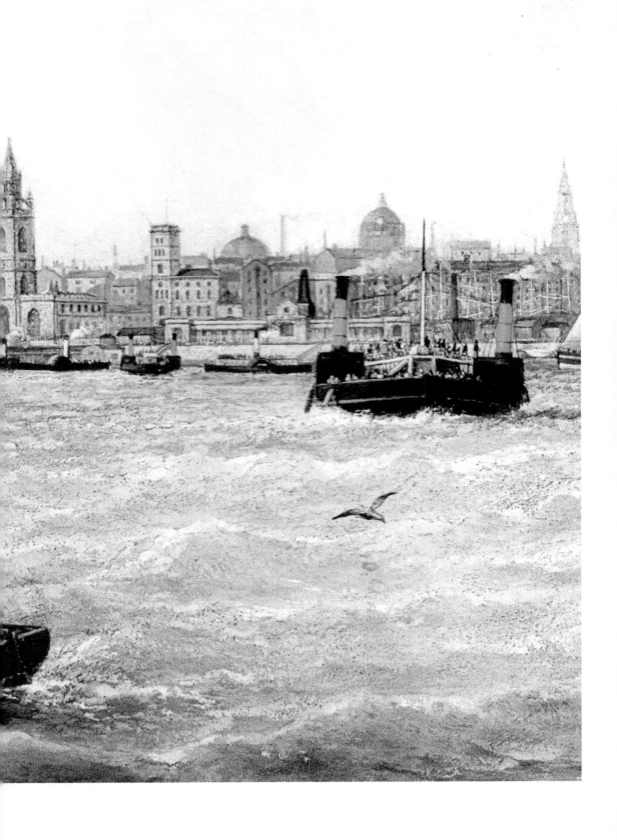

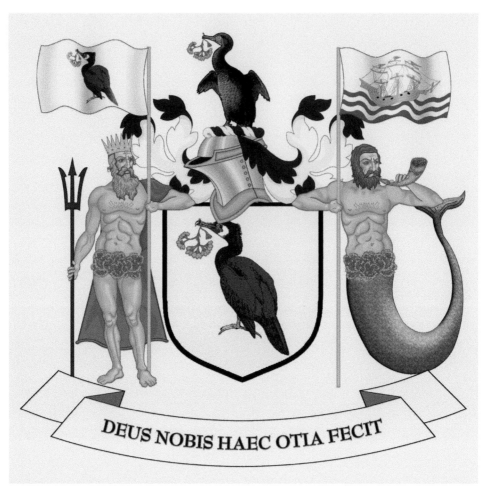

14. City crest and coat of arms.

15. SPQL: 'The Senate and the People of Liverpool'.

16. Seaman's Home, Canning Place, just after opening.

Below left: 17. Oriel Chambers.

Below right and opposite: 18 & 19. 'Giants' in the Sea Odyssey performance of 2012.

20. First World War propaganda poster.

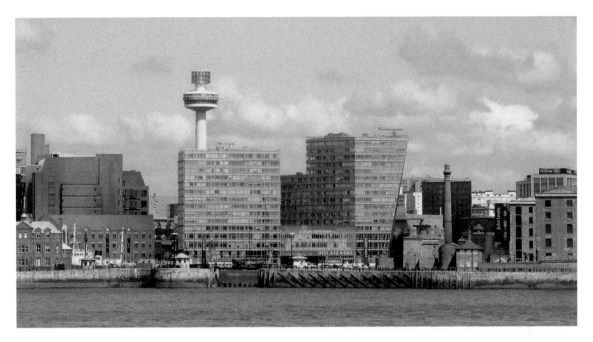

21. Liverpool ONE from the river.

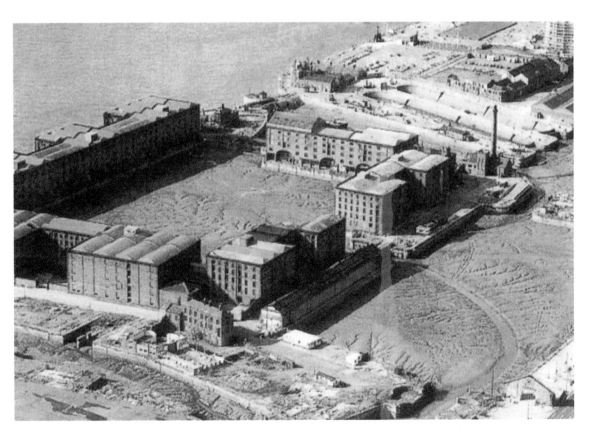

22. Silted-up Albert Dock.

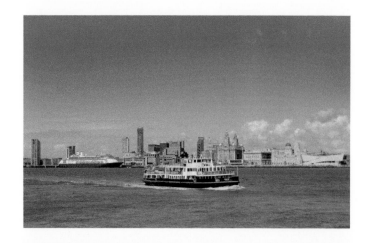

23. Old and new Liverpool side by side on the site of the original pool and Old Dock. (Liverpool City Council)

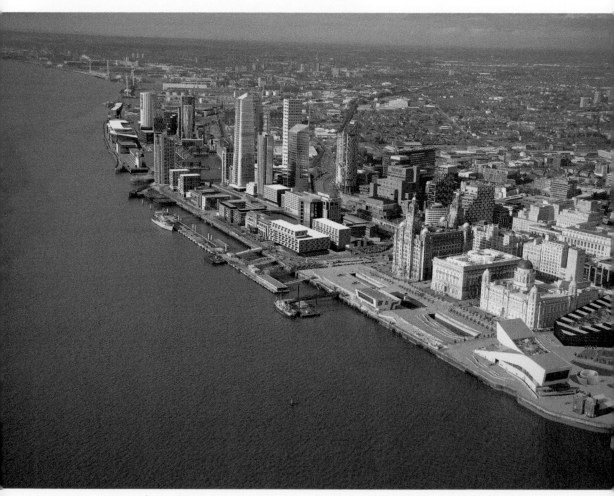

24. Liverpool Waters. (Peel Ports)

Seven years after the railway opened, Liverpool was linked to Birmingham and then to London by the Grand Junction Railway. Soon, there was a link from Birkenhead to the Midlands on the Birkenhead & Chester Railway, which eventually became part of the Great Western Railway. By the mid-nineteenth century, the Lancashire & Yorkshire Railway and the Cheshire Lines Railway had been added to the network serving Liverpool and this expansion drove forward the rapid industrialisation of Britain. This all fulfilled the ambitions of the railway's promoters, and Liverpool's pre-eminence as the most important port and town in the British Empire outside the capital was now unassailable.

Of course, well before railways, canals and roads, the town on the Mersey had been the hub of the local community and economy for centuries. The river itself had never been a barrier between the people living on its opposite shores; even before King John came to the Mersey, there had been a ferry across its turbulent waters. In fact, there have been boats on the Mersey for as long as people have lived in the area; probably since Neolithic Boat People, about 4,000 years ago.

It is likely that the Romans may have been the first to use a ferry to cross the river, although the word 'ferry' comes from an Old Norse word, '*feryu*', meaning 'passage across the water'. This means that it is just as likely that the invading Vikings may also have needed a ferry. But in recorded history, the first known Mersey ferry service was provided by the monks of Birkenhead Priory, which had been founded in 1150 by Hamon de Massey (1129–1185), Baron of Dunham Massey. This religious order had established their priory on the shore of the Wirral peninsula, on a promontory overlooking the River Mersey.

By 1160, the monks were operating a ferry across to the small fishing community of Liverpool. They had established a mill and a corn warehouse on what would eventually become Water Street. With the founding of the new town in 1207, the ferry began to get busier. Although this was operated by the monks, they had to lease the rights to do so from the reigning monarch, who actually held ownership. Indeed, King Edward I (1239–1307) visited Birkenhead Priory twice, in 1275 and 1277, and was impressed by its location.

As the monks were now crossing the river so frequently, they realised that they could transport other people across too and so they soon began to provide a ferry service to local travellers for a small fee. Their passengers were farmers, merchants and perhaps medieval tourists. This ferry service became known as the 'Monks Ferry', a name that lasted for centuries even after the monks ceased operating it.

Because the small boats that made the crossings were mostly rowed across the river, sometimes using a small sail when conditions were suitable, the journey from Birkenhead to Liverpool could take up to one-and-a-half hours on a good day and considerably longer if the river was rough. Indeed, the monks only attempted the crossing in fair weather, but they provided stranded voyagers with free food and lodgings at the priory until it was safe to cross. They also built and maintained free hostels on the Liverpool side of the river, adjacent to their mill.

In due course however, along came the Reformation during the reign of King Henry VIII and so did the Dissolution of the Monasteries. In 1538, Birkenhead

Priory was closed down by the king's troops and the monks were forcibly evicted and dispersed. From that time, the priory buildings, including the travellers' hostel, were allowed to fall into decay and ruin. While the ferry across the Mersey continued, the service was no longer operated by monks. In fact, over succeeding centuries, the ownership and licences of the ferries passed through many different hands.

By the nineteenth century, a modern pier had been built at the Monks Ferry and, as more and more people from Cheshire needed to get to and from Liverpool, there were soon many more sailing points on the Wirral side of the Mersey. Soon, ferries were regularly crossing from Ince, Runcorn, Ellesmere Port, Eastham, New Ferry, Rock Ferry, Tranmere, Woodside, Seacombe, Egremont and New Brighton. The ferry services might have thrived, but making the crossing could still be a perilous undertaking. A passenger on the old sailing ferry boats wrote of his experiences:

> The passage of the river, until steamboats were introduced, was a complete and serious voyage, which few undertook. The boatmen used to run their boats at one time on the beach opposite the end of Water Street and ply for hire. After the piers were ran out they hooked on at the steps calling aloud, 'Woodside, ahoy.' or 'Seacombe, ahoy.' And so on.
>
> It is a fact that thousands of Liverpool people at that time never were in Cheshire in their lives. We used to cross in open or half-decked boats and sometimes we have been almost as many hours in crossing as we are now in minutes.
>
> I recollect once wanting to go to Woodside on a stormy day. The tide was running very strong and the wind blowing hard and after nearly four hours hard work we managed to land near the Rock Perch, thankful for our lives being spared.

The true source of motive power for this new age was steam. This would have its greatest global impact at sea and Liverpool would benefit from this technological leap forward before any other port. The first use of steam power on the Mersey was on the ferry boats, which revolutionised the service. The first paddle steamers operating on the river appeared in 1817. Over the next few decades all the sailboat ferries were replaced by paddle steamers and the number of routes across the river was gradually reduced, as towns on the Wirral became better connected by both road and rail.

The old Birkenhead Ferry went out of use around 1872 and the Monks Ferry pier was last used in 1878. A brand new landing stage with modern facilities was then built at Woodside in Birkenhead, only half a mile further downriver from the original Monks Ferry site, and the Mersey ferries still operate from this location today.

By the mid-nineteenth century the ferry services were either in the hands of private entrepreneurs or companies, but eventually they all passed to the control of the local authorities. The Birkenhead Ferry passed into the hands of the Birkenhead Corporation, while the Wallasey Ferries Company, which had

landing stages at Seacombe, Egremont and New Brighton, passed into the control of Wallasey Corporation. The ferries continued to operate across the Mersey, with all of them docking at the Pier Head at Liverpool. This made the Liverpool waterfront a very busy place indeed.

In 1964, the Liverpool pop group Gerry and the Pacemakers recorded the song 'Ferry 'Cross The Mersey'. This sentimental tribute to Liverpool, the River Mersey and the ferries reached No. 8 in the British Top Twenty. The song is now the anthem of the modern Mersey ferries and it plays on-board as passengers embark and disembark from the vessels. The service remains a very popular attraction for the millions of tourists who visit the waterfront each year. The berth for the ferryboats at Liverpool has also changed over the years but, during the peak years of their operation, they all berthed at the extraordinary Pier Head Floating Landing Stages. This was yet another of Liverpool's great innovations.

With the massive expansion in ferry services during the Victorian era, a safer and larger method of embarkation and disembarkation was needed at Liverpool. Also, there were ever greater numbers of travellers sailing regularly to and from the Isle of Man, Ireland and North Wales. To meet this demand, in 1847 the first floating wooden landing stage was built at the Pier Head at a cost of £60,000.

This was over 500 feet long and 80 feet wide and was named 'George's Landing Stage', after the adjacent dock. The stage was supported on thirty-nine iron buoyancy pontoons, each one 80 feet in length, 10 feet wide and 6 feet deep. These could be entered for inspection and maintenance via manholes in the deck surface.

Even so, this great quay was soon not long enough, especially as great transatlantic passenger liners using the port now wanted to dock directly at the central waterfront. So, in 1873 the George's Stage was extended with the addition of a new and even longer floating platform. Also largely constructed of timber, this was named 'Princes Landing Stage', after the nearby Princes Dock, which had opened in 1821. The combined landing stages, known locally as 'The Pier Head Landing Stage', now floated on the river on 200 huge pontoons. They were anchored to the land by a series of solid metal connectors, great chains and covered gangways, all allowing it to rise and fall with even the highest and lowest tides.

The landing stages, at the time of their construction and for many years afterwards, were the world's longest floating structure and they stretched for almost half a mile from Mann Island to Princes Dock. A guidebook of 1904 described it as having 'Refreshment Rooms, Retiring Rooms, Telegraph and Telephone Offices and every convenience for passengers'.

In fact, this wonderful range of buildings, also mostly constructed from wood, included shops, covered waiting areas, lavatories, cafés, a post office, administration offices and shelters for the dock-hands and boatmen. Both landing stages housed a remarkable complex of services and structures. There were bell towers, fingerpost signs (indicating at which point along the stage the various ferry

boats were docking) and two-tier drawbridge gangplanks, allowing passengers to get on and off both the upper and lower decks of the ferries.

The full landing stage was also wide enough to take cars, lorries and heavy goods wagons, which would drive onto the stage down a remarkable floating iron roadway. This formed a fixed link between the stage and the land and was composed of a series of great metal plates, hinged together horizontally. This design allowed the roadway to respond to the movement of the waves and to rise and fall with the landing stage at the ebb and flow of the tides.

The Pier Head Landing Stage was always a bustle of thriving activity and commerce, with a hubbub of chatter and noise that washed over and around it, just as the River Mersey itself could wash over and around it when the weather was stormy or the tide was high. As a child, I was fascinated by the way the whole structure undulated with the movement of the river waves and how the buildings all along its length, which were connected to each other with overlaps and flexible joints, would move with it. All this accompanied by the creaks and groans of the old woodwork.

Whenever the weather was especially rough, the ferry boats could come in with a great hard 'thump' against the great rubber-tyre and woven-rope buffers. This would then drive the whole landing stage sharply backwards, occasionally knocking people off their feet as a result. This was great fun all round, at least for us kids.

As I write this, I recall the sound of the waves, the creaking of the landing stage, the roaring of the great diesel engines of the boats, the jostling of the crowds of passengers, the shouts of the men as they caught the ropes to tie up the vessels, the cries of the seagulls wheeling overhead and the salty smell of the great river.

I remember too, the thrill of watching the ferry boats coming and going and admiring the skill with which their captains guided them safely into dock against the jetty, whatever the weather conditions. And I miss it, because sadly this wonderful, exciting, evocative example of Victorian engineering ingenuity was demolished in the early 1970s. The great wooden floating landing stage was replaced by a much shorter and staggeringly arid concrete-and-steel structure. This has now been replaced within the last few years with a structure that is only marginally better.

Even so, and despite this small flaw, the excitement and glamour of the Pier Head has now returned to Liverpool, as the waterfront has seen major investment over the last decade. As we shall see later, the central river frontage has also been restored, redesigned and re-established as a major hub of commerce, community and entertainment.

9
Sailor Town

While the story of Liverpool is certainly one about the creation and growth of a major commercial conurbation and how this connected to the rest of Britain and the world, it is a story particularly about the port that still drives this. Most of all though, Liverpool's story is one about people. It is the tale of those who chose to make their homes and livings in the town and those who created and continue to build it.

The people at the town's core, of course, were the seafarers who sailed into and out of the port, to and from every country. These men are a very special breed indeed, especially those from Liverpool. They are people of courage who have a great curiosity about the world. They have a craving for risk and adventure, but they also have the imagination and soul to appreciate the wonder and majesty of the oceans and seas that cover the face of the globe.

Throughout the eighteenth and nineteenth centuries, Liverpool could certainly be described as being one of the most thriving yet depraved and dangerous nautical towns in the world, especially in the heart of the docklands and wharfsides of what became known as 'Sailor Town'. This was because everything in this district serviced seafarers and their ships and it was a place that ordinary folk would generally avoid.

The streets and alleyways of Sailor Town were right at the heart of Liverpool, surrounding the Old Dock, in an area of some 22 acres. It was bounded by Paradise and Hanover Streets, Lord Street and James Street, The Strand and Canning Place. This is the area now largely covered by the modern Liverpool ONE retail and leisure complex. Throughout the eighteenth century in particular though, this was a densely packed and heavily populated area of around fifty inns and taverns. There were also dozens of cheap lodgings and bathhouses, barbers and tattooists, warehouses and workshops, sail and rope makers, and ships stores and workshops.

There were also lots of places of entertainment, including dance halls, freak shows, fortune tellers and, of course, brothels. Around 50 to 75 per cent of

a sailor's pay was spent in the taverns and brothels of Sailor Town, in which prostitutes catered to even the most international and varied tastes. They had to, because seafarers came to Liverpool from every country and they often brought with them some very exotic customs. With the rapid growth of Liverpool, from the mid-nineteenth century, a further 70 acres were added to Sailor Town, when it spread southwards beyond Canning Place. This now covered an extra area bounded by Park Lane, St James Street, Parliament Street and Wapping, where there were dozens more brothels and around 112 more taverns.

Seamen were 'paid off' at the end of every voyage and they would then stay ashore for only as long as their money lasted, when they would seek a berth on another ship. Their pay could be anything between £4 and £50 for a single voyage, which was a huge amount at that time. In 1877 alone, 100,000 seamen were paid off in Liverpool, and tavern landlords, as well as the keepers of boarding houses and brothels, would compete fiercely for the sailors' custom.

Mariners of every shape, size, skin colour and language, mixed freely and in the kind of companionship that comes from being a member of a community that encompasses the world: the community of the sea. Of course, fist fights were frequent and drunkenness commonplace, because the life of a sailor, especially during that period, was a difficult one. The phrase 'they worked hard and played hard' may be a cliché, but it is appropriate. This was yet another aspect of Liverpool's dockland life that made a powerful impression on Herman Melville:

> In the evening, especially when the sailors are gathered in great numbers, these streets present a most singular spectacle, the entire population of the vicinity being seemingly turned into them. Hand-organs, fiddles and cymbals, plied by strolling musicians, mix with the songs of the seamen, the babble of women and children and the groaning and whining of beggars.
>
> From the various boarding houses, each distinguished by gilded emblems outside – an anchor, a crown, a ship, a windlass or a dolphin – proceeds the noise of revelry and dancing; and from the open casements lean young girls and old women, chattering and laughing with the crowds in the middle of the street.
>
> Every moment strange greetings are exchanged between old sailors who chance to stumble upon a ship-mate, last seen in Calcutta or Savannah; and the invariable courtesy that takes place upon these occasions, is to go to the next spirit vault and drink each other's health.

By the beginning of the nineteenth century, the population of Liverpool had risen to 77,653, but if the average number of seafarers in port was added to this, together with the number of other transient workers, then the figure would be nearer 90,000. In 1800, the number of ships that entered the port was 4,746 and there were now five large wet docks.

Sailor Town was a thriving maelstrom of life and living as seamen spent their pay and indulged every appetite, ready to take to the seas again on voyages that might last for years before they would see their homes again, that is if they had homes.

A Life on the Ocean Wave

To give a flavour of the life of a Liverpool sailor during Britain's commercial and industrial revolution, there are two aspects in particular that best exemplify this: the Privateers and the press gangs.

Liverpool has never been a Royal Naval Port; it was instead the centre of the international freebooting merchant shipping trade. From the early 1700s, until around 1850, Liverpool made a great deal of money from sailing ships known as 'Privateers'. These were heavily armed cargo vessels owned by private individuals or companies who had been granted a 'Letter of Marque' by the British Admiralty. These documents gave captains the authority to 'apprehend, seize and take the ships, vessels and goods' of the nation or nations with which Great Britain was currently at war, and we were usually at war with some country or other – generally the French.

Even though privateers were not officially naval vessels or warships, they would attack any foreign merchant vessel, especially if isolated and unarmed. And privateer captains left little to chance. During the mid-eighteenth century, there were quite a number of such vessels licensed to operate from Liverpool, including the *Thurloe* with 100 men and twelve cannon, the *Terrible* and the *Old Noll*, each with 180 men and twenty-two cannon. Manned by skilled gunners, they wreaked havoc on foreign merchant ships, killing many sailors and claiming vast quantities of booty.

This was also the time of the wars with America and by 1779 Liverpool was home to 120 privateer vessels, owned by entrepreneurs and investors for whom the financial returns could be vast. But by this time, foreign merchant ships were being protected by warships from their own countries, often now much more heavily armed than the privateers. But what did it matter if a Liverpool merchant lost one or two vessels and their crews? It only took one successful venture to make a fortune, because life was cheap and profit was all.

To obtain a berth on such a ship was a main goal for many Liverpool seafarers, because there would be adventure aplenty. Sailors could also return from such a voyage with purses bulging with gold from their share of the bounty. They then spent money in the port, thus supporting the local economy. The shipowners also paid anchorage fees and customs duty, so Liverpool Town made a great deal of money from this legalised, government sanctioned piracy.

Sailor Town became notorious for often being awash with rough, tough, salty sea-dogs, with their cutlasses, pistols and their fists ever at the ready to take advantage of any potentially profitable situation. One contemporary description of a typical privateer crew stated,

> What a reckless, dreadnought dare-devil collection of human beings, half disciplined, but yet ready to obey every order, the more desperate the better. Your true privateersman was a sort of half horse, half alligator, with a streak of lightning in his composition, something like a man-of-wars man, but much more like a pirate.

Generally with a super abundance of whisker, as if he held with Sampson that his strength was in the quantity of his hair.

'Piracy for fun and profit' was the name of the game and it was said that 'there was scarcely a man, woman, or child in Liverpool, of any standing, that did not hold a share in one of these ships'.

While this form of seafaring meant that wages were higher and there was always the possibility of prize money, life aboard ship was indeed harsh.

During this period, if a boy wanted to make a life for himself at sea then he would need to do so from the age of thirteen or fourteen. Throughout their teenage years, such volunteers would train at the hands of older seamen, often as apprentices to learn specific skills. Or they might sign on-board as a ship's boy, learning as much as they could as they acted as a general dogsbody on the voyage. By the time these young men reached their early twenties they were known as able seamen; simply because they were fit, strong, able to climb ropes and rigging and play their part in keeping their vessels afloat during squalls, tempests and tornadoes.

Mariners had to be able to cope with extremes of temperature, especially as many ships sailed wherever trade was most profitable, no matter how inhospitable a climate this might have. Heat stroke and sunburn were common, as were hypothermia and frostbite. Sailors could be at sea for anything from three weeks to three months, or sometimes for years, and you could well spend an entire voyage mostly wet through.

The food on-board ship was not generally very good and a lot depended on the generosity of the shipowners and captains, who decided what provisions a vessel would carry. Mostly though, how a sailor was fed depended on the skill or otherwise of the ship's cook, who was not usually a capable chef. Often he would only know how to boil or stew food.

A basic diet would consist of salted pork or cured ham and dried vegetables, unless fresh food could be bought in whatever ports the vessels visited. Fresh fruit, especially lemons and limes, were important though, because this kept the dreaded disease of scurvy at bay. Ship's biscuits were standard fare as they could fill otherwise empty stomachs, even though they were hard and dry and often infested with weevils. Light ale (known as small beer) was drunk more at sea than water, as this would stay fresher longer.

Most of the work on-board ship was strictly physical; on sailing ships in particular. A sailor's job would consist mainly of constantly maintaining and adjusting rigging and of furling and unfurling sails. On three- or four-masted ships, men could often be working at heights of over 150 feet. Falls were frequent, especially in rough conditions and as men got older and weaker. If they fell from a height into the sea then they might survive. If they fell to the deck they would be killed outright if they were fortunate. If not, then they were likely to be horribly crippled and forced to beg for a living for the rest of their lives.

In fact, death at sea was commonplace; from storm and shipwreck, disease, starvation, brutality, enemy action and by simple accident. Although battle

casualties were particularly high in the Royal Navy, they were nothing compared to the number of deaths from having to live in cramped, damp, unhygienic and vermin infested conditions as well as from diseases such as smallpox, tuberculosis, malaria and typhus.

If there was a death on-board ship, then a burial at sea would take place if there was a body. However, this was something that every sailor dreaded, because there was no guarantee that the angels would know where to find his soul at the bottom of the ocean and so would not be able to carry him up to heaven. Even as Captain Horatio Nelson (1758–1805) lay dying at the Battle of Trafalgar, after he asked Captain Hardy to kiss him, he also whispered, 'Don't let them bury me at sea.' His body was indeed brought back to England (preserved on-board in a cask of brandy) and he lies at rest in St Paul's Cathedral. But for an ordinary seaman, Davy Jones' Locker would often be his final resting place.

He would be sewn up in his own hammock, with the last stitch through his nose to ensure he was dead, and would stay in his canvas coffin. Weights or a cannonball were placed inside with him to make sure he would sink to the bottom and not simply be eaten by sharks or other fishes.

If a sailor from Liverpool died at sea and left children, they could be taken into the Seaman's Orphanage, which, though closed now, still stands in Newsham Park in the city. Opened in 1864, this might be necessary even if the seaman had a widow. Without his wage coming in, she herself would be destitute, so the children would have nowhere else to go.

A particular feature of the operating policy of the orphanage, and one that was quite revolutionary for the time, was that children of all nationalities were accepted and welcomed. However, in keeping with the prevalent Protestant work ethic and the Victorian concept of 'the deserving poor', the regime was strict and the children were educated towards a life of unimaginative work. Boys were kept until the age of fourteen and taught a variety of basic trades, while the girls were kept until the age of fifteen, when they were sent into domestic service.

'Hawks Abroad'

Life at sea was indeed hard, but life on land could be equally brutal for merchant sailors. It could also be just as dangerous for able-bodied men who had never been to sea and who never intended to set sail. This is because both kinds of men were at risk when the 'press gang' was operating in the port.

During the eighteenth and early nineteenth centuries in particular, the British Royal Navy was the strongest and largest in the world. But, to ensure that Britannia continued to 'rule the waves', she had to fight other ambitious countries and their navies. Life aboard royal naval vessels was particularly cruel and often far too short; much more so than on merchant vessels.

This meant that regular recruits were needed to keep up crew numbers aboard naval vessels, but volunteers were very few and far between. This was because

Fighting off the press gang.

Navy sailors lived on-board in especially cramped and unhygienic quarters, were ill fed, poorly heated and underpaid. They were also exposed to the threat of violent death at war or by shipwreck in storms, and naval discipline was brutal. Death was the penalty for most crimes, while punishments for even the most trivial offences could also often be casually fatal and usually involved flogging with the 'cat-o'-nine-tails'. This consisted of nine thin ropes, each about a yard in length, bound together at one end to form a handle. Each rope was waxed with a large knot at the end and other knots along their length.

When repeated lashes were forcefully 'laid on' by a burly bosun in front of the entire crew assembled on deck, the torn flesh of the victim caused him great pain and the resultant bleeding and shock might kill him. Those who survived this beating were then dragged below decks to have salt rubbed into the wounds. This was ostensibly to prevent infection, but it only exacerbated the torment, hence the proverbial phrase. Another pitiless punishment was 'keelhauling'.

Although not an official punishment in the British Navy, it was nevertheless carried out by more sadistic captains. This involved the sailor being tied to a rope that was looped under the ship. He would be dragged from one side of the ship to the other or from the front to the back (stem to stern). However, because the keel was usually covered in barnacles and other marine growths, this would result in severe cuts and bruises at least, or even mutilation or amputation. If the unfortunate matelot was pulled slowly it was likely that he would drown.

This was all well known and deeply repellent to ordinary men as well as to experienced merchant seamen. These sailors were used to much more freedom

and relaxed discipline at sea and to the opportunity for booty and profit. So, in order to maintain acceptable levels of manpower in the Royal Navy, the government found it necessary to forcibly enlist preferably experienced men into the 'Senior Service'. Because Liverpool was such a significant port, with large numbers of ships coming into harbour every day, the town was a prime target for the press gang.

Although often far too late, the alarm cry of 'Hawks abroad' would be shouted through the narrow cobbled streets and alleys, warning the people that the dreaded press gang was in the town. These teams of brutal and extremely violent men, under the authority of the king, would roam the streets at night, leaping on unsuspecting, solitary passers-by, or those coming into and out of taverns and inns. Often clubbed and then bound, these innocent men would be abducted from their homes and jobs with little hope of escaping their fate. They could be away at sea often for years, if they were ever seen again.

Being 'impressed' into the Royal Navy had has nothing to do with 'pressing' in the sense of 'forcing', but derived from the 'prest' or 'imprest' money (French 'preter': 'to lend') that was paid to the men once on-board ship, rather like the 'King's Shilling' in the Army. During this period, pressed men made up about half of every Royal Navy ship's crew. The press gang also brazenly prowled the town in broad daylight, literally tearing men away from their wives and children.

> But woe is me. The press-gang came,
> And forc'd my love away
> Just when we named next morning fair
> To be our wedding day.
>
> 'The Banks of the Shannon', Irish Ballad (1785)

A contemporary report from eighteenth-century Liverpool vividly describes the activities of the press gang:

> Fierce, savage, stern, villainous-looking fellows were they, as ready to cut a throat as eat their breakfast. What an uproar their appearance always made in the street. The men scowled at them as they passed; the women openly scoffed at them; the children screamed and hid themselves behind doors or fled round the corners.
>
> And how rapidly the word was passed from mouth to mouth, that there were 'hawks abroad', so as to give time to any poor sailor who had incautiously ventured from his place of concealment to return to it.
>
> But woe unto him if there were no warning voice to tell him of the coming danger; he was seized upon as if he were a common felon, deprived of his liberty, torn from his home, his friends, his parents, wife or children, hurried to the rendezvous house, examined, passed and sent on-board the tender, like a negro to a slave ship.

And so it went on, until the floating prison was filled with captives, when the living cargo was sent round to one of the outports and the prisoners were divided among the vessels of war, which were in want of men.

Apart from kidnapping men on land, the thuggish gangs also seized merchant sailors from ships at sea or in harbour. The threat of being abducted by press gangs was so real in Liverpool that merchant sailors frequently and literally 'jumped ship', as their vessels sailed into the river and approached the port. They would swim across the Mersey to reach the relative safety of the Wirral shore, where the gangs did not operate. By the law of the day, impressed men had no redress. In fact, 'failure to allow oneself to be pressed' was punishable by hanging. This meant that if you were not fast enough to run away from the gangs, or strong enough to extricate yourself from their relentless grip, then you were at their mercy, unless your friends and neighbours came in to fight on your behalf.

And this was often the case in Liverpool, whose citizens were determined to prevent the press gangs succeeding in their ruthless work. Pitched battles between the press gangs and groups of townspeople were frequent and bloody, as local men would often fight to the death rather than fall into their clutches. But such victories were very few and far between.

With the end of the Napoleonic Wars in 1815, the activities of press gangs steadily reduced, although the British Navy still relied heavily on this method of 'recruitment' until the 1830s. By this time though, thanks to the work of outstanding seamen such as Admiral Lord Nelson, conditions for ordinary seamen in the British Navy had steadily improved, as had their rates of pay. The Royal Navy was now finding itself manned more and more by volunteers and career sailors.

Even though impressment has not, strictly speaking, ever been formally abolished, by the middle decades of the nineteenth century, the press gangs were no more. This was to the great relief of merchant seafarers and ordinary able-bodied men in ports around Britain and to their wives and families, but especially in Liverpool.

Steam on the Seven Seas

Despite what was certainly a hard if not brutal life, seafaring was a popular profession for young men. Life on-board ship compared very favourably to work ashore, which was generally poorly paid, in appalling conditions and extremely exploitative. Because of this, shipowners and captains had no difficulty whatsoever in fully crewing their vessels, especially in ports like Liverpool.

Before long, conditions for ordinary seafarers, as well for those in the Royal Navy, were also about to improve. This was because the days of sail were passing and the age of steam was dawning. From being used on short distances in smaller vessels such as on the Mersey ferries, the technology of steam engines had quickly developed. Soon, great paddle steamers were sailing across the oceans of the

world. Voyages were now going to be quicker and more predictable, ships and therefore the size of their cargoes became larger and the age of the passenger liner began to dawn. Also, conditions on-board these ships were not only much more comfortable for passengers, but also for their crews.

But standards were already improving on sailing ships too, especially as the demand for transatlantic passenger services developed. Also, a new breed of dynamic shipowner was now using Liverpool as a base for their businesses and trade became worldwide and highly competitive. Many great shipping lines were either founded in the town, or they set up their headquarters here at this time. Or they simply ensured that their vessels used this gateway to the world, especially to America.

Indeed, even as early as 1817, the American Black Ball Line, based in New York, began some of the first regular passenger trips between its home town and Liverpool. They sailed in both directions twice each month and the journey time took, on average, twenty-three days from New York to Liverpool, but around forty days the other way round. By the 1830s, the demand for passenger vessels had increased so much that companies such as the Red Star Line and the Swallow Tail Line had been established to meet it.

Apart from voyages of exploration that could take years, ordinary commercial journeys that once took months, now took only weeks or even days under the power of steam. Also, with the continuing development of the port, even more shipping lines were being established. Many of these soon grew in importance, making world-famous names such as White Diamond, Cunard, White Star, Blue Funnel, Harrison, Booth, Ocean Fleets, Elder Dempster, Holt and Bibby.

On Sunday 20 June 1819, the first steamship to ever cross the Atlantic arrived in Liverpool. This was the *Savannah*, which had crossed the Atlantic from America in only twenty-six days. She stopped off in the port on her voyage to St Petersburg in Russia, where she was being presented as a gift to Emperor Alexander. By August 1819, advertisements were published announcing regular sailings of the steamer *Robert Bruce* from Liverpool to Greenock in Scotland and of the *Waterloo* from Liverpool to Belfast.

The first steamship to cross the Atlantic from Liverpool under continuous steam was the *Royal William*. Sailing on 5 July 1838, she arrived in New York after a voyage of nineteen days, carrying thirty-two passengers. She left New York on her return voyage on 4 August 1838 and arrived in Liverpool on the 19 August after a voyage of only fourteen-and-a-half days.

One of the most famous transatlantic steamships was also the first vessel of the Cunard Line, which had originally been named the 'British & North American Royal Mail Steam Packet Company'. This was the RMS *Britannia*, the first transatlantic mail ship. She left Liverpool on her maiden voyage on 4 July 1840 and reached Boston in America on 19 July after a journey lasting just over fourteen days. The first steamship to be built entirely of iron was the SS *Great Britain*. Designed by the renowned Victorian engineer Isambard Kingdom Brunel (1806–1859), she too sailed on her maiden voyage from Liverpool. This was on

26 July 1845 with forty-five passengers aboard. She arrived in New York on 10 August 1845. However, the story of the age of great steamships is not entirely a tale of triumph.

Brunel also designed the *Great Eastern*, which first set sail in 1859. This huge vessel was 770 feet long and weighed 22,500 tons and she paid her first visit to Liverpool on 4 June 1861. Designed as a passenger vessel, she was prone to major breakdowns and from 1865 she was reduced to laying the first transatlantic telegraph cable on the bed of the Atlantic. Known as 'Brunel's Folly', the *Great Eastern* ended her days in 1886, anchored in the Mersey and being used as a giant advertising hoarding for the Liverpool department store Lewis's. She was eventually towed to Rock Ferry on the Mersey and between 1888 and 1889 she was broken up. The ship's tall flagpole now stands in front of Liverpool Football Club's ground at Anfield.

By the 1890s, steam power had transformed seafaring and maritime commerce in terms of speed and cargo capacity. However, sailing ships remained dominant in Liverpool until the last decades of the nineteenth century, when the docks were expanded to accommodate the larger steamships.

But the lives of seafarers were also changing because of steamships. As voyage times were now faster, sailors were becoming much less transient. Many more of them, from around the globe and of all races and creeds, were now settling permanently in the town. They were marrying local women and setting up home, and because they were now away at sea for much shorter periods of time, they were returning home more frequently and so could raise families. Sailor Town and the culture and communities of Liverpool were beginning to change forever.

As the nineteenth century drew to a close, living and working conditions for people on land, as well as at sea, steadily began to improve and the excesses of Sailor Town were steadily being addressed. Dock and Town Police Constables now patrolled these areas, and charitable institutions did their best to offer more savoury and safe alternatives to the resources on offer around the docks. The majority of sailors were only too willing to take advantage of these and especially the secure, comfortable, clean and affordable accommodation provided by the Seaman's Home, which stood on Canning Place.

This had opened in 1852 to provide sailors of every nationality and faith with a place to stay while in port. Here, they could keep out of the clutches of footpads, cardsharps, pickpockets and others who were waiting to rob or cheat them out of their pay. Inside this tall, imposing building were three levels, each with forty-four wooden-walled rooms on the landings. These had been designed to look like ship's cabins to make the sailors feel at home and each one measured 8 feet by 5 feet and was 7 feet high.

On each level there were thirty-five lavatories and three wash basins and the home was very popular and always full. In fact, in 1885 alone, 9,954 men stayed here at a cost of fifteen shillings a week for able seamen and ten shillings for apprentice sailors and ship's boys.

This was one of many examples of how seriously port and town officials were now taking the welfare of seafarers in Sailor Town. But, by the late twentieth century, the home was no longer needed. As we shall see, by this time the port and city of Liverpool were going into a rapid decline and sadly the Seaman's Home closed in 1969 and was demolished soon afterwards.

However, it was also during the eighteenth and nineteenth centuries that Liverpool's wharfs and quaysides became a seething mass of humanity, coming into and travelling out of the port, each seeking a new life with hope or desperation in their hearts. Liverpool was now indeed 'the crossroads of the world'.

10

'Give Me Your Tired, Your Poor, Your Huddled Masses …'

Liverpool was created by people who came to the town from somewhere else and this has continued over the centuries. However, this reached a particular peak during the Industrial Revolution, when the face and fabric of Britain, and of Liverpool, was changed forever.

People now moved from the rural countryside as never before, and in their thousands. Often poor and desperate, they came seeking work and opportunity in the new manufacturing towns and ports around Britain. Not only were tens of thousands of people now coming into Liverpool from the surrounding countryside, but millions were also coming to the town from countries outside Britain. They were using the port as their gateway to, hopefully, a better life. From Liverpool, they would take ship, principally to the 'New World' of America. This was a young country and, rather like Liverpool, it was being built on immigration. If a fresh start was possible anywhere, these migrants believed it would be in this fledgling nation.

The Port of Hope

Emigration to America had begun almost as soon as the first British colonies had been established there in the seventeenth century, increasing during the eighteenth century. However, once America gained her independence in 1776, the number of migrants increased rapidly, reaching a peak between 1840 and 1914. During these long decades, almost 35 million Europeans left the old world for the new. Of those, 4,750,000 passengers sailed from Liverpool on ships owned by companies like Cunard and Inman. In 1887 alone, 199,441 emigrants sailed from the port. Almost 69,000 of these were from continental Europe; over 62,000 were British and more than 68,000 were from Ireland.

Even though the ports of London, Bristol and Glasgow saw emigration on a large scale, most migrants passing through Britain chose to sail from Liverpool.

Many came from Scandinavia and Germany and large numbers also came from China. In addition to small numbers travelling from the countries of Africa and the Middle East, most migrants were arriving from Austria-Hungary, Italy, Eastern Europe and Russia.

These people were leaving behind lives that were often nothing more than painful existences. People were escaping exploitation, political unrest, war, religious persecution, starvation, or poverty. They came to Liverpool with hearts full of hope, even if their pockets were largely empty. They came seeking a new beginning for themselves and their families in America; perhaps to begin a new enterprise, to improve their job prospects, or simply for a chance of improving their quality of life.

Consider what was truly involved for these people in their attempt to transform their lot in life. First, after leaving behind their loved ones and all they had known in their homelands, they had to make their way to England. They next faced the uncertainty and confusion of the journey across an unfamiliar country where the language and customs were strange. Then, once in Liverpool, these confused and uncertain travellers, many of them only rural peasants and most having little or no English, would be overwhelmed by the size, noise, pace and pressure of the great port.

Upon arrival, they were immediately inspected by medical officers. This was to ensure that they were not bringing infections into the town and to safeguard against them exporting contagion when they left. Also, like the transient sailors on the wharves and dockside roads, they too would have to endeavour to avoid the pickpockets, swindlers and others who would try to take advantage of them.

The poorer passengers who were travelling to America had to find, as well as money for their onward tickets, temporary accommodation in the town as they waited for their ships to sail, and food and supplies for their voyage. Once aboard ship of course, unless you were exceptionally rich, the amount of supplies that you could bring was limited by what you could afford and manage to carry and by what the master of each vessel would allow. After undergoing the further indignity of personal searches, they would then finally board their vessels and try to find a secure place to call home while aboard ship.

The wealthier passengers on these transatlantic vessels would spend their journeys in very comfortable first class accommodations with private cabins and other luxuries. Some migrants might be able to afford second-class cabins, with bunks instead of beds and no luxuries at all. However, most would be travelling in third class, which were communal berths with very few facilities. These were often called the 'steerage' compartments, because this was the lowest deck of a passenger vessel, through which the control lines of the rudder ran.

In the days before steam, these voyages could take weeks depending on the weather conditions. Steerage passengers would do their best to make themselves comfortable and keep occupied, in what were invariably dark, overcrowded, largely unhygienic and unpleasant surroundings. They would also have to compete for space with ropes, yards, sailcloth and other ship equipment, which were all stored below decks.

Also, for many of these 'innocents abroad', their closer and more intimate contact with the sailors and the habits of these hard-drinking, swearing, coarse and rough men, would have been a major culture shock. Conditions would become intolerable if the weather was bad and storms afflicted their voyage, because lavatory and washing facilities aboard ship would have been in very short supply. But, in finer weather, passengers could at least go up on deck to take the air and get some exercise.

It is easy then to understand the high emotion that the travellers must have felt as their ships sailed into New York Harbour and from 1886 as they saw the magnificent Statue of Liberty waiting for them with all that she promised. However, once docked in New York, they would then have to undergo the rigours of the immigration procedures at Ellis Island before facing the rest of their journey and a hopeful, if uncertain future. The inscription on Lady Liberty reads,

> Give me your tired, your poor,
> Your huddled masses yearning to breathe free,
> The wretched refuse of your teeming shore.
> Send these, the homeless, tempest-tost to me;
> I lift my lamp beside the golden door.

Of course, it was not only the 'tired and huddled masses' that were crossing the Atlantic Ocean (and the rest of the Seven Seas), but also the wealthy of the world who, by the end of the nineteenth century, were taking advantage of the rapidly increasing availability of international luxury liners, now sailing the oceans for both business and pleasure.

While migrants had always been an essential element of the history and character of Liverpool, in the pre-Victorian era, their periodic arrivals had seldom had a significant impact. During the nineteenth and early twentieth centuries though, people from many overseas countries were not just passing through the port, they were also coming to Liverpool to make it their home. However, it was when one particular community of desperate people arrived at the port, in incredible numbers, that the existing infrastructure of the town was overwhelmed.

The Great Hunger

The exploitation of the Irish by the British goes back to medieval times, in fact to King John's invasion of that country, for which he used Liverpool as a base. This oppression continued during the Tudor and Stuart monarchies and on through the Civil War. It reached a peak during the time of Cromwell and the Commonwealth when the brutality of the invading and occupying armies was inhuman and catastrophic.

Exploitation of the Catholic Irish peasantry persisted through to the eighteenth and nineteenth centuries, when the British Crown granted vast Irish estates to

Protestant absentee landlords. This even exceeded the exploitative practices of previous centuries. These landowners, for the most part, were only interested in extracting as much wealth from their holdings as possible without putting anything back into the local economy or community.

Ireland is a fertile country and, during this period, large quantities of wheat and other crops were grown there. However, the vast bulk of this produce was being exported to England for the enrichment of the titled estate owners. These exports also included most of the livestock, which would either be shipped live to be slaughtered in Britain, or after being killed in Ireland the salted carcasses would find their way to English butchers and the dining tables of the wealthy.

The Irish peasantry never had access to any of this produce and they could not have found the money to pay for it even if they had been allowed to buy it. This left only potatoes for the Irish people to live on and by 1840 this was literally the only food available for almost half of Ireland's population of 8 million. But then in 1845, and again in 1846, an almost nationwide blight completely ruined the potato crop. The leaves on potato plants suddenly turned black and shrivelled and began to rot. This process produced a foul stench, which was described at the time as being 'like the miasma of death that washes the mortuary corpses'.

An airborne fungus (*Phytophthora infestans*), unknowingly carried into Britain on ships from North America, was now blowing across the Irish Sea from England. The infection then spread quickly throughout the potato fields around Dublin and the plants then fermented, providing food for the mould to thrive. As the spores rapidly multiplied, the winds then carried the pestilence all around the country and a single contaminated potato plant could infect thousands more in just a few days. This caused dreadful suffering and an eyewitness who visited a poor hovel in which one family of these starving peasants was living, reported,

My hand trembles while I write.

The scenes of human misery and degradation we witnessed still haunt my imagination, with the vividness and power of some horrid and tyrannous delusion, rather than the features of a sober reality.

We entered a cabin.

Stretched in one dark corner, scarcely visible, from the smoke and rags that covered them, were three children huddled together, lying there because they were too weak to rise;

Pale and ghastly, their little limbs – on removing a portion of the filthy covering – were perfectly emaciated – eyes sunk, voice gone and evidently in the last stage of actual starvation.

Crouched over the turf embers was another form, wild and all but naked, scarcely human in appearance. It stirred not, nor noticed us.

On some straw, soddened upon the ground and moaning piteously, was a shrivelled old woman, imploring us to give her something – baring her limbs partly, to show how the skin hung loose from the bones, as soon as she attracted our attention.

Above her, on something like a ledge, was a young woman, with sunken cheeks – a mother I have no doubt – who scarcely raised her eyes in answer to our enquiries, but pressed her hand upon her forehead, with a look of unutterable anguish and despair.

Even though there had been many outbreaks of famine in Ireland during the early part of the nineteenth century, already forcing many people to leave the country for England and Scotland, nothing had ever been as bad as the plague that now swept across the land. The Great Irish Potato Famine, which in fact lasted from 1845 to 1852, killed 25 per cent of the Irish population; almost 2 million men, women and children. Two million more emigrated to America and 1,300,000 of these came through Liverpool.

Travelling in desperation and hunger from Belfast or Dublin to Liverpool in overcrowded sailing ships could take a long time if the seas were particularly rough or there were storms. Many of the people on these voyages were already so weakened from starvation that they did not survive the journey. The ships bringing the Irish into Liverpool became known as 'coffin ships' as a result.

Once docked in Liverpool, many ship's captains told the uneducated Irish that they had now arrived in New York. The busy streets with their crowds of people, wagons, horses, omnibuses, tall buildings and warehouses, convinced these poor people that Liverpool was indeed America. They had paid for a passage across the Atlantic and as far as they knew, the Irish Sea was that great ocean. Now they added being swindled and abandoned to their long list of sufferings.

Those that could not afford to continue their journey to either the New World or other parts of Britain – and there were hundreds of thousands of them – were

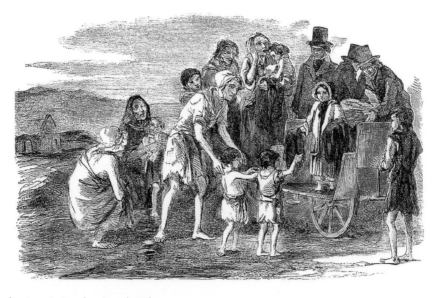

Irish famine victims leaving their homes.

forced to remain in Liverpool. Those Irish immigrants that were able to, settled in the now rapidly developing slums around the docks, all trying to find work where they could. Others moved into the northern town centre districts of Vauxhall and Kirkdale and the Scotland Road area. Many others sought refuge out of town and established themselves in some of the outlying districts and villages of Liverpool. These swelled dramatically the populations in semi-rural communities, such as Woolton, Garston and Wavertree.

Around 344,000 Irish stayed in Liverpool, which put intolerable pressure on what was an already heavily overburdened infrastructure. This resulted in thousands of famine victims finding themselves in conditions no better than those that they had left behind. Most of these people were forced to live, at best, in squalid, disease-ridden rooms or cellars, and in courts. These were densely packed and overcrowded dwellings built around a communal yard. Some courts, but not all, might have access to a water supply and a shared lavatory, but these were seldom connected to any form of sewage system. At worst, they would find themselves on the streets as starving beggars.

This new and dependant population exponentially increased the spread of disease, poverty, crime and the social degeneration that followed in their wake. Also, while there were a few Protestants among the Irish, most of these immigrants were Catholic. They were coming into a Protestant town, so this added another layer of tension that the already overburdened indigenous people of Liverpool had to address. Over the next decades there were periodic outbreaks of sometimes very brutal sectarian violence on the streets of the town.

During the middle decades of the nineteenth century, the living conditions in the town were dreadful for the Irish, as well as for other immigrant peoples and for many of the indigenous working-class people of Liverpool too. This was simply because the sudden and dramatic increase in the population broke the town's ability to adequately provide for its citizens. Liverpool suddenly drew attention from the rest of Britain for all the wrong reasons.

The Black Spot on the Mersey

Because of an overwhelming lack of available and affordable accommodation, landlords could charge the highest rents. Before long, many more immigrant families, and native Liverpudlians as well, were being forced to occupy cellars, attics and outbuildings. As with the court dwellings, very few of these had access to any form of sanitation or to a fresh or untainted water supply. They were also often flooded, had no windows, and were infested with rats and parasites.

These slums provided Britain with some of its worst and most insanitary working-class housing. For example, in 1848, 118 people were found living in just one single court dwelling and, in 1851, at least 1,544 people were living in just one street, with an average of eleven people per house. A report written at the time

Court dwelling.

recorded that in the cellars alone some 30,000 people were eking out an existence. These were typical figures for the period, but they took no account of the transient, mainly seafaring population who added to these figures considerably. This made the actuality even worse than the statistics revealed.

Unemployment levels rose and there was now so much labour available that employers could get away with paying the lowest wages. People worked on the Leeds & Liverpool Canal and in the warehouses and industries that grew up around it. They also worked on the docks and the railways and by the late 1840s, in the workshops, rope-works and iron foundries, as well as in the soap, alkali and chemical factories of the central and northern districts of the town. Sometimes the employers and landlords were the same individuals, so poverty, starvation and disease were also rife among the exploited working people.

The population was now becoming densely packed. As well as the courts and cellars, they were mostly living in ranks of streets with terraces of increasingly squalid, back-to-back houses and tenements. Between 1841 and 1851, 4,000 additional houses were built in the Vauxhall Road and Scotland Road area to meet the increasing need for cheap rented accommodation. Even so, this was not good-quality housing and these also became quickly overcrowded.

Because of this insanitary overcrowding, a catastrophic cholera outbreak struck Liverpool in 1849, killing around 5,000 people. The frequent, if localised outbreaks of this and other killer diseases was like a latter-day plague all over again, only now with even greater loss of life.

The average life expectancy in the poorest districts of the town was seventeen years of age. By comparison, life expectancy in similar districts of Manchester was

twenty years of age, and in London poor people might expect to live to the age of twenty-six. Over 50 per cent of deaths in Victorian Liverpool were of children under the age of five. In the Irish Catholic areas of the town, which were the most densely populated, the death rate was 50 in 1,000.

The corporation of Liverpool knew that this squalor and disease could not be allowed to continue and they realised that they had the responsibility for taking action. The town had become a victim of its own success and they could not have predicted the massive and sudden increase in its population. Neither could the corporation have expected the resulting social and public health issues; Liverpool had been taken by surprise. Nevertheless, the town rose magnificently to the challenge and once again demonstrated its ability to be visionary, innovative and dynamic.

In 1847, within two years of the first of the Irish famine victims arriving, three remarkable men had been appointed by the corporation with a very clear brief to address and remedy the issues. Each of these new professionals was the first in the world in his profession and their roles and methodologies would soon be copied around Britain and the world.

These men were Dr William Henry Duncan (1805–1863), both Liverpool's and the world's first medical officer of health; James Newlands (1813–1871), the first borough engineer; and Thomas Fresh (1803–1861), a former policeman, who was appointed as inspector of nuisances – the world's first environmental health officer.

Duncan recognised immediately that there was a clear link between housing conditions and the outbreak of diseases, such as cholera, smallpox and typhus. It was he who named his town 'the Black Spot on the Mersey' and described it as 'the most unhealthy town in England'. He and his new colleagues faced a seemingly insurmountable task, which would take decades to address fully, but these were determined and skilled professionals. They and their staff began to tackle the problems of poor housing and sanitary provision in the town. They encouraged the corporation to clear away the cramped, unsavoury slum dwellings and to replace them with spacious and well-ventilated new housing.

As time passed, and as social and housing conditions steadily improved, many homes were connected to the gas supply. This had been available in Liverpool since 1817, but had then only been available to the wealthier classes. Electricity was also brought to Liverpool in 1883 by the Liverpool Electric Supply Co. Ltd.

But the fight against poverty, squalor and disease, throughout nineteenth-century Liverpool, was not simply left to the town corporation. People also began to help themselves and each other. Working in the poorer areas of the town as well as Duncan, Newlands and Fresh, one of these remarkable people was a washerwoman named Kitty Wilkinson (1786–1860). Kitty lived in the Vauxhall district, in Denison Street, and worked entirely as a volunteer, or for just a few coppers if people could afford to cover her costs, nursing cholera and typhoid victims in the district. She also washed their clothes and soiled bed linen in a large copper boiler that she heated over a fire in her kitchen.

With no regard for the risks to her own health, as well as nursing the sick and diseased and assisting the few heavily overworked local doctors, each morning Kitty made enough porridge to feed sixty people. She also gave up her own bedroom so that twenty children whose parents had the fever might themselves be washed and tended there. She had been an early refugee from Ireland and was regarded as a saint by the local people among whom she lived as well as cared for.

Because of her tireless work with the poor on personal hygiene and washing, which had already become well known in the town, the corporation paid for the building of a large network of public baths and washhouses throughout Liverpool. The first of these opened in Frederick Street as early as 1842. Kitty and her husband Thomas became its first managers. These important new facilities, together with the work of Duncan, Newlands and Fresh, soon began to radically improve public health and sanitary conditions.

Kitty Wilkinson continued to work voluntarily with the poor of Liverpool and died in 1860 at the age of seventy-three. A heroine to the ordinary people of Liverpool, she lies buried in St James's Burial Ground at the foot of Liverpool's great Anglican Cathedral. Here, in the Lady Chapel, she is commemorated in a stained-glass window. An inscription reads: 'Indefatigable, self-denying, she was the widows' friend, the support of the orphan, the fearless and unwearied nurse of the sick and the instigator of public baths and wash houses for the poor.'

City of Sanctuary

Despite the poverty and problems that afflicted Victorian Liverpool, as they did every other British conurbation during that period, people from all over the world still chose to come to the town seeking a better life. To them, Liverpool remained not just a place of hope, but one of sanctuary.

In fact, even throughout the eighteenth century, many black people had begun to set up home in Liverpool. Many more came following the abolition of the slave trade in 1807. Not all of these people were emancipated slaves or even servants; they worked in the town as sailors, craftspeople of all kinds and also as accomplished musicians and writers, or as businessmen and traders in their own right. These people were the founders of the longest-established black community in Europe.

Black migrants to Liverpool first settled in the densely packed streets around Pit Street and the South Docks. As their numbers increased, they also began to move into the ranks of terraced houses that once rose from there, lining the flanks of St James's Mount, upon the summit of which the Anglican Cathedral would eventually take its dominant place.

It was also around the beginning of the nineteenth century that people of other racial and ethnic origins began to settle permanently in the town. It was from this time that the ethnic and cultural diversity that so characterises Liverpool began to take shape.

Most of these first immigrants were sailors, for whom living in Liverpool held particular advantages. All of the important international shipping lines had their headquarters, or at least major branch offices, in Liverpool and generally it was from these that wages were paid out directly in cash. All sailors had to come to the town for their money and here they spent it. Also, because of the large number of shipping lines in the town and the endless supply of vessels sailing with all kinds of cargo to all parts of the world, work for them in Liverpool was more readily available.

As these foreign sailors and other migrants started to put down firm roots in the town, they began to marry local women, both white and of other races. This now created a vibrant mixed-race heritage throughout the inner districts. While their husbands were at sea, these women and their children bonded together in a very special community of mutual support and assistance, especially whenever money was in short supply.

From the late nineteenth century, another race of people made Liverpool their home and in significant numbers: the Chinese. The first wave of these immigrants arrived in 1866 with the establishment of the Blue Funnel Shipping Line. This company operated a regular trading and passenger service directly between Liverpool and China.

As with so many other ethnic groups, the Chinese liked Liverpool and settled here, establishing themselves in and around Nelson Street, not far from Pitt Street. This district became what it remains, the heart of Liverpool's 'Chinatown'. Liverpool once had the largest and oldest Chinese community outside mainland China and many Chinese people still live in Chinatown, as well as throughout Merseyside. Like the other nationalities in the city, they are now well established and integrated into the community, while retaining their own identity and rich cultural heritage.

People seeking sanctuary and a new home continued to arrive in Liverpool throughout the early twentieth century too, with a major influx in the years immediately after the Second World War. Indian sailors had first settled in the town from the 1860s, but it was the granting of Indian Independence in 1947 and the partitioning of that country into India, Pakistan and Bangladesh that saw the greatest numbers of people from the Indian subcontinent come into Liverpool.

As with Afro-Caribbean people from the West Indies in the 1950s, they and their families had been encouraged to come to Britain to meet the country's labour shortage in the wake of the war. It was not sailors who were now coming to Liverpool, but people with a whole range of skills and professions; from doctors and lawyers to postmen and bus drivers. Migrants into Liverpool also came from all over Britain. As well as the Irish, the Scots and the Welsh came to the town, the latter in such numbers that Liverpool was sometimes referred to as the capital of North Wales. At one time, there were so many Welsh in the town that in 1884, 1900 and 1929, Eisteddfods were held in Liverpool.

Nevertheless, it was the people of Ireland who certainly had the greatest impact on Liverpool. Those who arrived in the town during the Great Famine did so

through the massive, imposing black gates of Clarence Dock, lying just to the north of the town centre. Opened in 1830 and initially used for steamships, this soon became the harbour for vessels employed on coastal and Irish Sea routes. Therefore, these gates were the first sight of Liverpool for the millions of starving, anxious and desperate Irish coming to the town.

However, all that remains to mark this is an inadequately small plaque, mounted high on the outside wall and facing onto the Dock Road. Unveiled at 1.00 p.m. on Sunday 22 October 2000, this reads, in Gaelic and English, 'Through these gates passed most of the 1,300,000 Liverpool migrants who fled from the Great Famine and "took the ship" to Liverpool in the years 1845–52 – Remember the Great Famine.'

Fortunately, there is a larger, more appropriate memorial to the victims of the Great Famine in the gardens of St Luke's Church on Berry Street in the town centre. This acts as a reminder of how the victims of famine were able to overcome their adversities and turn their lives around in Liverpool. In so doing they became major contributors to the personality and power of the city, as did the peoples of so many other countries and communities.

This is the hope and sanctuary that Liverpool continues to offer to the people of the world. The town and its port were built on immigration and the ancestors of every modern Liverpudlian arrived in the port from somewhere else, even if they did not so themselves. The experiences and the cultural legacy of each of these peoples have created a vibrant social richness in the modern city. Indeed, the multi-faith and multi-cultural community of Liverpool is a microcosm of the greater community of humanity, in this 'World in One City'.

11

The New Rome

It was the nineteenth century that was to see the zenith of Liverpool's economic strength and global commercial influence. This was the period during which the town became a city, and the city became a great conurbation, surrounded by expanding and leafy suburbs and public parklands. The port too remained at the very core of Liverpool's prosperity and, as well as great ocean-going liners and ferryboats using the waterfront to transport local passengers and international travellers, the amount of shipping using the commercial docks continued to increase.

In a period of just under forty years this grew from 15,038 vessels in 1837 to 20,121 vessels in 1871. Even though the number of ships had only increased by around 5,000, these were becoming much larger. This meant that even deeper and broader docks now had to be built along Liverpool's riverfront and over the next hundred years these included:

Albert Dock	1846
Bramley-Moore Dock	1848
Collingwood Dock	1848
Nelson Dock	1848
Salisbury Dock	1848
Stanley Dock	1848
Sandon Dock	1849
Wapping Dock	1850
Wellington Dock	1851
Wellington Half Tide Dock	1851
Huskisson Dock	1852
Canada Dock	1859
Brocklebank Dock	1862
Herculaneum Dock	1866
Princes Dock Half Tide Dock	1868

Alexandra Dock (and three branches)	1880
Hornby Dock	1884
Langton Dock	1897
Gladstone Graving Dock	1913
Gladstone Dock	1927

The construction or enlargement of these docks, and the town's continuing financial investment in the maritime trade, demonstrated the commitment and significance of Liverpool to the rest of Britain, to its empire and to the world. The civic leaders, entrepreneurs and shipowners of Liverpool, who were directing the next phase of growth and expansion of the town, recognised that like Ancient Rome, 'all roads led to Liverpool'. This meant that by the opening decades of the nineteenth century they had a new vision for Liverpool and for themselves.

In Queen Victoria's Britain, this oligarchy felt that their town had outgrown its Georgian 'Florentine' cultural revolution and had now evolved into a new 'Rome'. They saw themselves as having evolved too into the dynamic driving force of capitalism and imperialism. However, they also saw themselves as members of a benevolent social elite with a paternalistic responsibility towards the citizenry. They absolutely knew this to be true, just as they knew that Liverpool was still the richest and most significant port in the British Empire outside London.

To declare and reinforce this dual responsibility, they were building even more roads, canals and railways, as well as all the stations, bridges and tunnels that went with them. They built more warehouses and factories and they built more ships. They also erected the great powerhouse offices of commerce that still stand on Castle Street and Dale Street.

For themselves and their households, they erected new homes, the 'Merchant Palaces', in the new suburbs and desirable satellite communities, such as Crosby, Allerton, Woolton, Childwall and Mossley Hill. As gardens became fashionable, many of these properties were soon being built with spacious gardens at the front. These suburban mansions also had much larger, often landscaped grounds to the sides and rear. The grand terraces built around Abercromby or Falkner Squares had their own private gardens in the centre of the squares.

Many of the new middle-class elite chose to live in the grand detached mansions now being built around the perimeters of new public parks, such as Princes Park, Newsham Park, Stanley Park, Walton Park and Sefton Park. Literally on their doorstep were the vast areas of beautifully landscaped parkland and gardens that now came with these 'up-market housing estates'. Mimicking the aristocracy, these very large residences had grand entrance halls, vast dining rooms and ballrooms for entertaining. Many also had libraries, private art galleries, music rooms and conservatories. There might also be billiard or smoking rooms for male family members or guests. Other properties also had stables and carriage houses and separate servants' quarters.

For those that could not afford these grander merchant palaces, smaller versions began to be built along new wide tree-lined roads and avenues in exclusive

districts such as Cressington, Fulwood and Grassendale Parks to the south of the town. Just to the north of Liverpool were similar desirable properties in places like Waterloo Park, Crosby, Blundellsands, Brighton-le-Sands and Seaforth. Across the river on the Wirral, there were also middle-class enclaves like Rock Park and Hamilton Square.

In keeping with their new self-perception and with increasingly typical Victorian paternalism, many members of the monied classes sought to use their benevolence to 'improve the lower orders'. These were men who aped the *noblesse oblige* condescension of the aristocracy and who saw themselves as latter-day Roman senators, casting largesse to the masses. They therefore paid for the building of churches, schools, infirmaries, asylums, orphanages and workhouses.

However, many more of these newly wealthy remembered their own, often humble origins. They acted out of genuine philanthropy and generosity and established meaningful charitable organisations to benefit ordinary people. They also funded such outstanding institutions in Liverpool as the School for the Blind, and the School for the Deaf. Like so many other innovations in the town, these were the first such establishments in the world.

By 1821 the population of the town had reached 119,000 and in 1835 Liverpool's boundaries were extended for the first time. Half of Toxteth Park, and the communities of Everton, Kirkdale and a part of West Derby, officially became part of Liverpool. By 1841 there were 286,000 residents within this larger town boundary and by 1871 this had risen to 493,000. Liverpool was now one of the fastest-growing towns in Europe and would have a population of 685,000 people by 1901.

To the leaders of Liverpool it now seemed a logical next step that the town should become a city and a diocese in its own right. This would then consolidate its status as a 'hub of empire' and their own as its 'Senators'.

A Crest, Forum, Charter, Mitre and Chain

As the eighteenth century drew to its close, the new and greater ambitions that the leaders of Liverpool had for the status of their town began to be fulfilled. This had started in 1797 when the corporation applied to the Crown for a royal charter granting Liverpool its own civic crest. On 22 March that year, a special Grant of Arms Charter was indeed awarded to the town. This gave the corporation the authority to emblazon its own town crest, or coat of arms.

The design is indeed distinctive and comprises a central symbol of arms surmounted by a crest and with supporters on either side. The design places the Liver Bird at the centre of the emblem and on the left this is supported by the figure of Neptune. He carries a trident in one hand and a banner bearing the Liverpool Coat of Arms in the other. The figure of Triton stands on the other side of the Liver Bird and he holds a banner showing a sailing ship.

In Latin, and so in keeping with the town's classical empathies, the civic motto on the coat of arms reads *Deus Nobis Haec Otia Fecit*. This translates as 'God

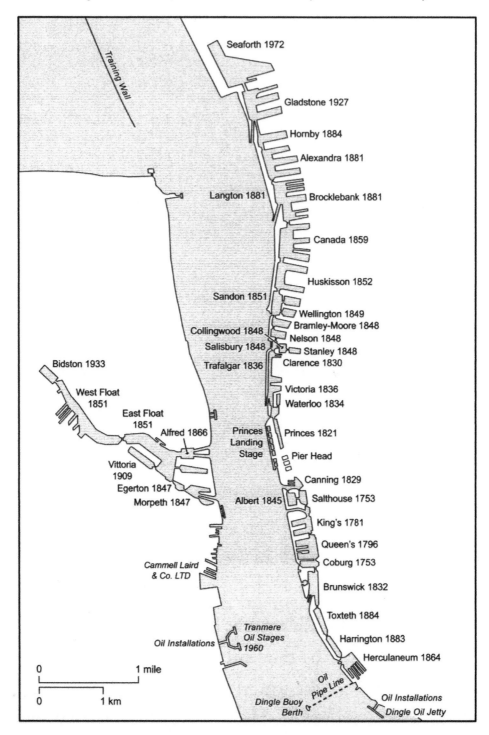

Docks development chart up to 1972.

has made this leisure for us'. This is a quotation from a poem by the Roman poet Virgil, which centres on a conversation between two characters, Meliboeus and Tityrus. The latter is explaining his good fortune at being able to take it easy and enjoy the good life; 'God has given me this leisure,' he states. 'But tell me of this God of yours, my friend,' asks Meliboeus. His companion explains that the god to whom he refers is 'the City that men call Rome'.

The choice of this motto by the leaders of Liverpool at the threshold of the nineteenth century confirms how they now regarded themselves and their town. However, what they now felt they needed was their own equivalent of the great civic centre of Ancient Rome.

From the first decades of the nineteenth century, Liverpool had been building great commercial palaces in the centre of the town, in what was rapidly developing into the business district. Private banking houses, insurance brokers, and the headquarters of shipping lines and large companies were being erected on Water Street, Dale Street and Castle Street. However, to reconfirm the cultural status that they had claimed throughout the Georgian period, great civic buildings were also required.

In what is now known as Liverpool's 'Cultural Quarter', a large area of land was earmarked for transformation into a contemporary forum of Rome. The creation of this began with what remains one of Europe's most stunning neoclassical buildings: St George's Hall.

On the coronation day of Queen Victoria, 28 June 1838, the foundation stone of St George's Hall was laid by one of Liverpool's greatest Victorian philanthropists and benefactors, William Rathbone V (1787–1868), who was mayor in that year. Upon its completion in 1854, the first and greatest building in Liverpool's new forum was opened by Queen Victoria and her consort Prince Albert (1819–1861).

Of all the buildings in the Cultural Quarter this is without doubt the most magnificent and it is the largest example of Victorian classical revival architecture in the world. It was designed and built by an equally remarkable young man by the name of Harvey Lonsdale Elmes (1813–1847). He was only twenty-three years old when he won the design competition for a new assize court and ceremonial hall. In 1841 he dedicated himself completely to this new project. He wore himself out in the process and, after five years of supervising the hall's construction, his health began to rapidly deteriorate. He retired to Jamaica to recuperate, but unfortunately died there, still a young man. His father mourned him as 'a martyr to architecture'.

The interiors of St George's Hall were completed by Professor Charles Cockerell (1788–1863) and the building opened as law courts, civic banqueting hall and as a setting for concerts and performances. With its grand stepped approach on Lime Street, which stretches the full length of the plateau upon which the building stands, the hall dominates the entire area. Its huge columns, broad plazas, grand entrances, and richly ornamented stonework combine to create a structure that is both powerful and beautiful.

The identification of Liverpool with Ancient Rome was perfectly reflected in Elmes's and Cockrell's designs. Indeed, at the south end of the hall, overlooking St John's Lane, is a massive portico supported by a double row of columns. Above this, inscribed in Latin, are the words, *Artibus Legibus Consiliis Locum Municipes Constituerunt Anno Domini MLCCCXLI*, which translates as, 'For Arts, Law and Counsel the townspeople built this place in 1841'.

Inside, the structure is even more impressive and around the walls of the main great hall at the centre of the building stand twelve statues of prominent Victorians of the time, each of whom had a significant connection with Liverpool. The larger-than-life-size figures reflect the larger-than-life personalities of these men, who are Revd Hugh McNeil, William Roscoe, Sir William Brown, Samuel Robert Graves, Edward Whitley, Sir Robert Peel, Frederick Stanley 16th Earl of Derby, Edward Stanley 14th Earl of Derby, Revd Jonathan Brooks, George Stephenson, Joseph Mayer and William Ewart Gladstone.

The most recent addition to the sculptural roster of the great and the good of Victorian Liverpool and just as deserving of this place of honour is the Irish washerwoman Kitty Wilkinson. Unveiled in September 2012, it was carved by London-based sculptor Simon Smith and cost £100,000. She is the only female thus recognised in the building, but other niches stand empty, so perhaps she will not be the last.

St George's Hall is a masterpiece with its rectangular, tunnel-vaulted great hall, which was inspired by the baths of Caracalla in Rome. This space is lavishly decorated throughout and the panels in the vast ceiling show images of the coat of arms of Liverpool, Greek and Roman symbols of commerce and authority (the caduceus and fasces), mermaids and tridents. A splendid and richly coloured stained-glass window showing St George slaying the dragon overlooks the space. On the bronze doors, light fittings and in other pieces of stained glass throughout the building, the monogram 'SPQL' can be seen. In keeping with the town's Roman self-image, this represents the phrase 'the Senate and People of Liverpool'.

At the north end of the great hall sits the magnificent 'Father Willis' organ. Some of the greatest organists in the world have sat at these keys, producing wonderful music from its 7,737 pipes.

At both end is of the great hall are the courtrooms. W. S. Gilbert (1836–1911), the lyricist in the great Victorian theatrical partnership of Gilbert and Sullivan, was the prosecuting counsel at the first trial ever held in St George's Hall in 1865. However, apparently he did not do a very good job. He lodged in Marine Parade in Waterloo where he met Arthur Sullivan (1842–1900). In 1875, Sullivan agreed to write music to go with Gilbert's words of *Trial by Jury* and the first 'G and S' light opera was born.

Not only is St George's Hall a fine example of art and architecture, but it is also one of scientific achievement. This is demonstrated by the remarkable heating and ventilation system that was designed and installed by Dr David Boswell Reid (1805–1863). Fresh air was drawn down into the basement via apertures in the

walls, but mainly through shafts at the east portico end of the building facing Lime Street. However, there were no such openings overlooking the cemetery, which at the time of the hall's construction still occupied the land behind the building that is now covered by St John's Gardens. This was in case 'a miasma of death' should be drawn into the building.

Depending on the weather, the air could then be passed over hot water pipes or jets of steam to be heated, or cooled by cold water pipes. The air was then circulated throughout the building by four great fans, each 10 feet in diameter, powered by a steam engine under the concert hall. The flow was controlled by a series of canvas flaps, which were manipulated mechanically and controlled by an army of staff. The whole air-conditioning system was zoned, so that different parts of St George's Hall could be heated or cooled at different times.

Perhaps the most remarkable feature of the great hall is the sunken Minton Hollins encaustic tile floor. This vast expanse is opulently decorated with images of the Liver Bird, Neptune, sea nymphs, dolphins and tridents. This also forms part of the ventilation system as grilles are set into the rim of its large central sunken section to facilitate the circulation of the air. Needing to be preserved, the tiles are usually completely covered by a removable wooden ballroom floor, and are only ever opened up for display a few times a year.

Following the building of the hall, other structures now helped to establish the legitimacy of Liverpool's Civic Forum and the next was the Museum of Liverpool. The founding of the museum began in 1851 with the bequest to Liverpool of part of the 13th Earl of Derby's magnificent natural history collection. In 1857 the foundation stone was laid by Sir William Brown (1784–1864), 1st Baronet, MP.

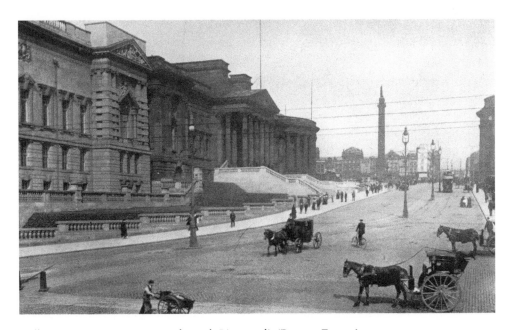

William Brown Street running through Liverpool's 'Roman Forum'.

He had donated the princely sum of £6,000 towards the building's construction and so the street outside was widened, upgraded, re-laid and named after him.

With its very high and steep stepped approach leading up to a massive portico supported on six tall columns, this neoclassical temple to science and history was opened in 1860 in front of an enthusiastic crowd of 400,000 people.

During the Second World War, enemy bombing in the May Blitz of 1941 destroyed much of the museum building, but fortunately the magnificent façade and many of the rarer items in the collections survived. Consequently, the museum had to remain closed for fifteen years after the war until the money could be found to restore it. Once all the funds had been secured, work began on complete rebuilding and renovation. It was finally and officially reopened in 1966 by Harold Wilson (1916–1995), the MP for Huyton and the serving Prime Minister.

In 2005, another complete redesign of the building was carried out and it reopened as the World Museum Liverpool. Just as St George's Hall had attracted vast crowds at its opening, the people of Liverpool genuinely appreciate all things cultural and artistic, which is why, in the first year after its modern reopening, the museum received 582,143 visitors.

Part of Sir William Brown's original building was also designed to accommodate the Liverpool Central Libraries, but the inauguration of the Public Library Service in Liverpool was due largely to the work of Sir James Picton (1805–1889). He was an architect, historian and a town councillor. As chairman of the Liverpool Libraries, Museums and Arts Committee from 1851 until his death, Picton's impact on the quality and range of these public resources was profound and the new library complex opened in 1860 with the museum.

Another of Liverpool's great civic benefactors, Picton was passionate about providing access to knowledge and ideas to the greatest number of people. He also wanted to ensure that Liverpool's collection of books, pamphlets, articles, private publications and archives was the best that it could be. This is why the Central Libraries now comprise many separate collections. In 1879, the library was extended into a new building, which still contain the magnificent rooms that house, among others, the Picton and Hornby libraries.

Following a £50 million restoration and redevelopment project, the library was completely modernised while retaining its original historic façade on William Brown Street. Reopening in 2013 and with a universally applauded redesigned interior, the Central Libraries are home to the purpose-built, climate-controlled repository for the Liverpool Record Office. Here, in almost 8 miles (14kms) of archives, are stored some of the city's most historic treasures from the last 800 years.

In December of 2013, the library was ranked as the most popular of 124 attractions in the city, making this the only public library in any of Britain's major cities to win such an accolade. This recognition alone clearly qualifies the library for a place in the city's Roman forum.

At the top of William Brown Street and landmarking the forum stands the great Wellington Memorial Column, mounted on a stepped plinth. This was erected as

a tribute to Arthur Wellesley, 1st Duke of Wellington (1769–1852). He was one of Victorian Britain's greatest national heroes and a potent symbol of Liverpool's world pre-eminence. This was particularly because of the duke's victory over Napoleon Bonaparte (1769–1821) at the Battle of Waterloo, which was fought in 1815.

Known by the public as 'The Iron Duke', because of his determination and formidable resolve, he was also known affectionately by his men as 'Conky Bill'. This was because of his equally formidable large, hooked nose. The monument was unveiled on 16 May 1863, accompanied by the firing of a salvo from nineteen cannon and a great civic celebration.

Standing 132 feet high, the column supports a bronze statue of Wellington. His figure is 14 feet high, and is cast in bronze melted down from cannon captured from the French at Waterloo. It is said that the statue was positioned facing south-east, so that the Iron Duke would always be looking towards the site of the Battle of Waterloo.

Next to the column and a focal point in the Cultural Quarter and forum sits the Steble Fountain. This was built in 1879 and it is made entirely of cast iron. It is named after Lt Colonel Richard Fell Steble who was the mayor of Liverpool from 1845 to 1847 and who gave £1,000 (worth around £70,000 today) to pay for it as a gift to his town.

A steam-driven water pump was constructed at the cost of £400 to drive the water flow of the fountain. This was housed in the basement of St George's Hall, but the sound of its engine often disrupted the proceedings in the courtrooms above. There is now a modern pump driving the fountain, which cascades water over the four larger-than-life-sized mythical figures below, each with maritime associations.

As it always has on hot summer days, the fountain provides local children with endless fun, when they play around the manly torso of river god Acis, with his voluptuous lover, the nymph Galatea, and the god of the sea, Neptune, with his consort, the sea goddess Amphitrite. In the classical myths, Acis was crushed to death under a rock by the Cyclops Polyphemus who himself loved Galatea and was jealous of his rival. After the murder of her lover, Galatea threw herself into the sea.

The next building to take its place on William Brown Street was the Walker Art Gallery. This was opened in 1877 by the 15th Earl of Derby and it received 324,117 visitors in the first four months. Even four years after its opening it was receiving an average of 2,000 people each day. As with the other buildings in the forum, these visitors were mostly just the ordinary people of Liverpool.

The gallery was donated by Alderman Andrew Barclay Walker (1824–1893) who was a Warrington brewery company owner and the Lord Mayor of Liverpool at the time. Prior to this, the only other buildings that he had erected in Liverpool had been particularly ornate pubs in which to sell his ales. The gallery therefore was a special project for him, as he felt it established his cultural credentials.

There are many masterpieces on view in the Walker and the building itself is impressive. Its classical stepped approach is flanked by the statues of Raphael and Michelangelo and the exterior walls support friezes that show scenes from Liverpool's history. On the roof over the entrance sits the 'Allegorical Statue of Liverpool'.

Finally, in 1884, and at the very top of William Brown Street, the County Sessions House was opened. This civil courthouse served the county of Lancashire and, standing next to the Art Gallery and overlooking the Wellington Column and the fountain, this building completed the collection of extraordinary buildings that made up New Rome's forum.

As Liverpool's stunning collection of huge, neo-classical structures neared completion, it was clear to the corporation that the town's official position in Britain and the empire needed to be elevated even further. Being granted the status of 'city' would achieve this and would also open many more economic opportunities for the people and the place.

Traditionally, from the time of King Henry VIII, cities were large towns with a cathedral and therefore a named Anglican diocese. To achieve this particular ambition, the corporation of Liverpool now petitioned government for a special royal charter, renaming the town as the 'City and Bishopric of Liverpool'. On 9 April 1880, this special charter was granted and signed by Queen Victoria and part of the existing diocese of Chester became the new diocese of Liverpool. The boundaries of the new bishopric stretched well beyond Liverpool itself, reaching from Southport in the north to Widnes in the south, and from the River Mersey to Wigan in the east.

The first Anglican Bishop of Liverpool was John Charles Ryle (1816–1900), who was consecrated in what had been designated the pro-cathedral of Liverpool, St Peter's Church on Church Street, on 11 June 1880, but plans to build a cathedral in Liverpool were already under way. Ryle had been appointed on the personal recommendation of the then Prime Minister, Benjamin Disraeli (1804–1881), 1st Earl of Beaconsfield, and during his tenure the new bishop built forty parish churches in his diocese. When he died, he was buried in All Saints' Church, Childwall.

Queen Victoria also granted another special charter, which she signed in 1893, granting authority for all future mayors of the city to be styled Lord Mayor of Liverpool. Between King John's Charter of 1207, and those of Queen Victoria, Liverpool had received eighteen other royal charters, including the Grant of Arms in 1797. Each of these either confirmed or granted particular economic, commercial, political, or social rights, privileges and guarantees, but the two special charters of Queen Victoria were among the most significant, and added further to the prestige of the city: the new Lord Mayors' Chain of Office was the glamorous icing on this particular civic cake.

Liverpool now had its crest, a forum, a new royal charter, a bishop and a lord mayor and in 1895, the new Liverpool City Council felt that its boundaries should be extended once more. This almost trebled the size of the city with the absorption

of its adjacent communities of Walton, Wavertree, the remainder of Toxteth and more of West Derby. Over the following decades, the other local villages were also absorbed, including Childwall, Gateacre, Woolton, Allerton, Garston, Fazakerley, Croxteth, Speke and the remainder of West Derby. The people living in these communities now became the newest citizens of Liverpool. They shared this status with the sailors and migrants who were still coming into the port to make it their home.

The City of Faith

Those people coming to Liverpool from overseas were bringing with them, not only new languages, cultures and customs, but also their religious beliefs. It has always been said that 'there are no atheists at sea' and so the personal expression of religious belief has always been of especial importance in the seafaring city of Liverpool.

The history of religious worship in the city is closely linked to its social and economic history, particularly during the Middle Ages. As the population grew during these periods, so did the manifestation of their religious beliefs and the number of their places of worship. Although very little remains of Liverpool's earliest medieval churches, the parish churches of Our Lady and St Nicholas on the riverfront, Walton-on-the-Hill, Holy Trinity in Wavertree and All Saints in Childwall, have illustrious histories and each of these retain physical remnants of their ancient histories. Indeed, All Saints Church is one of the oldest churches in England.

The religious conflicts during the Reformation and Counter Reformation in the sixteenth century, the English Civil War and the Jacobite Rebellion in the seventeenth century all had profound effects on the local people. Firstly Catholics, then Protestants, then Puritans, then Catholics again, at various times were each victims of serious persecution. In 1593, a law had been passed that strictly prohibited Roman Catholics from practising their faith in any way and this remained in force for almost three centuries.

Also, one of the legacies of the Civil War was a consolidation of the 'established' Church of England and further suppression of Roman Catholicism. However, there was an increase in religious dissent and nonconformity against this official state religion, leading to a rise in the number of supporters of more radical Christian doctrines, such as Methodists, the Society of Friends (Quakers) and in due course, Unitarians. Perhaps again because of the independent nature of Liverpudlians, from this time there were large numbers of followers of all of these doctrines in the town, well into the late nineteenth century.

Indeed, among the families driving forward Victorian Liverpool's new civic and cultural status, many were followers of the dissenting religions. These included some of the city's greatest benefactors and social philanthropists, such as the Rathbones, the Mellys, the Holts, and the Roscoes, who were all Unitarians.

The ancient city of Rome had magnificent temples to its gods and as part of the nineteenth century vision for New Rome, Liverpool wanted its great temples too. However, these would actually be built in the twentieth century and in very different architectural styles.

With the confirmation of Liverpool as a new city and diocese, plans were immediately set in motion for the building of an Anglican cathedral. The Roman Catholic Archdiocese also planned for a cathedral of their own. Today, these two unique and very different buildings dominate the city skyline and they stand, appropriately enough, at opposite ends of Hope Street.

After much debate about an appropriate site for the new Liverpool Anglican Cathedral of Christ, St James's Mount was selected and in 1901, the top of this ancient hill was cleared and work began. This is one of the world's most atmospheric and impressive Neo-Gothic buildings and was designed by Giles Gilbert Scott (1880–1960), who was only twenty years old at the time. The foundation stone was laid by King Edward VII in 1904 and the building would take over seventy-four years to complete.

The first part of the building to be finished was the Lady Chapel, which was consecrated and immediately used for worship in 1910. This became the central church of the diocese until 1924, by which time the choir and north transept had been constructed, which meant that the building could then be fully consecrated as the cathedral. This was the first time that a new cathedral had been consecrated in England since the thirteenth century and not only were King George V (1865–1836) and Queen Mary (1867–1953) present, but also eight Archbishops and forty-five Bishops from all around the world.

During the bombing of the city in the Second World War, the south wall and the stained-glass windows of the Lady Chapel were destroyed. This part of the cathedral was then out of commission for fifteen years. However, it was also during the war that the last stone on the highest point of the tower was laid, in very cold weather and by the architect himself, on 20 February 1942. This was a real triumph of faith in the face of the Nazi assault on Liverpool and the rest of Britain and during the war, construction work was never halted.

Between 1950 and 1960, the first bay of the nave was built and by the summer of 1967, the second bay was almost complete. On 25 October 1978, Queen Elizabeth II (b. 1926) came to share in a great service of thanksgiving and dedication to mark the completion of the building. Unfortunately, Giles Gilbert Scott did not live to see this very special moment, as he had died in 1960. He is buried just outside the West Door and his memorial is set in the floor at the centre of the cathedral, directly below the tower. However, as is said of Sir Christopher Wren, the architect of St Paul's Cathedral in London, if you want to see Scott's true monument, then stand in the transept of the building and just look around you.

Among his other claims to fame, Scott also designed the old red telephone box, one of which stands inside the cathedral, thus celebrating his greatest and his smallest achievements. The cathedral has many remarkable statistics associated with it, including:

It has the tallest stained-glass windows in England, at 53 feet high.

It has the highest vaulting in the world, at 175 feet.

It has the highest and heaviest peal of bells in the world, the largest bell being named, like the clock in the Liver Buildings, 'Great George' in tribute to King George V.

It is the largest Anglican cathedral and the fourth largest cathedral in the world.

Inside the cathedral are two curiosities: 'the whispering arch' over the tomb of Lord Derby; and the tiny bronze mouse, which one really has to search for. This is crouching, partially hidden, somewhere in the memorial figure of Lord Derby on his tomb. The mouse's nose is brightly polished, as rubbing it is supposed to bring good luck. To experience the unusual sound effects of the arch, one person should stand at the base of one of the recesses in the wall, at one end of the tomb. Someone else should then stand in the same position at the other side of the arch. Even the softest whisper will be clearly heard at the other side as the sound is carried overhead through the channel in the stonework.

The cathedral's architect said, 'Don't look at my walls, look at my spaces' and the building's vaulting is indeed impressive. However, most spectacular of all is the view from the roof of the massive Vestey Tower, which is open to the public. From this vantage point, the view is breathtaking and at the other end of Hope Street, the tower of the Metropolitan Cathedral of Christ the King can also be clearly seen. Just as the Victorian Protestant Liverpudlians had wanted their great cathedral, so too did the nineteenth-century Roman Catholics of the town. However, Mount Pleasant had not been the original location chosen

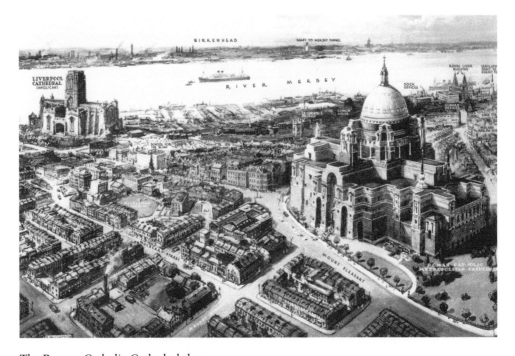

The Roman Catholic Cathedral that never was.

for a Catholic cathedral: Everton was to be the site for this important new building.

The Church of Our Lady of the Immaculate Conception, on St Domingo Road, had been opened in 1856. This was planned to ultimately become the Lady Chapel of a great Roman Catholic cathedral and had been designed by Edward Welby Pugin (1834–1875), whose father, Augustus Welby Pugin (1812–1852), had designed the Palace of Westminster. This project had to be abandoned though because money needed to be spent elsewhere, especially among the Catholic poor of the archdiocese. It would not be until the 1930s that the plan for a Catholic cathedral would be revived.

When the new site had been selected the decision proved controversial. This was because from 1771, this land adjacent to Mount Pleasant, ironically, had been the location of Liverpool Parish Workhouse. This had been notorious across Europe because of its harsh regime and often brutal treatment of its inmates. The workhouse had actually been a large complex that covered over 9 acres and which included a house of correction. This had been the unpleasant home for over 4,000 destitute men, women and children.

By the early years of the twentieth century, the workhouse had changed its role to one of providing care for sick, poor and elderly people. Then in 1928, the revision of the Poor Laws closed the workhouse and brought the property onto the market. The prospectus for the sale announced that on 26 March 1930, the entire site was to be sold by auction.

It was the Roman Catholic Archdiocese that bought the complete site for £100,000 and Sir Edwin Lutyens (1869–1944) was commissioned as the architect for the new cathedral. By this time, Lutyens had already established an excellent international reputation, including the building of the Indian city of New Delhi and the Cenotaph in London.

The site of the old workhouse and prison was cleared and on Whit Monday, 5 June 1933, the foundation stone was laid. At the recommendation of Pope Pius XI, the cathedral was dedicated to Christ the King and Lutyens' original design was for a huge Byzantine edifice. This was deliberately in direct contrast to the Gothic style of the Anglican Cathedral, which was then being built half a mile away. Construction of the Catholic cathedral began with the crypt which was completed by 1937, but the Second World War and the expense of the project stopped the work once this had been roofed over.

The project resumed in 1960 when a competition was held to find a new and less ambitious design. From over 300 entries, the plans of Frederick Gibberd (1908–1984) were chosen. Whereas the architect of the Anglican Cathedral was a Roman Catholic, Gibberd was an Anglican and the positive symbolism of this was not lost on the people of Liverpool or on their respective Church authorities.

Gibberd's plan was for a radical and contemporary building designed 'to reflect 1960s energy and creativity'. Work began over the existing crypt in October 1962 and only five years later in 1967, the new cathedral was consecrated. Gibberd was knighted that same year.

Considerably smaller than the building proposed by Lutyens, because of its unusual shape, the cathedral is sometimes locally referred to as either the 'Mersey Funnel' or 'Paddy's Wigwam'. The building remains controversial, but one only has to stand inside this magnificent place of worship and look around to feel the power of the design. The blending of the colours of the glass in the Lantern Tower, which is the largest stained-glass window in the world and which represents the Holy Trinity, is particularly stirring. Below this, the altar and central space, almost completely surrounded by the pews, is the focal point of the worship area and surrounding this around the nave are several side chapels.

These are dedicated to different devotions and purposes, including the Chapel of the Blessed Sacrament, the Baptistry, the Lady Chapel, the Chapel of Unity, the Chapel of Reconciliation and the Chapel of the Holy Oils. My personal favourite is the chapel dedicated to Saint Joseph, the earthly father of Jesus. The plain wooden panels around the three walls, carved with softly coloured reliefs showing scenes from the saint's life, give this chapel a homely warmth.

Outside, the front of the building is perhaps its most inspiring perspective, standing as it does on top of a high plateau and at the head of a magnificent stepped approach. The bell tower dominates the entrance, and its four bells represent the four gospel saints, Matthew, Mark, Luke and John. Above this, the massive coned roof of the building narrows towards the tall tower. This is surmounted by the powerfully emblematic crown of thorns, which can be seen from miles around.

The late eighteenth century had begun to see a greater tolerance towards religious diversity in Liverpool and by 1877 there were over 250 sites of worship throughout the town. These represented a wide variety of faiths and doctrines and included places of worship particularly dedicated to serving the beliefs of, among many others, the German, Greek, Italian, Polish and Swedish communities. But other great buildings were also constructed, providing places of worship for those people in the town other than Christians.

Not the least of these was the impressive Princes Road Synagogue, which was consecrated on 3 September 1874, to serve Liverpool's Jewish community. At the time, this was the largest synagogue in Britain, accommodating as it does up to 900 people. It is a richly decorated and impressive building with a high, vaulted ceiling, which is beautifully carved and decorated. At the end of the nave overlooking the wide central space is a great rose window. This not only adds light but also emphasises the magnificence of the interior of what is one of the finest synagogues in Europe.

The first Jews in Liverpool came to the town in the mid-eighteenth century and were a small group of itinerant migrant peddlers, probably of German extraction. Liverpool's was the first Jewish community in the north of England and for over a century it was the largest outside London. In 1789 the Jewish population of the town stood at 100 people and the year 1807 saw Liverpool's first synagogue established on Seel Street in the town centre. By 1825 the Jewish community had grown to around 1,000 people and by 1914 to its largest figure of 11,000.

However, by the 1950s, the population had declined to 8,000, and today now stands at approximately 3,000 people.

The Jewish community for many generations has, and continues to be, a vital part of Liverpool life. Many of the city's most famous sons and daughters and most significant benefactors have been and continue to be of this faith. This includes David Lewis, who founded the chain of Lewis's Department Stores in Liverpool, expanding to other cities. Other prominent Jewish Liverpudlians include Ian Broudie, the lead singer of the pop group the Lightning Seeds; the late Judge Rose Heilbron QC; Edwina Currie MP; solicitor E. Rex Makin; former Attorney General Lord Peter Goldsmith; the much missed entertainer and local benefactor Frankie Vaughan; and the Beatles' manager, Brian Epstein.

Only a few hundred yards away from the synagogue, and standing on Hatherley Street in the heart of Toxteth, is the centre of worship for Liverpool's Islamic people, the Al-Rahma Mosque. There is a large and thriving Muslim community on Merseyside and the history of Islamic worship in Britain has quite an unorthodox beginning, being founded, as it was, by a Liverpudlian.

William Henry Quilliam (1856–1932) was born at 22 Elliot Street in Liverpool. In 1882 he went to Morocco. Here he developed an interest in the Islamic faith and culture and in 1887 at the age of thirty-one, he proclaimed himself a Muslim convert. He took the name of Abdullah and after returning to Liverpool, he gave a series of lectures on Islam in the town. He soon recruited the first of a number

Britain's first mosque.

of converts and before long there were enough of these to establish the Liverpool Muslim Institute.

In 1889 the expanding group moved to their own premises at No. 8 Brougham Terrace, just outside Everton, where they established their mosque in the building; the first in Britain. In 1893, they began to publish a weekly newspaper, *The Crescent*, and later the monthly journal, *The Islamic World*, which was distributed to more than twenty countries around the world. This was all done using their own printing press, which was operated from the basement in Brougham Terrace.

This building closed many years ago, but it has been completely restored and has reopened as the Abdullah Quilliam Heritage Centre. Most Merseyside Muslims now regularly worship at the large and impressive Toxteth Mosque. Opening in 2007, this attractive building is of a traditional Islamic architectural design, but with contemporary styling and very modern facilities. It can accommodate around 2,500 people and is welcoming to non-Muslims and Muslims alike, as are the people of this well-established Liverpool community.

While this and the other more established religions continue to play a major part in the life and culture of Liverpool, so also do the members of other faiths, such as the non-conformist Christian denominations and the Hindu, Sikh, Buddhist, Baha'i, Rastafarian, Taoist and other communities.

The way that the modern city forms a hub for so many people continues to be a legacy of the grand vision that the Victorian leaders of Liverpool had for their town and port. As the nineteenth century drew to a close, they saw that their ambitions for Liverpool to become a new Rome had certainly been fulfilled. This had been achieved not just in the splendour of their cultural, commercial and religious architecture, but in the social fabric of its citizens of all classes and cultures.

The city on the Mersey, spread across its seven hills, now sat as the fulcrum of a great empire, just as the ancient city on the Tiber had, spread across its own seven hills. All the roads that once led to Rome now led to Liverpool and people came in their millions. But the roads also led out from Liverpool to reach across the seas and the continents.

Liverpool had truly become a beacon of energy and enterprise, driven by a richly diverse, creative and independent people. They now faced the dawn of a new age with excitement and optimism. Would the twentieth century fulfil its promise? Would it be a brave new world?

12
The Twentieth Century – A Brave New World?

In the early years of the eighteenth century the author Daniel Defoe made his third visit to Liverpool. Later writing about this, he not only commented on the town's docks, but on its thriving architecture. He said,

> Liverpoole is one of the wonders of Britain, and that more, in my opinion, than any of the wonders of the Peak; the town was, at my first visiting it, about the year 1680, a large, handsome, well built and encreasing or thriving town.
>
> At my second visit, anno 1690, it was much bigger than my first seeing it, and, by the report of the inhabitants, more than twice as big as it was twenty years before that; but I think I may safely say at this my third seeing it, for I was surpriz'd at the view, it was more than double what it was at the second; and, I am told, that it still visibly encreases both in wealth, people, business and buildings: What it may grow to in time, I know not.

At the dawn of the twentieth century, as the great Victorian age passed into the much briefer Edwardian period, a new wave of great architecture and engineering was sweeping across the city. This seemed to be the absolute fulfilment of Defoe's prophecy, as Liverpool stood on the threshold of a 'brave new world'.

The new century seemed to herald a world of unprecedented opportunity, as science, technology, communication and travel took their places at the forefront of economic growth and cultural transformation. Each of these had already begun to play their part in Liverpool's continuing evolution, with the creation of the impressive Liverpool Overhead Railway. This innovative transportation system not only connected the full length of the city's docklands, but it was a direct bridge between the solid dynamism of the late nineteenth century and the bold optimism of the early twentieth century.

The Docker's Umbrella

By the late nineteenth century, the traffic at the entrances to all the docks and on and around their surrounding roads, had reached such a volume that terrible congestion occurred on a regular basis. This frequently brought transportation and commerce to a noisy and frustrating halt, and was also making it difficult for the thousands of dockers and office employees to get to work on time. Some method of relieving the problem was urgently needed.

In 1852, a narrow-gauge steam railway had been built to service the dock entrances and this ran the entire length of the docks between the roadway and the dock wall. The railway was being used to carry goods and supplies, plus small numbers of dock employees, but this could in no way help to ease the problem. In fact, the railway was adding to the congestion as it competed for right of way with trams and omnibuses, with wagons and carts, and with horses by the hundred and pedestrians by the thousand.

What was needed was an efficient transportation system that would radically reduce the overcrowding. As ever, Liverpool's consistent ability to find imaginative and profitable solutions to complex issues met this challenge, and it was agreed that to 'alleviate' the solution would be to 'elevate'. This led to proposals being made for a new dockside railway that would follow the same route as the existing

The overhead railway at the Pier Head Station.

ground-level railway, but running directly above it. So in 1888, the Liverpool Overhead Railway Company was formed and construction began the following year.

Originally, the company had intended to use steam locomotives, despite the experience of New Yorkers, who found hot cinders, ash, oil and water regularly dropping onto their heads from their elevated railway as they walked beneath its tracks. Fortunately, this idea was rejected once it was also realised that falling sparks could ignite the timbers of the hundreds of wooden ships moored at Liverpool's docksides. Instead, in 1891 a system of electric traction, supplying power from a third rail, was commissioned from the newly formed Electric Construction Company.

The first overhead train ran in 1892, carrying all the company directors and their friends and families. Then, in February 1893, the new railway was officially opened to the public by Lord Salisbury, as the world's first elevated electric railway. The 'Overhead', as it had also been nicknamed, soon covered a distance of 7½ miles and the track ran 16 feet above the Dock Road. The journey took 25 minutes and with its seventeen stations, it was also the first electric, elevated, twin-track railway in the world to use an automatic signalling system. The railway was also more affectionately known as 'The Docker's Umbrella', because its weatherproof decking allowed pedestrians to shelter beneath it during rainfall.

The southernmost terminus was originally at Herculaneum Dock, where the station was at ground level and the platform was accessed up a special staircase. From here, specially designed engines and carriages then ran the full length of the Liverpool docks system to Seaforth Sands at the north of the city, where a purpose-built elevated station had been constructed. The Overhead Railway quickly became very popular and commercially successful and it was soon carrying over 4 million passengers every year.

In 1896 the railway was extended from Herculaneum Dock across a gantry above the Cheshire Lines Railway and through an arched entrance carved into the sandstone cliff-face towering above the dock. It continued under the terraced houses of the Dingle district along a half-mile tunnel, to a new underground terminus at Park Road. Now, dock workers living in the densely populated Dingle and Toxteth districts could travel directly to their places of work, cheaply and efficiently. By 1887, the railway was now carrying 8 million people a year.

This helped to ensure that the railway continued to be a cheap, convenient and fascinating mode of transport. By 1919, the railway was now carrying 19 million people a year, which was its highest ever passenger figure.

The technology of the railway did not stand still and the company introduced many innovations. These included, in 1921, Britain's first escalator, which was built at Seaforth Station. This consisted of a narrow conveyor belt with wooden slats upon which passengers would stand to be carried up to the high-level platform.

The railway was bombed on more than twenty occasions during the Second World War. When such damage occurred, the trains continued to run between

unaffected stations. Buses then carried passengers past the smashed sections until the railway was repaired, which it was every time. The company's offices were badly damaged in the May Blitz of 1941, so temporary headquarters were set up in one of the railway carriages that had been parked at the Pier Head Station.

Eventually, over sixty years of continuous operation took its toll on the railway structure. This had been weakened by salt from the River Mersey, steam rising from the dock railway running directly beneath its track and damage from the wartime bombing. Maintenance costs rose and in 1954, a report recommended the renewal of large sections of the track at a cost of £2 million. The directors of the company could not raise the necessary capital for this and so they decided to close the line. Despite serious opposition from the public and the city council, an Act of Parliament confirmed the decision.

The wonderful 'Docker's Umbrella' ceased operation on Sunday 30 December 1956. The trains began their last journeys at 10.03 p.m. from each end of the track. Both trains were crowded and cheers rang out as they reached their final destinations. Demolition began in September 1957 and was completed by the end of January 1959. Thousands of sightseers came to watch.

In its final year of operation when I was five years old, my mother took me for a trip along the full length of the railway. She was determined that I should have the opportunity to travel on the overhead just once before it disappeared forever and I remain very grateful for the experience.

I clearly remember boarding the carriage at the Dingle Station terminus and then puzzling over why we were travelling underground as we rattled, clanked and shook along the ½-mile-long Dingle Tunnel; we were after all supposed to be on an 'Overhead Railway'. I remember the feel of the highly polished wooden seat slats on the backs of my legs in my short trousers and how crowded the carriage was. I noted too how that, apart from me and my mum, all the passengers were men. I remember too their reassuring, masculine smell, which reminded me of my dad; a combination of sweat, engine oil, and Capstan Full Strength cigarettes.

Suddenly, the train shot out of the dark at breakneck speed it seemed to me and along the gantry bridge at Herculaneum Dock. It then banked steeply over to the right as the train took the sharp right-hand curve onto the main dockside track. I was seated by the window and I recall gazing down on the docks as we clattered overhead on the metal tracks, looking down on what appeared to be hundreds of ships sailing on the river and berthed in all the docks.

I remember too seeing crowds of people of all shapes and sizes and skin colours walking the length of the Dock Road. I recall vividly the sounds of the strange accents of the sailors, dockers and workmen on the train, from all over the world, as we all shared the fun of this trip on the overhead. Even today, the excitement and thrill of it all is a joyous memory.

All that now remains of the Liverpool Overhead Railway are some of the lower track-support girders, set in concrete mounds, standing against some stretches of the dock-road wall. However, the complete underground station area at the Dingle still remains deep inside the cliff under the streets of houses. The platforms,

ticket office and the signal box have long gone, as have the tracks and the trains, and the whole underground station area is now the workshop for a large car-repair company.

From their workshop though, the full length of the Dingle Tunnel still exists, leading all the way to the tunnel mouth above Herculaneum Dock. I have walked this tunnel in the pitch dark, past the old railway sleepers and avoiding the water that drips down through the roof from the bedrock above. I have climbed a ladder against the wall that blocks off the lower part of the tunnel mouth and have gazed across the sports centre and the apartments that now replace the former dock, above the nearby Jaguar car showroom and a Chinese restaurant and beyond the river to the Wirral.

What an asset such a unique public transport system would prove to be today, had the Liverpool Overhead Railway survived. All we can do now though, is breathe a sigh of regret as we look back on what was an engineering marvel and once one of the city's greatest social and economic triumphs. However, how Liverpool's vision for the twentieth century began to truly manifest itself is best seen in the design and purpose of some of the city's major buildings and construction projects that took shape in its first decades. These continued to make bold statements about Liverpool's ambitions.

A City of Vision and Bold Enterprise

While the commodities that made Liverpool great were coming into and out of the docks, the business of international maritime commerce was conducted in the offices in and around the original seven streets. However, until the late nineteenth century, these were generally located above shops and warehouses, where conditions were often cramped, overcrowded and unhealthy. This did not make for efficient business practice, and the merchants and brokers of Liverpool realised that they had to move with the times and create premises that would meet ever increasing demand for their commodities and services.

It was at this time that the concept of one building for a single company began to be replaced by purpose-designed structures that could accommodate a number of companies of various sizes. Indeed, a company might construct an office block much larger than its own needs required and rent out the rest of the floors to pay for the building itself. This would also provide a regular revenue stream: the speculative office block was born.

Liverpool was home to the first such development solely for office purposes, which was Oriel Chambers in Water Street. Built in 1864, this was designed by local architect Peter Ellis (1805–1884). He also was first to use an iron frame for his building. Ellis was so proud of this that he incorporated it into the visible design of his five-storey structure. He also installed large, projecting, oriel windows – hence the building's name – which let in considerably more daylight through their tops and sides. Sadly though, his design style was far too radical for

many of his contemporary leading architectural colleagues around the country and they virtually hounded Ellis out of the profession.

Nevertheless, his commercial concept did strike a chord, as did his use of iron as the structural skeleton of his office block. Of course, until the invention of steel-framed buildings that supported the floors and upon which the stonework was hung like cladding, office buildings could not stand much higher than four or five stories. Height was also limited by the number of staircases that staff could climb, until the invention of hydraulic-powered lifts in the 1860s and of electric-powered lifts in the 1890s. But, because of Ellis's pioneering approach, the more progressive and imaginative builders, architects and engineers of the time, including a number from Liverpool, now went over to America to study the building of office skyscrapers.

This not only led to taller buildings, but also to improved building design. This now saw a wider range and improving quality of stone, brick and other building materials being used. Also, architects wanted to make their new buildings aesthetically appealing as well as commercially attractive. They also wanted them to be unique, so they embellished them with ever greater detailing and decoration. This included such ornamentation as the use of columns and colonnades, or of carved statuary, busts and medallions, and a greater use of colour.

Each new building may have had a character of its own, but they were each deliberately styled to emphasise the taste, authority, ambitions and fiscal credibility of their owners and occupiers. This then attracted increasing numbers of aspirational tenants who were prepared to pay ever higher rents.

A great many of these impressive structures survive throughout the city, but especially on Dale, Castle, Water, Tithebarn, Old Hall, and Chapel Streets. However, the accepted architectural taste in the late Victorian and Edwardian eras still favoured traditional styles overall. This is why these buildings reflect variations on the themes of Mock-Medieval, Neo-Gothic, Neo-Classical, Regency, Italianate and Oriental Revival, etc. However, by the opening decades of the twentieth century, local architects were getting bolder – inspired by buildings in the USA. This now led to the construction of Liverpool's most iconic waterfront office buildings, collectively known as 'The Three Graces'.

In yet another example of Liverpool's considerable engineering ingenuity, these massive structures are all built directly over the former George's Dock at the Pier Head. Water still flows under the buildings and the roads between them are, in fact, cleverly designed causeways. Individually, these extraordinary structures are: the Port of Liverpool Building, opened in 1907; the Royal Liver Building, opened in 1911; and the Cunard Building, erected in 1916.

The Port of Liverpool Building is listed Grade II* and was built as the ornate and assertive headquarters of the Mersey Docks and Harbour Board (MDHB), who owned and operated all the docks on both sides of the River Mersey. Like others of his professional contemporaries, the principal architect of the building, Frank Briggs, had been sent to America for inspiration and education. Suitably motivated, Briggs returned to Liverpool and began work on the new design.

Constructed in Portland stone, the building has a magnificent copper dome and is decorated with many reliefs, sculptures, niches, pediments and other features. It is certainly impressive and its final cost was £350,000. Inside the atrium, which is accessible by the public, are many motifs and symbols to do with international shipping. In gold lettering around the first floor gallery are words from the 107th psalm, which read, 'They that go down to the sea in ships and do business in great waters, there see the works of the Lord and his wonders in the deep.'

The external features of the building include cast iron gates and gate piers, which are decorated with maritime symbols, and lamp holders in the form of naval monuments.

In 1941, the building was struck by a German bomb, which fell through the roof of the building. This burrowed its way to the basement where it exploded causing considerable damage, and it was not until after the end of the war that the building was completely reconstructed and restored to its original magnificence.

Between the Port of Liverpool and the Royal Liver buildings stands the Cunard Building, which was built for the world famous shipping line in 1916.

Samuel Cunard (1787–1865) arrived in Britain from Canada in the early years of the nineteenth century and with his business partners, George Burns and David MacIver, he founded the British and North American Royal Mail Steam Packet Company. Soon, the shipping line was renamed 'The Cunard Line', and its routes and the size of its fleet increased rapidly over the succeeding decades. The prosperous company eventually absorbed Canadian Northern Steamships Limited and its principal competition, the White Star Line, owners of the ill-fated *Titanic*. After that, Cunard dominated the Atlantic passenger trade with some of the world's most famous liners.

By the outbreak of the First World War, the company was internationally renowned; however, it lost twenty-two ships through enemy action, including the *Lusitania*. The liner was sunk, without warning, just 10 miles off the Irish coast. She was struck by a torpedo fired from a German submarine, with a loss of 1,201 people from the 2,661 people on board. As so many of the great ship's passengers were American, the sinking precipitated the entry of the USA into the war.

The great Cunard liners *Mauretania* and the Queens *Mary* and *Elizabeth* were registered in Liverpool and both proudly bore the city's name on their sterns throughout their periods of service. However, the Cunard Line was only one of a large number of equally renowned and important shipping companies that began their operations from the Port of Liverpool. These included the Holt, Booth, Bibby, Brocklebank, Harrison, Elder Dempster, Ellerman, Inman, and Ismay Shipping Lines, among many others.

Also listed Grade II*, this great office block is wider at the back than at the front, has six floors and a basement, and is based on the design elements of the Farnese Palazzo in Rome. Particularly imposing are the four massive stone eagles on the corners, supporting the Cunard Shield. Symbolising Liverpool's links with North America, the sculptures were carved from a single stone, which weighed 43 tons.

These monumental emblems symbolise Liverpool's links with the North American continent and there are many such architectural features on buildings throughout the city. This is because the links between the city and America were vital to Liverpool's economy, since the time when that country was a British colony. Nevertheless, the Cunard Line also traded around the world and to represent this, large portrait heads representing peoples from different races appear on the exterior walls.

This splendid structure has now found a brand new lease of life as in 2014, Liverpool City Council took it over and a number of its floors now house city council staff.

Of the three buildings at the Pier Head, it is undoubtedly the Royal Liver Building that was the most controversial and bold of the new waterfront buildings in terms of its design appearance. What is now the most iconic and internationally recognised symbol of Liverpool was the object of a major public campaign to have it pulled own, even as it was being built. Fortunately, Liverpool's determination to be innovative and radical won through; as it so often does.

A Grade I listed structure, the Liver Building stands at a height of 295 feet, from its base to the top of the Liver Birds. This was also one of the first multi-storey, reinforced concrete, steel-framed buildings in the world; its granite exterior is simply cladding. Like its two companions, the massive weight of the building is supported on concrete piers, which were sunk into the bed of the old George's Dock, to a depth of 40 feet.

Designed by Walter Aubrey Thomas (1859–1934), the building was commissioned by the Royal Liver Friendly Society. This company had adopted the Liver Bird as its emblem because this was the name of the inn in which the original society had first met.

The building is crowned by a pair of clock towers, with one clock face on the east tower facing the city. On the west tower and overlooking the river, there are faces on three sides. This is so that ships on the river can tell the time from any position. Each clock dial is 25 feet in diameter, 220 feet above ground, and 2½ feet wider than those on the Big Ben clock tower in London. Indeed, the clocks themselves are the largest electronically driven clocks in the UK.

Each minute hand is an impressive 14 feet long and the huge timepieces were designed to be accurate to within half a minute a year. Owing to the severity of the weather in the Mersey estuary, each dial has a 3½-ton iron framework, which carries the 660 lbs of opal glass necessary to withstand wind pressure of up to 11 tons per square inch. The clock itself was named the 'Great George', because it was started at the precise time that King George V was crowned on the 22 June 1911. This was accomplished via a telephone link with an observer at Westminster. To celebrate their manufacture, one of the clock faces was first used as a unique dining table, with forty guests comfortably seated around the 25 feet diameter dial.

While the optimistic transformation of Liverpool, from a nineteenth-century town into a twentieth-century conurbation, was taking place at ground level, engineers and architects were looking underground and in the skies in order to further deliver their visionary aspirations. They knew that it was not only office blocks that facilitated commercial growth, but that transportation infrastructure also remained a crucial ingredient in the economic mix. Skilled professionals in the city, such as Liverpool's first borough engineer John Alexander Brodie (1858–1934), recognised that the opening decades of the new century were heralding the age of the motor car and the age of the aircraft.

By the 1920s, he began to lay out Britain's first urban ring road around Liverpool, which was named 'Queens Drive'. He connected this to the town centre by dual-carriageway boulevards with central reservations. These were designed to carry the corporation electrified tramway network, which he also created. Brodie also saw that a vehicular link between the communities on both sides of the Mersey was an urgent priority. The Wirral peninsula had become an expanding dormitory zone for Liverpool, as more and more people were becoming car owners. Ferries could still transport thousands of foot passengers across the river every day, but his grand vision was for a road tunnel directly connecting Liverpool with Birkenhead.

This was not the first such local, subterranean transportation link, because a railway tunnel had been dug beneath the Mersey, opening to regular steam trains in 1886. This remains an outstanding example of late Victorian engineering and enterprise. Brodie would now bring twentieth-century technology to his construction of the first Mersey Road Tunnel.

Despite the great economic depression that was afflicting Europe and America in the decades immediately following the First World War, and which was having a devastating impact on the people of Liverpool, there was still hopefulness for a brighter future. The building of the Mersey Tunnel was a manifestation of this.

Begun in 1925, this was designed by Brodie and the renowned civil engineer Sir Basil Mott (1859–1938). The tunnel was opened by King George V and Queen Mary in July 1934 and named 'Queensway'. Built at a cost of £7,723,000, this was then the longest and widest underwater road tunnel in the world, at just over 2 miles. Now a Grade II listed building, above the Liverpool entrance, designed in his classical art deco style by the gifted Liverpool architect Herbert J. Rowse (1887–1963), is a carved relief of two winged bulls. These are shown on either side of a winged wheel and the composition symbolises the swift and heavy traffic that still uses this remarkable underwater roadway.

In the middle decades of the century, Queensway would be joined by 'Kingsway', the second Mersey road tunnel, this time linking Liverpool with the Wirral district of Wallasey.

As well as pioneering and then leading transportation and commerce by sea, mail-coach, canal, railway and now by road, the city also sought to do so by air. Liverpool had established its own airport in 1933, near the ancient village of Speke at the southern edge of the city and standing on the shore of the river. The

first flight from a regional airport to Europe took place from Speke Airport in 1934. In 1950, the first scheduled passenger helicopter service in Britain would begin from Speke with flights to Cardiff. Then in 1952, Britain's first package air holidays would take off from the airport. In fact, Speke Airport was established three years before Gatwick and thirteen years before Heathrow.

When the airport was opened by the Marquis of Londonderry, who was Secretary of State for Air at the time, the terminal complex was considered to be a triumph of architecture. The celebrations at the opening event included the biggest air display ever held outside the Hendon Air Display, involving almost 250 aircraft and a crowd of 100,000 thrilled spectators.

Following the construction of the terminal building, two large adjoining aircraft hangars were constructed. The first of these was designed and built by Fokker, the German military aircraft and engineering firm. This company submitted their bill for the construction work at Speke in the closing weeks of August 1939. On 3 September of that year, the then British Prime Minister, Neville Chamberlain (1869–1940), announced that Britain was at war with Germany. The city of Liverpool knew only too well that Fokker fighter planes would be used against Britain and her Allies, so they refused to pay the bill. To date, this remains unpaid.

Across Britain and especially in Liverpool, which retained its dominance as the 'Second City of the British Empire', the twentieth century had begun with a bold dream of advancement and of a 'Brave New World'. However, the new century had hardly begun when all of these hopes and goals were suddenly pushed out of immediate reach. This was because, in August 1914, the greatest man-made catastrophe that the world had yet seen would sweep across the globe.

What became known as 'the Great War' would devastate Europe in particular, would change the lives and social structures of the British people forever, and would slow economic and social progress in Liverpool to a crawl. It would also lead to the Great Depression of the 1920s and 1930s, which would have a massive impact on the people of the city.

13
Trenches, Convoys and Blitzkrieg

When Pals and Patriots Perished

On 28 June 1914 at Sarajevo in Bosnia, the heir to the throne of the Austro-Hungarian Empire, Archduke Franz Ferdinand (b. 1863), and his wife Duchess Sophie of Hohenberg, were assassinated. This precipitated what was to be initially described in its immediate aftermath as 'the War to End All Wars'. Tragically however, this would eventually enter history as the 'First World War'.

For generations, Liverpool had provided soldiers for the British Army, so much so that the renowned King's Regiment has always been made up mainly of Liverpool men. This tradition continued when Britain declared war on Germany on 4 August 1914, just five weeks after the shooting of the archduke.

The outbreak of the war generated a period of romantic patriotism and imperialist jingoism right across Britain. Posters appeared everywhere of Lord Kitchener (1850–1916), who was then Secretary of State for War. He was shown, behind his great moustache, pointing his finger and stating 'Britain Needs You'. This prompted the young men of Britain to see themselves as the nation's saviours and heroes.

Other propaganda posters depicted wives and mothers with their young children standing by them, gazing encouragingly at a distant column of British soldiers as they marched across a beautiful rural landscape towards a bright sun. The words on the poster read, 'Women of Britain say "Go!"' This was a time too, when old soldiers from previous imperial wars were also urging young men, especially in Liverpool, to 'get out there and see some action' and 'if you don't go now you'll miss it. It'll all be over by Christmas!' Girlfriends and fiancées also told their young men that they should go to war, and 'do their bit for King and Country'.

These youngsters, for such they were, could not even escape the propaganda in the music halls, because their favourite female singers were regaling them with rousing verses from a song entitled 'Your King and Country Want You'. This ran,

We've watched you playing cricket and every kind of game.
At football, golf and polo you men have made your name.
But now your country calls you to play your part in war.
And no matter what befalls you,
We shall love you all the more.
So come and join the forces,
As your fathers did before.

Oh, we don't want to lose you but we think you ought to go.
For your King and your country both need you so.
We shall want you and miss you,
But with all our might and main,
We shall cheer you, thank you, bless you,
When you come home again.

What was a young man to do? If he did not sign up to fight then he might very well receive a white feather, sent to him anonymously in the post and marking him out as a coward. In fact though, most young men actually did want to go, especially in Liverpool. This was because they saw this as the honourable and right thing to do. Apart from this, in the naivety of the time, they thought that the war was bound to be a 'glorious adventure'.

So, go they did to 'answer their Country's call' in their tens of thousands and none more so than in Liverpool. But an adventure was the last thing this war was going to be, because of the complete failure on the part of the military and political leadership to recognise the implications of fighting a modern, mechanised war. No one had any conception of the unprecedented horrors that this was about to unleash on an unsuspecting Europe.

Liverpool's young men were sent to fight in the muddy swamps that were the trenches of France and Belgium. Not because they were fools, but because they believed in themselves and in Britain and in the rightness of the patriotic cause. With that sense of community and tribalism that is so particular to Liverpool, they also went as Pals.

It was Edward George Villiers Stanley (1865–1948), the 17th Earl of Derby, whose idea it was to recruit groups of young men who were already comrades and friends to form a new fighting regiment. Also serving as Secretary of State for War from 1916 to 1918, Lord Derby ordered that an advert be placed in Liverpool's newspapers on 27 August 1914. This suggested that men wishing to join 'a battalion of comrades, to serve their country together' should report to the headquarters of the 5th Battalion the King's Liverpool Regiment.

The amount of men who turned up overwhelmed the capacity of the recruiting hall and extra rooms had to be opened; already there were enough to form two battalions. The volunteers were then all told to come to St George's Hall on 31 August, where they would be officially enlisted. Here, Lord Derby took the opportunity to deliver a rousing, patriotic speech to an audience of 1,050 new

recruits, using the phrase 'Liverpool Pals' for the first time. The 17th Earl told the enthusiastic but enthralled crowd,

> This should be a Battalion of Pals, a battalion in which friends from the same office will fight shoulder to shoulder for the honour of Britain and the credit of Liverpool.
>
> I don't attempt to minimise to you the hardships you will suffer, the risks you will run. I don't ask you to uphold Liverpool's honour; it would be an insult to think that you could do anything but that. But I do thank you from the bottom of my heart for coming here tonight, and showing what is the spirit of Liverpool – a spirit that ought to spread through every city and every town in the kingdom.

In the following weeks and months, men and boys from all over Liverpool continued to sign up. They did so in small groups as 'mates', as complete neighbourhood football teams, as bands of apprentices or workers from single factories, offices and shipping lines, as neighbours from single streets, as fellow worshippers in churches and as gangs of lads from corner pubs. The response to the emotional recruitment campaigns was phenomenal, so much so that the volunteers eventually made up four battalions of the King's Regiment Liverpool: the 17th, 18th, 19th and 20th, with each regiment comprising an average of 1,400 men.

As well as the city of Liverpool sending volunteers to fight, equally significant was the Wirral Battalion of the Cheshire Regiment. Young men from all over the towns and villages of the peninsula also left their homes and loved ones to fight overseas. The largest contingent of these recruits joined from Port Sunlight, mainly from the Lever Brothers' Works. Indeed, the greatest number of volunteers obtained from any works in the country came from this Wirral soap factory.

However, the war was being fought, essentially, as a protracted game of stalemate between the combatants. On opposing sides of a broad stretch of open ground that formed the battlefield and was known as 'no man's land', each army faced the other from lines of deep trenches. These often stretched for miles and were occupied not just as defensive positions but as the troops' homes. In turn, and as a prelude to a ground-based attack by their soldiers, each side would continuously bombard the other, often for hours, using heavy artillery that was positioned behind their own lines. Hoping that this assault would have weakened and decimated their enemy, they would then climb out of their trenches and make their way across no man's land.

For the most part though, the trenches provided excellent protective cover, thus rendering the artillery assault largely redundant. This meant that advancing and exposed troops would face a barrage of shell and machine-gun fire that would mow them down, often in huge numbers. No man's land stretched for miles and could be anything from 45 to several hundred feet wide. This bleak landscape rapidly became a quagmire of mud, blood and bodies in a tortured landscape of shell holes and destruction.

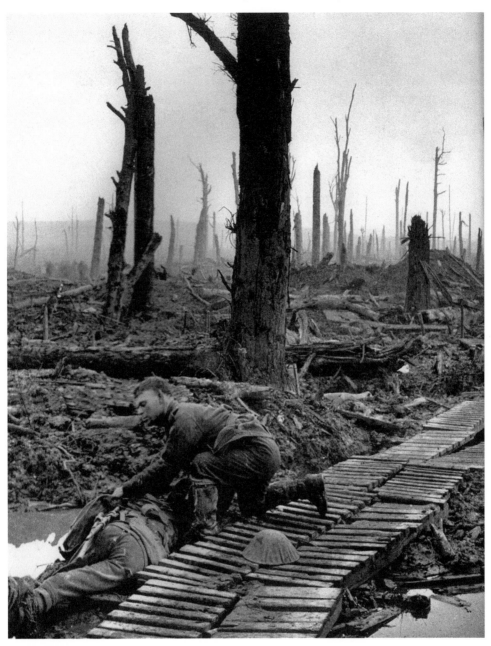

No man's land.

The trenches too would become either rivers of mud and filth during the rains, ice-cold tunnels of frozen earth in the winters, or sweltering concentrations of energy-sapping heat in the summer. For three-and-a-half years this was how the war was waged, with territory being captured or lost, often only in measurements of yards rather than miles.

In late 1915, the Liverpool Pals battalions had been sent to training camps in France near the River Somme, ready for what was being called 'The Big Push' in the summer of the following year. By the morning of 1 July 1916, the Liverpool Pals were on the front line. Then the order came and these young Liverpudlians went 'over the top' of their trenches. Immediately, almost 200 of them were killed outright and over 300 were wounded, taken prisoner, or eventually declared missing. This war being what it was, far too many of those who died never had their own graves. These soldiers are remembered though, on the 'Memorial to the Missing of the Somme', at Thiepval in France.

Of the four original Pals Battalions who sailed to France in November 1915, 20 per cent would be dead by the end of the war. But, if the figures of the wounded are added to this, then the actual number of casualties is nearer 75 per cent. Those football teams, church congregations, factories, shops, streets and pub bar-rooms would never be the same again. Nevertheless, these young men died and suffered as proud Liverpudlians, Lancastrians and Cestrians, determined to do their duty as they saw it.

Writing home to his family on the eve of his regiment's departure for France and destined to be killed in his first battle, one young soldier, Private W. B. Owens, wrote,

> Well we're away at last and 'tho no one feels that it's a solemn occasion to be in England for perhaps the last time, I think that the predominant feeling in every chap's heart – in mine at any rate – is one of pride and great content at being chosen to fight and endure for our dear ones and the old country.

Boys as young as fourteen joined up to go overseas, lying about their age often with the collusion and encouragement of family, friends and of the recruiting sergeants. Initially flushed with pride, their lives would end brutally as they fought and bled in the mud and the filth. Thousands more were gassed, mutilated, wounded and psychologically damaged, but at least they would eventually make it home alive.

However, thousands of the Liverpool Pals and the Wirral Battalion did not and they were among the 13,000 local soldiers who were massacred on the European battlefronts of that 'foreign field that is now, forever England'.

During the First World War, 5,397,000 men had been mobilised from across Britain. Of these, 703,000 were killed and 1,663,000 wounded. This is a total of 2,367,000 war casualties, or 44 per cent of the serving men.

One of the heroes of the conflict was Noel Godfrey Chavasse (1884–1917) from Liverpool and the son of the then bishop of the city. Noel received the

Victoria Cross twice – one of only three people so honoured – for saving the lives of his comrades on the battlefield. Tragically, Noel too was killed, so his medals were awarded posthumously.

The end of the war began quite suddenly, in the summer of 1918, for a combination of reasons. These were the entry of the Americans into the conflict in April 1917, the more strategic use by the Allies of tanks supporting ground assaults, and the use of aircraft for air cover and filming of enemy positions, and guiding artillery strikes. Coupled with a German army that was, by now, completely exhausted, under-equipped and demoralised, the end was now inevitable.

There was no ultimate victory in what had also been dubbed 'the Great War'. It ended with an armistice, which was signed at five o'clock on the morning of 11 November 1918. At 11.00 a.m. on that day in London, Big Ben struck for the first time for four years. In Liverpool, church bells rang out around the city, announcing the end of the Great War.

As the second decade of the twentieth century began, there was a period of economic growth, radical social change and of a broadening of accessible democracy. Then in 1929, the collapse of the American Stock Market was one of the catalysts for a global economic failure that became known as the Great Depression. Europe and Britain suffered badly, especially in heavily populated and industrialised conurbations such as Liverpool. Mass unemployment, poverty and disease took their toll on the city, but by the mid-1930s, Liverpool began to emerge from this as the international economy strengthened once more.

The city and its port was soon able to recover its position as the hub of global maritime trade, as a world-class city and as the 'crossroads of the world'. Indeed, the highest population ever reached in Liverpool was in 1937, when 867,000 people were resident within the city boundaries. This was a time when Liverpool could also genuinely celebrate its place in the modern twentieth-century world, as a 'New Rome' and a new 'Seat of Empire'.

This was also a peak time for the great shipping lines of the world too. These were not only using the port regularly, but many had their headquarters there. Such companies as Anchor Line, Brocklebank, Bibby Bros and Co., Alfred Holt and Co., Booker Line, Booth Steamship Co. Ltd, Canadian Pacific Steamships Ltd, Cunard Steam Ship Co. Ltd, Elder Dempster Lines Ltd, Ellerman & Papayanni Lines Ltd, Furness Withy and Co. Ltd, T. & J. Harrison, Pacific Steam Navigation, Royal Mail Lines Ltd and the White Star Line, were all based in Liverpool.

However, just as the global economy was strengthening and as optimism and hope once more began to rise, so too did the power of Germany under the Nazi leadership of Adolf Hitler (1889–1945). Now, this latest German leader was about to enshroud the world in the black shadow of war. The people of Liverpool would again answer the call to fight against an enemy that was determined to dominate and subjugate the globe. But, just as the previous German leader, Kaiser Wilhelm II (1859–1941), had discovered, Hitler too would learn the hard way that Liverpudlians aggressively resist domination in any form.

The War in the Western Approaches

The importance of Liverpool's role throughout the Second World War cannot be underestimated. During this next great conflict after the fall of France in 1940 and before America came into the war in December 1941, Britain stood virtually alone against the Nazi juggernaut that had rolled out across Europe. Liverpool was vital to the nation's survival, because it was through the port that the convoys of ships brought essential supplies of food, fuel, medicines, raw materials and munitions to beleaguered Britain.

Protected by an escort force of warships of the Royal Navy and Britain's Allies, especially Canada, these lines of merchant vessels sailed into Liverpool Bay from America, Canada, around the Empire, as well as, in due course, from Soviet Russia. Hitler was perfectly aware of this and of the port's strategic position and so he launched a relentless campaign of submarine U-boat attacks on the convoys. This assault was under the command of Grand Admiral Karl Dönitz (1891–1980).

It was not just supplies coming into Liverpool that had to be protected, because it was also through the city's docks that no fewer than 1,747,505 Allied service personnel passed on their way to and from the battlegrounds of the world. Indeed, during the war, 4,648 special trains arrived from across Britain at the Riverside Station (which no longer exists) alongside Princes Dock.

From here these troops left Liverpool on ships bound for theatres of war around the world. In fact, on one particular tide there were twelve ships queuing up in the River Mersey, waiting to pick up American soldiers who had disembarked from the USA, to take them by train from Liverpool to the south of England. On 6 June 1944, they would join the Allied assault on Europe, in what became known as the D-Day Landings in France.

Children being evacuated from Britain and bound for safety in America and Canada also passed through Liverpool. Great ocean-going liners would often carry up to 2,000 of them at a time from the port. All these transports were under constant threat of attack from the Nazi U-boats and they all needed protection. Tragically, not every ship reached its destination safely. Such was the case on the 18 September 1940, when the passenger ship SS *Benares* left Liverpool for Canada. She was carrying 100 evacuee children among her passengers and crew and was torpedoed by German submarine *U-48*. She sank with massive loss of life, including seventy-seven of the children.

Against these attacks, the Royal Navy fought a determined resistance that became known as the 'Battle of the Atlantic'. This was the longest-running campaign of the war because it lasted for the entire duration of the conflict. The first attack on a British ship had been the sinking of the SS *Athenia*, which had been sailing from Liverpool to Canada. This occurred on 3 September 1939, only twenty-four hours after war had been declared, and 117 merchant seamen lost their lives.

The last attacks of the Battle of the Atlantic resulted in the sinking of the British freighter *Avondale Park*, the Allied minesweeper *NYMS 382* and the Norwegian

merchant steamer *Sneland*. These attacks took place in separate incidents, only hours before the German surrender on 2 May 1945. Nevertheless, during the war, over 1,000 convoys of between twelve and forty ships each, around 76,000 vessels in total, successfully thwarted the German (and later Italian) submarines and entered Liverpool mainly through Herculaneum Dock.

This crucially strategic naval campaign was commanded by Admiral Sir Max Horton (1883–1951). He directed his 'Scarecrow Patrols' of de Havilland Tiger Moth single-propeller biplanes to spot enemy U-Boats in the North Atlantic Ocean and radio back their positions. This information was then passed to the Royal Navy vessels protecting the convoys. These were then escorted into Liverpool Bay and the Mersey by an escort force of warships, set to defend a rectangular area of the North Atlantic around the coast of the British Isles, known as the Western Approaches.

These ships of the Royal Navy were under the command of the highly respected Captain Frederick John 'Johnnie' Walker (1896–1944), whose leadership and strategic skills were renowned. He had been about to retire at the outbreak of the war but agreed to take command of the 36th Escort Group based in Liverpool and he was very effective. Mentioned in dispatches three times during his career, Captain Walker was awarded the Distinguished Service Order on 6 January 1942, after his group sank five Nazi U-boats while escorting a convoy of over thirty vessels. In command of the sloop HMS *Stork*, Walker fought and won many battles and was awarded a Bar to his DSO on 30 July 1942.

In 1943, Captain Walker took command of the sloop HMS *Starling* and of the 2nd Support Group. This was tasked with seeking out, attacking and sinking enemy submarines and that year he succeeded in sinking six enemy vessels. His actions continued with equal success and in January 1944 alone, he sank a further five U-boats. Ships under the command of Captain Walker destroyed more enemy submarines than those of any other Allied Naval Commander. In 1944, on 22 February, he was awarded a second Bar to his DSO and later, on 13 June, he received his third Bar.

The defence of the Western Approaches and the direction of the Battle of the Atlantic all took place in 50,000 square feet of gas-proof and bomb-proof bunkers in the basement of Derby House in Exchange Flags behind Liverpool Town Hall. When the Second World War was declared, the operational headquarters for 'Atlantic Defence and Conflict' was being constructed. Fully completed in 1941 and known as 'The Fortress', it was from here that a continuous and desperate maritime conflict was fought upon these enemy attacks against Allied shipping.

Sadly, Frederick 'Johnnie' Walker suffered a brain haemorrhage in the summer of 1944 and died two days later on the 9 July in the Naval Hospital at Seaforth in north Liverpool. He was so respected by his men and fellow officers and by the people of Merseyside that over 1,000 people attended his funeral. This was held with full naval honours in Liverpool Anglican Cathedral, following an emotional procession through crowded streets. 'Johnnie' Walker CB, DSO and three Bars,

RN, was buried at sea and a life-size statue of him, by renowned local sculptor Tom Murphy, stands at the Pier Head overlooking the river.

During the Battle of the Atlantic despite achieving ultimate victory, the Allied losses were astronomical. The worst years were 1941 and 1942 when respectively, 1,300 and 1,661 ships were sunk. In total, over 12.8 million tons of Allied and neutral shipping was destroyed, but the loss of life was the real catastrophe. Royal Naval losses totalled 73,600, with a further 30,000 sailors being killed from the Merchant Service. An additional 6,000 men from coastal command and 29,000 from the anti-German U-boat flotilla also died. Memorials to these gallant sailors can be found at the Pier Head, together with those dedicated to the Merchant Navy, to Norwegian seamen, to 'All those Lost at Sea' and to Belgian merchant seamen.

In 1998, the road that passes in front of the Three Graces at the Pier Head was renamed as 'Canada Boulevard'. This is an avenue of maple trees (the national tree of Canada), which was first planted in 1995 by the Canadian Government. These form 'a living memorial to Canadians' who had been killed during the Battle of the Atlantic. Each tree has a plaque set in the pavement next to it, commemorating a Canadian ship lost at sea during the conflict.

The British wartime Prime Minister, Sir Winston Churchill (1874–1965), wrote in his history of the Second World War that 'the only thing that ever really frightened me during the War was the U-boat peril'. It is certainly true that without the Liverpool-led victory during the Battle of the Atlantic, it is almost certain that Britain would have been defeated by the Nazis.

The underground headquarters of the Western Approaches Command 'Fortress' is open to the public as a museum and is set out exactly as it would have looked during the war. Visitors wander through authentically furnished and equipped bunkers, map and radio rooms, corridors and offices. They can imagine for themselves what it must have been like for the men and women stationed here during the defence of Liverpool, Britain and the North Atlantic.

The museum also gives a glimpse into the dreadful wartime conditions that the civilian population had to endure. This was particularly devastating for Liverpool and the Wirral, as the Nazis mounted a direct bombing assault on the ordinary people of the region.

The Lightning Wars

Liverpool was not only the command centre for the Battle of the Atlantic, but a communications and supply hub for the rest of Britain. The interconnected dock system itself connected to a major road, rail and canal network that was vital to the country's survival and freedom. Because of this too, Adolf Hitler was absolutely determined to destroy the strategically vital port and city. The Nazi Dictator specifically ordered the commander of the German Luftwaffe (airforce), Reichmarshall Hermann Goering (1893–1946), to 'bomb Liverpool into oblivion'.

Throughout Europe, one of Hitler's most devastating and effective modes of warfare was his blanket bombing of industrial centres, docks, railways, warehouses, factories and shipyards and of the areas of civilian population around them. Not concerned about how many innocent men, women and children he slaughtered, his 'Blitzkrieg' or 'Lightning War' bombings of towns and cities across the continent laid waste to many heavily populated areas. Britain suffered very badly too under these callous aerial bombardments, but Liverpool and Merseyside most of all.

The first German bombs landed on Merseyside on 9 August 1940 at Prenton in Birkenhead, followed by intermittent air-raids of varying intensity over the coming months. Most of these were targeted at the docks and waterfront yet, despite this, those docks that remained undamaged were as busy as ever. Over the weekend of 26 April 1941, they handled over 136,000 tons of food and animal feed and around 45,000 tons of other cargo. However, one of the most violent aerial assaults on any British city, the real Blitz, was launched against Liverpool every night from 1 to 8 May 1941. This was the worst week of sustained raids ever on any part of the country and was an all-or-nothing attempt by the Germans to wreck the port from which the Western Approaches were being defended. In that single week 1,453 people were killed and around 1,000 more seriously injured.

After this, the Nazis continued to bomb Liverpool almost every night during the remainder of May and through the first two weeks of June. Altogether there were seventy-nine separate air raids during the Blitz, leaving the centre of the city lying in waste. Also, the full length of the docks was heavily damaged, notably the Wapping and Albert Docks. Huskisson No. 2 Branch Dock was obliterated when, on 3 May 1941, the vessel SS *Malakand* took a direct hit from a high-explosive bomb and blew up.

The ship was carrying 1,000 tons of ammunition in her holds and when she was hit, great chunks and sheets of shrapnel were blasted into the air. Some of these were propelled for a distance of over 2½ miles and one of Malakand's 4-ton anchors was thrown for a distance of over 100 yards. The entire dock area itself was devastated, together with adjacent warehouses and dock sheds, as was the Huskisson Dock station of the Overhead Railway.

One docker was blown off his feet by the explosion and as he was about to get up off the ground, one of the ship's great metal plates blew on top of him. To his amazement it had buckled in its flight and ended up covering him in a protective shield. He was completely uninjured. Fortunately, and even though the fires and explosions continued for seventy-four hours, only four people were killed in the blast.

Many important buildings in the city were struck by either incendiary or high-explosive bombs, including the Customs House, India Buildings, the Corn Exchange, the Central Library, the Bluecoat Arts Centre and the Museum. However, the work of the port had to go on and people had to live their lives. They also managed to find ways to still get to work through destroyed and

rubble-strewn streets. Regardless, morale in Liverpool remained very high and the people of the city were recorded as having the highest level of community spirit and positivity of any blitzed town or city in the country. Nevertheless, throughout Liverpool and its suburbs there were 15,000 bombed sites.

Raids continued intermittently following the 1941 Blitz and though still bad, these were not as terrifying as those that the people had already endured. Even so, there was still much damage to property and loss of life. Between July 1940 and January 1942, the Luftwaffe bombing raids over Liverpool killed over 4,000 people and injured over 10,000 more. Indeed, in sheer tonnage of high explosive and incendiary bombs, Liverpool was the most heavily bombed city outside London. On 14 May 1941, a mass funeral was held at Anfield Cemetery in the north of the city, at which 1,000 victims of the May air raids were buried in a common grave.

Considerably more than half the houses in the four principal boroughs of Merseyside were damaged and over 10,000 were destroyed. The people of Bootle, the small town on the immediate northern border of Liverpool, saw a bewildering 16,000 of their 18,000 homes damaged. The overall housing loss in the Liverpool area was:

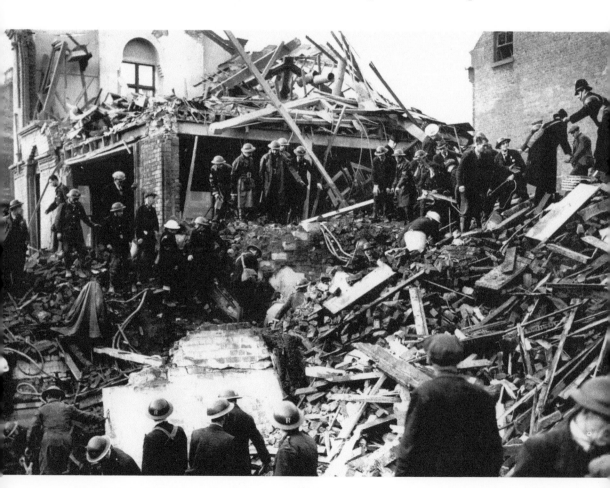

Searching for bodies in the Durning Road disaster.

Liverpool – of 202,000 houses, 5,598 destroyed and 124,989 damaged;
Bootle – of 18,189 houses, 2,013 destroyed and 16,300 damaged;
Birkenhead – of 35,727 houses, 2,079 destroyed and 26,000 damaged;
Wallasey – of 27,600 houses, 1,150 destroyed and 17,000 damaged.

Throughout the entire May Blitz, 250,000 meals were served from mobile canteens. These included 25,000 gallons of tea, 2,000 gallons of scouse, 21,000 dinners and 360,000 sandwiches. At one time, 9,000 workers from outside the city, together with 2,680 troops, helped Liverpool's own workmen to clear away rubble and debris to get the streets open again. Fire fighters from thirty-nine boroughs were brought in to supplement local Fire Brigades and they brought with them an additional 550 fire engines. Sadly, eighteen fire fighters were killed and 180 injured during the Blitz, as they fought to control and extinguish hundreds of fires.

While the effects of the bombing of London were fully reported and broadcast, the government kept the full impact of the Blitz on Liverpool from the British people. Not only did they feel that this information would seriously undermine national morale, but it would show the Germans how effective their air raids were being on the city. At that time, Liverpool was Britain's (and free Europe's) only fully functioning commercial port and such secrecy was essential so that the enemy would not be encouraged to intensify their attacks. Indeed, information about the results of one particular bombing in Liverpool was kept a government secret until well after the war had ended.

In the early hours of 29 November 1940, during the heaviest air raid to date, a parachute mine fell on the three-storey Junior Instruction Centre in Durning Road in the district of Edge Hill. This caused the building to collapse into the air raid shelter below, in which 300 people believed themselves to be safe from the bombing. The gas main and the central heating water pipes were fractured and those victims who were not crushed under falling masonry were either burned alive in the resulting fire-ball, or boiled to death in the now super-heated water that flooded the basement.

Many others were buried alive, while fires burned uncontrollably above ground, making rescue work extremely dangerous. In all, 166 men, women, and children were killed and many more were severely injured. Winston Churchill described the disaster as 'the single worst civilian incident of the war' and the close-knit community of Edge Hill was devastated.

The war ended six years before I was born, but I still remember my mother's tales of the May Blitz. She would say that while the raids were on, if she and my two elder brothers, who were children in the 1940s, could still hear the sounds of the trains shunting at nearby Wavertree and Edge Hill rail sidings, then they knew that they were still alive.

Following the end of the Second World War in May 1945, servicemen returning to Liverpool came home to a ravaged city and an exhausted community. Food, fuel, and commodities were in short supply. Indeed, rationing would continue until 4 July 1954, when restrictions on the sale of bacon and meat were finally

lifted. Even so, there was a mood of great optimism, because the Germans under Hitler and the horrors of Nazism had been defeated and the world could begin again. In fact, radical change was what the British people now demanded.

A Wind of Change

On 5 July 1945, the wartime coalition government of Winston Churchill was roundly defeated in the first post-war general election. This had been won by the Labour Party, led by the new Prime Minister, Clement Attlee (1883–1967). The policies of the new government were firmly socialist as they now nationalised the steel industry, the railways and the production of coal, gas and electricity. In 1948, perhaps most significantly of all, the Labour Government introduced free, universal healthcare under the revolutionary National Health Service.

To many people in Britain it seemed as if there really was a new dawn, when civilisation and progress were reasserting themselves and a fresh, decent society could be created. This was especially felt by the innately optimistic and dynamic people of Liverpool. As the late 1940s passed into the 1950s, the people of the city were discovering a new energy, a new determination to succeed and were refocusing on family and community. Even so, the country was unsettled following the war and uncertain about what the immediate future held. This is why, in the general election of 1951, this time the Labour Government was defeated and the Conservatives regained power. Once again, Sir Winston Churchill was back at Number 10 Downing Street.

In 1952 King George VI (b. 1895) died prematurely of lung cancer, at the age of only fifty-seven. He was much mourned by the country he had ruled and inspired throughout the war and in 1953, his daughter was crowned as Queen Elizabeth II (b. 1926). The British people saw this as a dawning of a new Elizabethan Age and there was great national celebration.

This revived sense of optimism was bolstered by the post-war boom in the global economy that was now taking place and which was leading to a dramatic rise in the standard of living in Britain. There was also an increase in industrial and commercial production in the country, especially in the car, steel and coal industries. Export earnings and investment were boosted too and wages were beginning to rise as the trade unions gained confidence in their demands.

The Conservatives retained power in the 1955 general election and in a speech he gave at a party rally, the then Prime Minister, Harold Macmillan (1894–1986), made his famous and very self-confident statement that in Britain,

> You will see a state of prosperity such as we have never had in my lifetime – nor indeed in the history of this country. Indeed let us be frank about it – most of our people have never had it so good.
>
> Go around the country, go to the industrial towns, go to the farms and you will see a state of prosperity such as we have never had in my lifetime – nor indeed in the history of this country.

Nevertheless, he and his government knew only too well that this economic growth was only temporary. In fact, the British economy was actually entering a period of serious inflation, not least of all because of the amount of war debt it had accumulated. This is why in the same speech Macmillan now urged wage restraint, as union demands became more strident. Neither the British public nor the TUC were aware of the economic truth and they felt that if things were apparently going so well then they wanted a larger slice of the fiscal cake. At the same time, the international balance of power had been irrevocably altered by the war and Britain was already slipping from its place as the dominant power in the western world.

This position now belonged to America and was reflected in the breakup of the British Empire. In 1947, the 'Jewel in the Crown' of British imperial possessions, India, had gained its independence, but only after a long and bitter struggle that had begun before the war. In March 1957, Ghana then became the first African nation to gain independence from the UK, with other colonies soon to follow suit. Many of these would also only do so after bitter and violent rebellions against the British Crown.

The term 'British Commonwealth', instead of 'British Empire', was now in common use, reflecting these changes. As MacMillan himself acknowledged, 'The pattern of the Commonwealth is changing and with it is changing Britain's position as the Mother Country. Our children are growing up.'

In another famous speech, which he gave to the South African Parliament in 1960, MacMillan also said of Africa, 'The wind of change is blowing through this continent, and whether we like it or not, this growth of national consciousness is a political fact. We must all accept it as a fact, and our national policies must take account of it.'

It was in the years immediately following this speech that it became increasingly and publicly obvious that 'boom' was becoming 'bust'. The evidence of this was clear in places like Liverpool, but no one wanted to believe it. This was because the hope and optimism of the post-war years had been part of a much needed healing process across Britain, which was not yet complete. It was also easy to ignore the cracks in the façade because there was, literally, an upbeat distraction sweeping the country. This, in fact, had come from Liverpool and it would see the city now gain an entirely new and very popular form of national and international influence.

14

A Fall from Grace

In 1927, the Swiss psychologist Carl Gustav Jung (1875–1961) had a dream about Liverpool. He believed that individuals are directly influenced by the accumulation of the experiences of their ancestors and by their own dreams and innate psyches. Jung, who never actually visited the city, certainly knew of it and of its history and international significance. He was profoundly affected by his dream and in his book *Memories, Dreams, Reflections*, he recounts and analyses it, by saying,

> I found myself in a dirty, sooty city. It was night, and winter, and dark, and raining. I was in Liverpool. I walked through the dark streets … found a broad square, dimly illuminated by street lights, into which many streets converged.
> … In the centre was a round pool, and in the middle of it a small island. While everything round about was obscured by rain, fog, smoke and dimly-lit darkness, the little island blazed with sunlight. On it stood a single tree, a Magnolia, in a shower of reddish blossoms. It was as though the tree stood in the sunlight and was at the same time the source of the light.
> … I had a vision of unearthly beauty, and that was why I was able to live at all. Liverpool is the 'Pool of life'.

Jung was absolutely correct in his perception of the city. As we have seen, Liverpool's role as 'the crossroads of the world' had created a diverse, multicultural and multi-faith community of self-confident individuals and modern tribes. Liverpool seemed to have had a charmed existence since its foundation in 1207. It had come through plagues, sieges, political and sectarian violence, warfare of every kind and economic depression. Each difficulty though had only made Liverpool and its people stronger and more determined to survive and succeed.

There was now a fierce resolve in Liverpool to consign to the past its suffering during the Second World War. The city had always stood on the Mersey with its

back to Britain and its face out to the world and despite the emerging signs of an economic downturn, its people were now looking to the future again with typical self-confidence. This outlook was uniquely underscored by the beat of a new rhythm; that of the sound of American 'Pop Music' and of 'Rock and Roll' in particular. This would take root in post-war Liverpool and the city would then gift this to the rest of Britain, to Europe and to the world.

The Mersey Sound

As the 1950s approached the 1960s, a major cultural shift had begun to take place across Britain and Liverpool was at its heart. This was led by young people and driven by a new and exciting form of popular music from America and the rebellious lifestyle that came with it. This was first heard on records being brought into the port by English sailors on merchant ships from the USA. They gave these to their younger brothers, sisters, sons and daughters, who began selling and swapping them in local pubs, coffee bars and dance halls. These records were modern, lightweight, unbreakable plastic discs that were played at 45 RPM. They soon became commercially available in record shops and rapidly replaced the old shellac records that were played at 78 RPM.

The people buying this new music were generally aged between thirteen and twenty, many of whom had lots of pocket-money from their parents or were in reasonably paid jobs. As well as now having a considerable disposable income, these young adults were much more independent and self-aware than their parents had been at that age. Increasingly, young people began to express their new sense of freedom quite openly, causing confusion and hostility in the older generation and the establishment. The phrase 'generation gap' was being heard for the first time and the era of the 'teenager' had arrived.

A transition now began from the lightweight, middle-of-the-road songs of the 1950s, into the much more raw and energetic pop music of the 1960s. This had started with the arrival of American Country and Western Music; the first type of music to ever be performed live in Liverpool's new Cavern Club, which had opened in January 1957. Country Music gave birth to Skiffle, which became very popular in Liverpool, at the same time as Jazz and Blues music was also being played in smoke-filled coffee bars and licensed basements in the city.

This predominantly black form of music evolved into Rhythm and Blues, which soon combined with Skiffle to produce Rock and Roll. This sound in particular was instantly accessible to the youth of Liverpool and Britain, but not only as records. Rock and Roll was increasingly being performed live by amateur and semi-professional pop groups in community as well as commercial venues.

The simple structure of Rock music meant that it was easily played on very basic musical instruments, predominantly by young men. These 'Rock Groups' or 'Pop Groups', as a minimum, generally consisted of a drummer with at least a bass and snare drums and possibly a hi-hat cymbal, and two acoustic guitarists,

one playing lead and the other playing rhythm. There would perhaps also be a separate vocalist, who might play the harmonica. If they had more money, a group might have electric guitars, an amplifier and speakers and the vocalist might then have a microphone. Perhaps too, a keyboard player might be added to the ensemble.

The number of these groups increased rapidly. Indeed, if a young man in late 1950s or early 1960s Liverpool was not a member of some sort of musical group, then he was exceptional. In fact, I was lead singer with two such groups in the 1960s, neither of which made any impact whatsoever on the pop music scene.

The rawness of the music allowed the musicians to express their individuality and personality through performance and so make an instant and emotional connection with their audiences. Teenagers were now a force in their own right and no longer simply anonymous members of the general population. This perfectly suited the collective psyche of Liverpool youth.

In 1953, the Liverpool singer Lita Roza had become the first entertainer in Britain to score a number one hit in the brand new Top Twenty Pop Charts with her jaunty version of 'How Much Is That Doggy in the Window?' In 1958, another Liverpool singer, Michael Holliday, had also got to number one with the gentle ballad 'The Story of My Life'. By the start of the 1960s though, a completely different kind of Liverpool entertainer would be at the forefront of the new wave of radical and dynamic popular music.

Gerry and the Pacemakers, the Swinging Blue Jeans, the Merseybeats, Billy J. Kramer and the Dakotas, Billy Fury and Cilla Black, were pop groups and singers who came from among the thousands of amateur performers of Liverpool. However, with skilled managers behind them, such as Brian Epstein (1934–1967), they soon became nationally and then internationally famous as professional performers. In 1962 though, when another of Epstein's groups, The Beatles, suddenly exploded onto a welcoming world, Liverpool itself, once again, became internationally renowned. This time though, it was for things other than wartime significance or global maritime influence: the 'Mersey Sound' had been born.

When in 1965, the influential American 'Beat' poet Allen Ginsberg (1926–1997) visited Liverpool, he made a pilgrimage to the Cavern Club. He did so because the venue had, by this time, become world famous as the place that had given The Beatles their start. Indeed, the 'Fab Four' performed there 275 times, between February 1961 and August 1963. Ginsberg wanted to see why the world was suddenly paying such attention to the smoky urban port city on the Mersey. He was so impressed by the passion and energy he was exposed to in Liverpool that he described it as 'the centre of the consciousness of the human universe'.

On the face of it this might appear to be an overblown and grandiloquent statement, but when one actually considers the influence that Liverpool and the 'Mersey Sound' were then having on the world, then perhaps he was just as accurate in his assessment as Carl Jung had been in his. All seemed well in Liverpool and across Merseyside and people truly believed that a new age was genuinely dawning. But this was a false dawn, because a commercial storm was

heading towards the region; one that no amount of optimism or self-confidence would easily weather.

Liverpool may have been leading the way in popular music and culture but this was really only a distraction. The post-war boom around the world had indeed proved to be temporary and inflation in Britain was rocketing as the national economy now began to flounder. Across Merseyside and beneath the surface of the hedonism of the Mersey Sound, this was beginning to have an increasingly negative impact. As a seemingly unassailable and powerful global port, Liverpool was about to enter a massive and rapid decline. It also had some fundamental economic and social problems that the city leadership were failing to address adequately.

The Death of the Docklands

Two of the most critical of these issues were slum or sub-standard housing and a decaying urban infrastructure. The population numbers were already in decline and the damage wrought by Hitler's bombs blighted the entire city and its suburbs. Like so many other British cities, Liverpool began to redevelop its town centre throughout the 1950s and 1960s and they also built many new council houses and flats.

Unfortunately, they did so with a blind commitment to the modernist, often soulless glass-and-concrete brutalism of the new wave of building design. The council now gave Liverpool the branding of 'City of Change and Challenge'. However, those pundits and members of the public who were more heritage conscious and community minded quoted this as 'City of Change and Demolition'. In fact, it was being said on many street corners and in many pubs, that the city council was doing more damage to Liverpool than the Nazis had.

Also, the heart of Liverpool was being gutted, not just by the wholesale pulling down of important nineteenth- and early twentieth-century commercial buildings, but by the bulldozing of large areas of residential streets. While great tracts of Liverpool's remaining slums were necessarily swept away, so were streets of perfectly sound and comfortable terraced houses. Entire communities were uprooted from their traditional neighbourhoods and broken up, and well over 160,000 people were displaced to large new housing estates, many outside the city boundary.

Places such as Kirkby, Runcorn, Skelmersdale, Cantril Farm and Netherley, had been designed by architects who seemed to give little thought to the fact that they were building for people and for families. Perhaps focusing rather on winning awards from their professional peers, they created some of these 'overspill estates' without public transport facilities or shopping centres. Others had no cinemas, pubs, or recreational spaces, while some had no schools. Others even had no footpaths or walkways.

Designers and planners seemed to think that traditional streets were now socially unnecessary or not modern enough. As a result, people's homes were being built

in great swathes of high-rise tower blocks, or in one- and two-storey walk-ups. New housing estates were also being constructed with groups of dwellings in odd configurations and juxtapositions. Trying to find the right address and front door certainly confused postmen, milkmen and refuse collectors, as well as their residents.

All of these problems created by the architects, local and national government planners and policy-makers had major negative effects of the self-esteem and quality of life of people on these estates. These communities had largely been unwillingly transplanted and now felt increasingly undervalued and clearly under-serviced by their city. This also led to a stunting of social and career aspiration. As the 1960s became the 1970s, Britain and especially Merseyside, went into a deep recession. This worsened dramatically by the time the 1980s began and the resulting rapid increase in unemployment fuelled social breakdown and a rising crime rate.

While this 'urban renewal' was underway, a major contributor to Liverpool's economic collapse in particular was the decline of traditional international and especially transatlantic maritime trade. What remained of this industry was largely focused on the rebuilding of the war-ravaged European economy. The continent needed a wide range of raw materials and commodities to fuel the reindustrialisation of commerce and manufacturing; Liverpool, looking out on the Atlantic, was simply facing the wrong way.

Added to this was the loss of our equally traditional trade with the British Empire. The countries of Africa and the Indian subcontinent, among others, were continuing to steadily gain their independence. These new nations were now establishing different trading partners, as they were no longer tied to the 'Mother Country' and to Liverpool.

As we have seen, for centuries thousands of ships had come to the port from all over the world, bringing foodstuffs, spices, tobacco, cotton, livestock, trade-goods, fabrics, minerals, metals and machinery. These had been the raw materials and goods that had driven the Industrial Revolution and the expansion of Britain and its empire and these had to be transported, loaded, unloaded and moved. Despite the growth of mechanisation, throughout the nineteenth and twentieth centuries, manpower remained the cheapest and most effective method of cargo-handling.

At their peak of operation, Liverpool's docks had employed 25,000 dockers and were a hive of day- and night-time activity, from Seaforth at the north end to Garston at the south. There were times, in the 1960s, when over 100 vessels could be moored in the port, which is why the Liverpool dockers were so vital to the life of the Mersey. Unfortunately, the supply of labour had always exceeded demand, especially before the Second World War. This was because the population seeking jobs was ever increasing, so work on the docks was often irregular and largely on a casual basis.

As if life for the dockers was not already hard enough, by the late 1950s the first use of large, standard-size metal containers to transport bulk quantities of

Derelict docks.

goods developed. This had begun with American shipping lines, but was almost universal by the 1970s. This now made a devastating impact on Liverpool's docks and dockers.

The commercial advantages of these shipping containers were that they could be loaded anywhere and then transported by road or rail to docksides. Next, special hoists and cranes would lift them directly onto a new breed of large container-carrying ship. These would then sail to their destinations where unloading and onward haulage were equally mechanised. This meant that a vessel could now be completely loaded in hours instead of days or weeks and so the economics of this reshaped international shipping.

Initially however, Liverpool's docks were too small to accommodate the larger ships now wanting to use the port and the Mersey Docks & Harbour Board did not have the container-handling cranes or transportation systems necessary to service this increasing demand. The port lost considerable trade as a result, unemployment on the docks rose quickly and the Harbour Board was hit by a

severe financial crisis. This almost forced the organisation into bankruptcy and complete closure, so, in 1970, the government wrote off £100 million of its debts and sold it off as a private organisation: the Harbour Board now became the Mersey Docks & Harbour Company.

Eventually though, the port upgraded its facilities to be able to meet new commercial demands and because the process of handling shipping containers was almost completely mechanical, thousands more Liverpool dockers now found themselves without a job. Completely inadequate management methods and staggeringly poor labour relations on the part of the port authorities resulted in strikes, closures, sackings and redundancies throughout this period. The Port of Liverpool soon became synonymous with industrial strife and the words 'Liverpool dockers' and 'strike' became inextricably linked.

Towards the end of the 1980s there was also a national downturn in the maritime industry. This led to a national dock strike in which Liverpool dockers were among the most determined participants. In due course this was resolved, but only temporarily. The massive reduction in dock labour continued and industrial unrest was always fermenting just below the surface of the apparent calm.

In 1995, another fierce dispute broke out between Liverpool's dockers and their employers, when a further massive increase in the containerisation of cargo handling was brought in and there were significant lay-offs and sackings. The employers refused absolutely to negotiate and so the Liverpool dockers had no other recourse than to take strike action once again. The company retaliated by immediately sacking eighty of the strikers. The dockers responded by setting up an unofficial picket line and the next day, a further 329 men were sacked for refusing to cross this.

A London-based company was then brought in by the employers to recruit replacement labour. These men were regarded as strike-breakers and scabs by the striking dockers, which led to many outbreaks of violence at the dock gates. This strengthened the determination of the dockers not to give in and the strike lasted for an unprecedented 850 days.

However, the ultimate victory of the employers was inevitable, as they were over-manned anyway and so the sacked dockers finally had to admit defeat. Many reluctantly accepted a severance-pay offer of £28,000 each, while others were given other jobs. Many, though, received no such payments or job offers and were regarded as martyrs and folk-heroes by many in the labour movement, both locally and nationally. The way of life for the dockers and of labour systems on the Liverpool docks had now changed forever.

Because Liverpool's economy and commercial structures were so tied in to the maritime industry, the knock-on effect of its decline was enormous. Supply companies to shipping lines now began to fail and close. These included insurers and brokers of all sizes, as well as a vast array of manufacturing, provisioning and servicing companies. Their former employees now swelled the ranks of Merseyside's unemployed.

In an attempt to address the developing employment crisis, the Local Authority with some government backing, had offered lucrative incentives to a wide range of

large employers to set up factories in the city. These were located at new industrial estates serving the equally new overspill towns, such as Kirkby and Skelmersdale. They were also building factories to provide jobs for displaced people now being moved to outlying districts of Liverpool, like Aintree, Speke, Huyton, and Halewood.

However, an essential requirement of most of these companies was that their manufacturing processes had to principally consist of production lines. This was because the Liverpool workforce was largely unskilled and blue-collar. Over the centuries, the main activity of Liverpool's workers had simply been to move things around. They had just loaded, unloaded, carried and transported commodities and goods from one place to another, which are occupations that require very little skill.

Even though most workers were both willing and eager to be in full-time, fairly paid jobs and were equally willing to be retrained and up-skilled, local and national government felt it would be cheaper and less complex to just replace one set of menial occupations with similar ones. The people of Liverpool had made billions of pounds for Britain and her empire for hundreds of years, but the short-sightedness of politicians of all parties was now failing them.

Governments also failed to recognise and accommodate the proud independent will of Liverpudlians that, in fact, had always driven the city to greatness. The management of the companies then setting up around the city also made the same mistake. Instead of engaging with, consulting, sharing, involving and inspiring their workforces, which is how any business succeeds, they simply ordered their employees to comply with outdated managerial practices and often inadequate working conditions and pay levels.

As a result, the workers felt disrespected and underrated, which is something that particularly irks Liverpudlians and so their response was predictable. Soon, industrial unrest and strikes became endemic across these newer industries too. This further fuelled the economic decline and social collapse, as many companies simply closed up and moved away, rather than invest in developing their management skills and labour relations. This began to entrench government hostility towards the city and the region, as Liverpool rapidly became an unemployment black-spot.

In parallel with the downturn in employment, the population of Liverpool continued to fall dramatically. From the pre-war peak of just under 900,000, by 1971 the number of people living within the city boundaries had fallen to 610,000. By 1981, the figure had reduced to a catastrophic 510,000. This meant that while Liverpool had an infrastructure for almost 1 million people, it did not have enough ratepayers or revenue streams to adequately fund this. The city was soon on the verge of bankruptcy. All of this, together with the policies of the then Conservative Government, drove many people in Liverpool to absolute desperation. The city became a powder-keg of unrest and an explosion was inevitable.

A Community in Flames

At the southern fringes of Liverpool town centre sits the very ancient district of Toxteth. At the beginning of this story of Liverpool, I described how the vast forest that once covered this large urban residential district had been one of the reasons that convinced King John to come here in 1207. The monarch's former royal hunting forest has been densely populated for almost two centuries and bisecting modern Toxteth is the wide, mid-Victorian dual-carriageway of Princes Road and Princes Avenue, also known locally as 'The Boulevard'.

On either side of this attractive, tree-lined and busy thoroughfare stand terraces of grand three- and four-storey town houses. These had been built from the mid-nineteenth century, to accommodate the families and servants of aspiring middle-class professionals. Then, in the early years of the Second World War, many of the affluent owners of these properties and of those in the streets branching off the Boulevard had been able to evacuate themselves to safer places outside the now bomb-ravaged city.

After the war many owners sold or sub-let their homes to new landlords who then converted the buildings into flats and apartments. The properties were soon being used to rehouse the largely mixed-race communities that had been bombed out of dockside streets. Even so, by the 1950s, many of these multi-occupancy flats and houses were still empty. They were soon occupied though by hundreds of new immigrants coming into Liverpool, mostly of Afro-Caribbean descent. These British citizens had been specifically invited into the country to ease the post-war labour shortage. Following the short-lived post-war boom though, these new Liverpudlians too became victims of the recession.

While racism has always been less prevalent in Liverpool than elsewhere, it certainly existed to such an extent that black and Asian immigrants in particular found it difficult to get work. The population of Toxteth at that time was 60 per cent black, Asian, ethnic minority and mixed-race and because of a combination of institutionalised racism and unequal educational opportunities, 52 per cent of those people were unemployed.

Many families were living on or below the poverty line and with landlords failing to adequately maintain their properties, Toxteth soon became one of Liverpool's and Britain's worst areas of economic, environmental and social deprivation. From 1975, I had been working as the Community Development Officer in Toxteth, employed by the local community council. My main job was to establish, capacity-build, empower and resource a wide range of resident and community groups. It was also my role to initiate and drive forward a series of issue-addressing projects.

I remember only too well the inequalities, frustration and anger that people shared with me during the surgery and advice sessions that I held in my office. Then from 1978 onwards, the nature of their requests for advice and support

moved away from concerns about the lack of jobs, rat infestation, housing decay, and bad street-lighting. Black residents especially were beginning to tell me more and more about their personal experiences of police harassment, unjustified arrest, abuse and brutality.

Throughout the poorer areas of Liverpool, but especially in Toxteth, the reputation of Merseyside Police Force at that time was irredeemably bad, particularly for stopping and searching young and adult black men under the infamous 'SUS' laws. This was the informal name for legislation that allowed a police officer to act on suspicion, or 'sus', alone. People were also afraid of having drugs planted on them while being 'stopped and searched'. This was a police tactic that was known as 'agriculture' or 'going farming'.

The force was also notorious for extremely insensitive, heavy-handed and frequently racist policing of what remains a multi-racial but predominantly black area. People felt they were being targeted simply because of their skin colour and they risked being stopped, or worse, by the police, simply for walking down a street or for driving a vehicle.

Indeed, one afternoon I was chatting with a number of people on Granby Street, which runs through the heart of Toxteth, when a police car approached us. Suddenly, the vehicle slowed down, the officer driving wound down his window and he yelled at us, 'White Power!' as he then sped away. Such openly racist incidents were far from unique and lodging a formal complaint was always a futile exercise. For almost two years, tensions in the area between the police and local black youths had been rising. Ken Oxford (1924–1998), the chief constable of Merseyside Police, had already declared Toxteth to be, 'a criminal community' that he 'would police accordingly'.

Chief Constable Ken Oxford and Cllr Margaret Symie.

In desperate attempts to forestall the violence that I felt was increasingly inevitable between the police and the local community, I and many other community workers and leaders, black and white, had been calling out for changes in official policy and tactics. With the unstinting support of local ward councillors, we asked for an urgent and radical overhaul of community relations and for serious social and economic investment in the lives and opportunities of Liverpool's minority communities. The police refused to respond and the leaders of the city council continually cried poverty.

Of course, it was not only in Liverpool that official failure to address such issues was driving ethnic and other deprived communities towards open and violent rebellion. This first came to a head in April 1980, in Bristol's equivalent to Toxteth, the predominantly black district of St Pauls. Following a catastrophically miscalculated, massively over-manned and violent police raid on a café serving the black community, the streets of St Pauls erupted into violent riot.

Tensions rose so much in Liverpool as a direct result that on 6 June 1980, I wrote to Chief Constable Oxford. I sought to warn him that, directly as a result of his own policies and policing methods, violence was likely to erupt in Liverpool too and that this would be of an unprecedented nature. He subsequently summoned me to meet him on 2 July 1980, in his office at police headquarters. Tragically, he completely failed to take me seriously and denied absolutely that there was any racism in his force, despite my first-hand evidence to the contrary. He simply demanded that I provide him with the names and addresses of 'every person in Toxteth who intends to riot'.

As soon as I pointed out how ludicrous this was on so many levels, he brought our meeting to an end by declaring that, 'Mr Pye, I will tell you two things: there will never be riots in my city and if there ever are, I shall contain them!' One year later the blind arrogance of this very senior police officer would lead directly to him being proved drastically wrong on both counts.

In April 1981, the predominantly black community of Brixton in London took to the streets in riot and for the same basic reasons that had caused the Bristol riots. I immediately asked for another meeting with Oxford, but he refused to respond. Then on 3 July 1981 some of the chief constable's officers badly mishandled an incident on Granby Street. This would directly trigger on the streets of Liverpool the worst public disturbances seen on the British mainland since the Civil War in the seventeenth century. What became known the world over as 'the Toxteth Riots' had begun.

Periodically, throughout July and early August of that hot summer, large numbers of black and white people poured onto the streets, not just of Toxteth but right across the city, with the specific intention of fighting the police. Full-blown battles took place between vast crowds of rioters and rank upon rank of police from forces all over England. The police were armed with shields and batons, as well as other unofficial weaponry, to protect themselves against the sticks, bricks, baseball bats and petrol bombs that were being hurled at them by the rioting crowds. At one point the violence escalated so much that the rioters

had complete control of large sections of Toxteth and other districts and the damage and injuries that resulted were unprecedented.

In all, there was one civilian death, over 1,000 police officers were injured as were many rioters, 500 people were arrested, £11 million worth of damage was caused to property and over seventy buildings had to be demolished as a direct consequence of the violence. Also, this was the first time that CS gas had ever been used on the British mainland. This was fired into a crowd in an unsuccessful attempt to quell a disturbance.

The major outbreaks of violence lasted a few days each and then they simply seemed to exhaust themselves. The police eventually regained control of the streets only when the rioters became bored and decided to go home. By the end of August, the street violence had finally petered out and a pall of depression and frustration settled over Liverpool.

It is often mistakenly assumed that the riots were 'race riots', that is 'black versus white' in a racist battle. This is absolutely not the case. The Toxteth Riots were a war: a conflict between a demoralised and desperate community, predominantly but not exclusively black, and a thuggish, brutal and bleak policing strategy. Throughout that summer many of the country's urban communities were in similar crisis and there were outbreaks of street violence in forty other British towns and cities. In the words of Dr Martin Luther King, 'Riots are the language of the unheard.'

Apart from the destruction, a further consequence of the Toxteth Riots was that Liverpool was nearly destroyed as a functioning city and the Conservative Government of the day was thrown into turmoil. Indeed, at one point, the then Prime Minister Margaret Thatcher (1925–2013), was actively considering replacing Liverpool City Council with direct rule from Westminster. The only other city in the UK to have been directly governed from London had been Belfast during the height of the 'Troubles' in Northern Ireland.

I had been on the streets every night of the violence with many other community leaders. We mediated where and when possible and tried to dissuade anyone we recognised or knew from taking part in the fighting or looting. We led the innocent away from the violence and forced curious and excited children to go back home, hoping that their parents were not among the rioters. We tended the injured police and civilians, but mostly there was little we could really do; this was a juggernaut that just had to roll on its destructive course.

My recollections of the fires and petrol bombs, of the running battles between the police and the mob, of the looting, the destruction and the terror of local people trapped in an almost apocalyptic scene, remain as vivid now as they were immediately after the events. With remarkable clarity I can still smell the smoke, the tear gas and the blood, I can hear the shouts, the screams and the crying and I can still feel the physical searing of the flames and the emotional scorching of the anger, the outrage and the fear, on both sides of the conflict.

Subsequently, under a much more enlightened regime than that of Kenneth Oxford, Merseyside Police admitted to 'institutionalised racism'. Under new

leadership, this was tackled directly and vigorously. This ultimately led to an announcement made by leaders of the black community in Liverpool that for the first time ever, they could now 'do business with Merseyside Police'. This statement was one of profound significance. Sadly however, many scars of the riots can still be found in the physical landscape of Toxteth and in a fragmented and unfortunately still somewhat disillusioned community in the district, even over thirty years later.

The violence attracted intense, inevitably negative worldwide media attention. For many years this gave the community of Toxteth and the people of Liverpool an undeserved reputation that further prejudiced the national view of the city. But the economic decline and mass unemployment in Liverpool continued and a television drama concentrating on the effects of this would once again throw a negative, if accurate, national spotlight onto the city.

The Boys from the Blackstuff

The stark and uncompromising contemporary BBC2 television series *Boys from the Blackstuff* was set in Liverpool and first broadcast from 10 October to 7 November 1982. This had been written by the Liverpool playwright Alan Bleasdale (b. 1946), as a sequel to his television play *The Black Stuff*. In five episodes and focusing on one character each week, the drama told the stories of a group of five working-class Liverpudlian friends, each unemployed and each struggling in their own way to come to some sort of terms with a radically changing way of life.

The plays also threw a harsh, revealing and very public spotlight on how the ineptitude of local authorities and the impact of the uncompromising political ideologies of the national government were corroding individual hope and the will and aspirations of entire communities. *Boys from the Blackstuff* specifically exposed how Liverpool and its people were on the edge of being irretrievably destroyed by slow, excruciating inches.

Each of the leading characters was memorable, even though some were more powerfully portrayed than others. The marital breakdown of Angie and Chrissie Todd, played by Julie Walters and Michael Angelis, was especially emotional. The ultimate defeat and hopelessness of dying working-class champion George Malone, played by Peter Kerrigan, was both poignant and agitating, but the portrayal of Yosser Hughes had the most impact of all.

Played by Bernard Hill, who would go on to portray King Théoden in Peter Jackson's *Lord of the Rings* trilogy, Yosser is driven to a complete nervous and psychological breakdown because of the loss of his job. Everything he believes in, not least of all his male pride and working-class credibility, are supplanted by an impotent despair. This becomes most destructive as he loses the capacity to adequately look after his children, whom the social services are determined to take from him. His descent into panicked desperation and his continual recitation of

the phrases 'Gizza' job!' and 'I can do that!', summed up perfectly the emotions of so many of the unemployed across Britain.

The series was so successful that only nine weeks later it was repeated on BBC1. It captured massive viewing figures and provoked national reaction and debate. This was because of its frank depiction of the destructive psychological and social effects that unemployment has on its victims and their families, as well as on their economic security and social stability.

Unemployment was now biting right across Britain in all industries and sectors and over 2.5 million people were out of work. It was also stated in parliament that 6,000 more were joining the dole queue every day. To throw the public spotlight on these appalling figures, the Merseyside County Association of Trades Councils decided to organise a protest march to London. With national support from the TUC and named 'the People's March For Jobs', this set off from Liverpool on 1 May 1981. The march began with 280 people, but thousands more joined along the route. It ended in London on 31 May, with a rally in Hyde Park attended by 150,000 people. The People's March was repeated in 1983, but Margaret Thatcher refused to meet with any of its representatives.

In Liverpool, *Boys from the Blackstuff* had rung so true that the plays had the effect of reinforcing both the desperation and militancy in the city. This increasing groundswell of working-class resentment fuelled a strengthening of left-wing and union activism, which only exacerbated a worsening political climate. In particular, and helping to shape the negative way the rest of Britain regarded Liverpool, were the policies and actions of its city council, especially those of its Deputy Leader.

Labour Councillor Derek Hatton (b. 1948) was a leading member of the extreme left-wing 'Militant Tendency' in Liverpool. This was a Trotskyist faction of the Labour Party, whose political tunnel-vision and partisan politics are often cited as being what administered the fatal economic coup-de-grâce to Liverpool and Merseyside at the close of the twentieth century. It is indeed true that it has only been in the last decade that Liverpool and the region has been able to finally overcome his legacy.

From 1983, Hatton was the deputy leader of the city council, but his dominance of the party and the council overwhelmed the much more retiring and gentler personality of its official leader, Councillor John Hamilton (1922–2006). Hamilton was a dedicated local politician, who genuinely cared for his constituents. His strongly held Quaker beliefs confirmed his political and personal integrity and guaranteed that he had no other motive than to serve Liverpool and its people, especially its working class.

Hamilton, like so many others, was therefore easily dominated and influenced by the aggressive personality and belligerent rhetoric of his deputy. This was a time when a thriving private sector was desperately needed to finance economic growth in Liverpool. However, while the economic decline of the city pre-dated the Hatton era, the ideology of the Militant Tendency actively deterred serious potential investors. In effect, Liverpool was 'closed for business'.

This was a time too, when the council abolished the ancient title but important constitution role of lord mayor and replaced this with the title of 'Council Chairman'. They also looked seriously at the demolition of major civic buildings, such as St George's Hall, and selling off the land. This, with other important buildings, was considered by Hatton to be a redundant example of right-wing imperialism. Fortunately, these sterile proposals came to nothing; St George's Hall survived and the position of lord mayor was eventually reinstated.

Derek Hatton and his colleagues in the local militant movement clashed directly and repeatedly with Margaret Thatcher's government. This included, in 1985, their refusal to set a legal council budget. The council then adopted a 'deficit budget' in which spending exceeded income and so created a major financial crisis. This further alienated the city from national government and undoubtedly affected their policy-making towards Liverpool and the region.

However, Hatton also regularly clashed with his own National Labour Party, under the then leadership of Neil Kinnock (b. 1942). The Liverpool Labour Party eventually succeeded in expelling the members of Militant Tendency and Hatton himself was expelled from the national party in June 1986. Labour's national executive had been eager to rid themselves of a man who was certainly a public relations disaster for the party. This was at a time when they were becoming more confident of defeating the Tories in the forthcoming general election. They used Hatton's membership of the Militant Tendency against him, as well as the results of an internal investigation that had accused him of manipulating local party rules. Hatton was later tried in court for corruption and fraud, but was acquitted of all charges. He subsequently left politics.

For Liverpool though, the damage was done. The impression of Liverpool and its people held by the rest of Britain was now one that was mostly entirely negative. The stereotypes of the lazy, work-shy, militant, dishonest 'Scouser' now became firmly embedded into the national consciousness. Militant Tendency and the council's absolute inability to run the city responsibly or deliver services effectively, certainly contributed to this view.

In 1984, in a televised lecture broadcast on national television, the Anglican Bishop of Liverpool, Rt Revd David Sheppard (1929–2005), pleaded with what he described as 'comfortable Britain', not to sit back in their complacency at a time of national social catastrophe. Always a passionate advocate for the people of his city and region, he demanded that the country should see beyond the media and government descriptions of Liverpool, Merseyside and of Britain's other failing industrial and urban conurbations.

Between 1966 and 1977, around 350 factories had either closed down completely in Liverpool or simply moved away, resulting in the loss of 40,000 jobs. Between 1971 and 1985, employment in the city fell by 33 per cent. Between 1979 and 1981, employment dropped a further 18 per cent. In the year of the Toxteth Riots, 20 per cent of the city's working population was unemployed and at the time of the bishop's lecture, there were only fifty jobs available for every 13,000 people registered as unemployed in Liverpool.

The bishop, also speaking on behalf of Liverpool's Roman Catholic Archbishop, the Most Revd Derek Worlock (1920–1996), urged the nation to acknowledge the harsh realities that the unemployed were facing. He insisted that they reject party political prejudices of all colours to fight for a fairer and more compassionate society.

Although some right-wing newspapers were critical of the bishop's lecture, the government was shocked by the overwhelmingly positive and supportive reaction his broadcast provoked, from the public and across the media. Throughout Britain, the negative images of Liverpool and its people were already beginning to soften. Nevertheless, the economic reality was still that the city needed some form of miracle if its degeneration was not to become terminal.

What was then completely unknown, however, and not just on the streets of Liverpool, was that the British Government had already decided that the city should be deliberately left to die. Secret cabinet discussions had been taking place within the Thatcher Government and these had begun immediately following the Toxteth Riots. The full extent and tone of these were only revealed in 2011, with the release of previously confidential government papers under the thirty-year rule.

Thatcher and her Conservative Party knew full well in 1981 that they were regarded in Liverpool as being completely indifferent to the industrial decline across Merseyside. She was convinced that the city and its surrounding communities was nothing more than a place of permanent industrial unrest, civil degeneration, political militancy and terminal urban decay. A few of her ministers though, notably the then Secretary of State for the Environment, Michael Heseltine (b. 1933), now Lord Heseltine, were arguing that riot-hit communities should be actively regenerated. Regardless of the authority behind such arguments, the Prime Minister preferred to listen to the alternative view held by many of her other cabinet colleagues, led by Sir Geoffrey Howe (b. 1926), now Baron Howe of Aberavon. He believed that declining industries and communities such as Liverpool should not be propped up at all and should be left to succumb to a process of inevitable attrition. Thatcher shared his view.

Howe, who was then Chancellor of the Exchequer, thought that to provide any form of economic or social resources to Liverpool would be a waste of money. In a letter he wrote to the Prime Minister at the time, which was then discussed in Cabinet, he warned Mrs Thatcher,

> not to over commit scarce resources to Liverpool. I fear that Merseyside is going to be much the hardest nut to crack. We do not want to find ourselves concentrating all the limited cash that may have to be made available into Liverpool and having nothing left for possibly more promising areas such as the West Midlands or, even, the North East.
>
> It would be even more regrettable if some of the brighter ideas for renewing economic activity were to be sown only on relatively stony ground on the banks of the Mersey. I cannot help feeling that the option of managed decline is one which we

should not forget altogether. We must not expend all our limited resources in trying to make water flow uphill.

Howe acknowledged that the suggestion Liverpool could be deliberately left to decline was potentially explosive and he went on to warn his leader that, 'This is not a term for use, even privately.'

The eventual release of these cabinet documents only confirmed a long-held conviction in Liverpool that there had always been an official and premeditated neglect of the city. Back in the 1980s though, and by now entirely fed up with the lack of political vision and unimaginative leadership of the city, the people of Liverpool demanded and forced a change of attitude in the city council. In a powerful backlash against the legacy of Hatton's methods and policies, the city's leaders, together with agencies and organisations from all sectors, began to forge new and effective social and commercial partnerships. They realised that this was the only way to stop Liverpool's otherwise inevitable downward spiral into bankruptcy and total collapse.

This new strength of purpose and focus laid a foundation upon which regeneration projects could be built. However, and despite Liverpool's total lack of faith in the government, what was to become the renaissance of the city would actually be driven by a member of the Thatcher Cabinet – it seemed that a miracle was indeed about to take place.

The Road to Renaissance

The Minister for Merseyside

In 1981, during the cabinet discussions about the future of Liverpool, there had been at least one minister, Michael Heseltine, who completely disagreed with the attitude of Geoffrey Howe and Margaret Thatcher. Heseltine, who was the then Environment Secretary, realised that with appropriate government initiatives and funding, Liverpool and its port could not only be saved but that it could be completely reinvented and regenerated. Speaking in 2011, immediately after the release of the secret government papers, now Lord Heseltine said of the idea to abandon Liverpool,

> It never really got any traction for the simplest reason that the Cabinet Minister responsible for so much of the policy that affected the City was me. I simply wouldn't countenance that you could say that one of England's great cities, a world city, was going into managed decline here.

During the time of the Thatcher administration, Heseltine had always been a political thorn in the side of the Prime Minister and a potential threat to her leadership. So when he suggested to her that he should go to Liverpool himself to see what could be done, she was delighted to get him out the way. When the Prime Minister had met with Bishop Sheppard and Archbishop Worlock in the immediate wake of the riots, the Liverpool Church leaders had pleaded with her to send some form of dedicated 'Minister for Merseyside' to their city. The media and the public soon identified Heseltine with this unofficial title and the label stuck.

Thatcher now quite happily despatched the flamboyant and energetic MP to the north, on what she expected would be a fool's errand that would damage his career. But the Prime Minister would be proved wrong, because one of Heseltine's first actions was to take oversight of the Merseyside Development Corporation (MDC).

Michael Heseltine in Liverpool.

Earlier that same year, an act of parliament had established the MDC as one of thirteen urban regeneration agencies around the country. The mission of the MDC was to 'secure, in partnership with others, advances towards self-sustaining regeneration on Merseyside' and it was to do so particularly by trying to 'bring life back to 865 acres of degenerated dockland on both banks of the Mersey'. This area included all of Liverpool's south and central docks, substantial parcels of land at Bootle and also dockland at Birkenhead and Wallasey. Heseltine saw that this would be an ideal vehicle through which he could operate, by ensuring that the corporation's energies were directed where he saw the most need.

His arrival on Merseyside was treated in most parts of Liverpool with considerable scepticism and with some hostility. Even so, he immediately went out onto the streets and into the most deprived districts, not only to Toxteth, to hear from the people directly. Typically of Liverpudlians, they told him in no uncertain terms about their lives, ordeals, complaints and their hopes. Adults, young people and children all spoke with sincerity and impressive clarity and the multi-millionaire MP was shocked by what he was learning. He stayed on Merseyside for almost three weeks and in his autobiography, *Life in the Jungle*, published in 2001, he commented,

> Day after day we walked the streets of Liverpool. In a hectic series of visits here and consultations there, we travelled hither and thither in a blaze of publicity. 'Why do

you waste your time there – with them?' I was asked again and again by Conservative sympathisers in the prosperous suburbs. 'There are no votes for us.'

But within days a pattern clearly emerged. Put simply, this was a city without leadership. It was that void it was hoped that I could fill. It was almost as though, subconsciously, people were waiting for it to happen. The apparent goodwill for a new direction was expressed on all sides.

The Environment Secretary identified his priority tasks by holding extensive discussions with politicians and professionals across the city, including me, as well as with local community representatives and residents. My politics were certainly not those of Heseltine and we fell out very publicly in a televised debate at the time, over the true nature of democracy.

As with most national politicians and especially members of the Conservative Government, Heseltine had never truly understood what urban decay and poverty really meant to the people for whom these were facts of life. However, his re-education was both rapid and comprehensive. While I also took some convincing about his motives and ability to deliver what Liverpool and Merseyside really needed, I could not fault Heseltine's integrity. I soon found as well, that his commitment to finding a genuine, lasting solution to the region's problems was indeed sincere.

The MP worked tirelessly to find ways of kick-starting the economic growth of Liverpool and of greater Merseyside and these needed to be very public, inspiring and instantly appealing to the widest number of people, especially the residents of places like Toxteth. Heseltine fully understood now too that any new initiatives would also have to convince investors, pundits and his fellow politicians back at Westminster that Liverpool still had the capacity and creativity to overcome its problems.

One of the first things that Michael Heseltine did to rehabilitate the image of Liverpool in the eyes of potential investors was to lead a coach trip around the city. On board were key industrialists and entrepreneurs from the private sector all over Britain. They visited many areas of Liverpool, but from a perspective that revealed just what potential the city had for economic and commercial growth. Heseltine also played an ace card when he introduced these initially sceptical passengers to ordinary people. He had been encouraged and inspired himself when he met his first 'Scousers' and their passion and hope made the same positive impact on his 'tourists'.

The minister very publicly established the Merseyside Task Force, which was made up of twelve top civil servants and twelve senior executives from large private sector companies. Government may have resented doing so, but it now began to direct significant levels of grant aid to Liverpool and the rest of Merseyside. The main objective of the task force was to spend this government money on the setting up of major projects that would encourage economic development and create jobs. With Heseltine's guidance, but under the inspired leadership of top civil servant Eric Sorensen (b. 1943), this government QUANGO identified and successfully delivered thirty such initiatives.

In the years following the riots, as well as funding new housing developments, among the other priorities for the task force was the creation of Enterprise Zones. These offered land, support and advantageous financial packages to a wide range of larger companies. The zones were designed to induce them to come to Merseyside to set up factories and offices to employ local people. Youth Training Schemes were also established to up-skill young people and get them into these new jobs. Also, new employers were encouraged to provide appropriate in-house or supported training for new staff. Not only would this increase the company's skills base, but it would open up the job market to many more previously unskilled, or differently skilled adults.

One of the task force's most imaginative projects was the creation of the Wavertree Technology Park in Liverpool, as a base for new companies involved in research, training, development, delivery and manufacturing, in the then embryonic fields of computing and information technology. It would be this initiative that would ultimately put Liverpool at the forefront of information technology, ready for when the digital revolution of the twenty-first century began.

In Toxteth specifically, the task force earmarked £20 million to improve housing and to manage and maintain existing local authority housing estates more effectively. They spent £7.5 million upgrading major roads through the district and on the planting of trees and shrubs to improve the environment in public areas and to overplant waste ground. They also match-funded over £1 million from the private sector, which was spent on the building of new sports and recreation facilities.

At the very beginning of his time in Liverpool, the 'Minister for Merseyside' had a particularly innovative idea. As part of its remit the MDC had taken ownership of a large tract of derelict waterfront land at the extreme south of Liverpool. This abandoned area was in the Dingle district and consisted of disused docks, former chemical dumps and derelict industrial sites, which Michael Heseltine and the MDC planned to reclaim and restore. This would then be transformed into the site of a major public celebration of horticulture, landscaping and gardening known as the 'International Garden Festival'.

This was part of their larger plan to improve the image of Liverpool and of reinventing the city as a tourist and leisure destination; a concept that most Liverpudlians (and the rest of the country) would then have considered laughable.

The industrial sites were cleaned up and reinstated and then filled in with over 30 million tons of city rubbish. Capped with clay as a barrier, 3 million tons of earth was then laid on top of this. The previously flat, polluted and ruined site was now radically changed into the attractive, sculpted hills and valleys that made up the festival area. The land was then skilfully landscaped and planted profusely with trees.

This was the first such event of its kind in Britain and over sixty glorious individual gardens were produced by dozens of teams of gardeners from all over the world. They represented a wide range of environmental themes and international horticultural styles. The Japanese and Chinese gardens were particularly outstanding and featured temples and pagodas designed and built by craftsmen from those countries. These skilled artists had come to Liverpool especially to use their native talents and art forms in the construction and

ornamentation of their national gardens. The exotic buildings they created were an exciting and beautiful tribute to their artistry and culture.

As well as the Orient, among the vast array of nationally themed gardens were displays from India, Africa, America, Canada, France and Australia. The displays also included much British artwork and sculpture, including the Blue Peter Ship on the BBC Garden and a full-size Beatles Yellow Submarine. There was a Sculpture Garden and even a Witches' Garden, as well as a miniature railway, playgrounds and performance areas for concerts and plays. Throughout the period of the festival, there were regular appearances of the very popular children's television character, the magic scarecrow Worzel Gummidge, in the person of actor Jon Pertwee (1919–1996), although less kind commentators at the time confused this character with the then leader of the Labour Party, Michael Foot MP (1913–2010).

A stunning cigar-shaped building named the Festival Hall was also constructed in the heart of the grounds. This cost £2.6 million and was used for concerts, exhibitions and displays throughout the Garden Festival. It was planned that the hall would provide a venue for entertainments and major events once the Garden Festival was over. A publicity brochure for the event stated at the time,

> As this Festival ends, a riverside parkland will be transferred to the City Council, landscaped with water features and exotic pavilions. The Arena, Festival Theatre, and Festival Hall will be available for conversion to a sports and leisure complex to match the city's record for sporting excellence. The Hall has been built so that it can be converted to accommodate a swimming pool as well as a sports hall, squash courts, and other facilities.

Despite some objections from those who felt the festival was merely 'papering over the cracks', in public relations terms at least, the International Garden Festival was seen as a great success both at home and abroad. It had also demonstrated, just as publicly, how previously blighted land could be reclaimed. This was the largest urban reclamation project then ever undertaken in Britain, attracting £12.5 million of government funding. When it was opened by the Queen in May 1984, it proved very popular and was always crowded. The festival ran for just five months, closing in October 1984 after almost 3½ million visitors from all over the UK had passed through its gates. The idea of attracting tourists to Liverpool no longer seemed to be such a far-fetched idea.

Part of the Festival Park was left as public open space and the rest was redeveloped as housing estates. Meanwhile, the MDC sought for a long-term owner and developer for the site, to fulfil the legacy plan, while other tourism developments were also taking shape. It was in 1984 that Liverpool held its first Tall Ships race, and the Beatle City Exhibition and the Maritime Museum opened.

Nevertheless, while all this investment of time and money was taking place however, Liverpool's economy was still very weak. Despite new employers coming into the region, this was hardly making a dent in the unemployment figures. What traditional manufacturing was left was finally closing down and taking thousands

more jobs away from local people. In 1984, the Tate & Lyle sugar factory, deep in the heart of the inner city and on the banks of the Leeds–Liverpool Canal, closed its doors and decimated an entire community in the process.

Britain's membership of the European Economic Community meant the country now had to follow different rules and one of these involved replacing sugar cane, grown in former British colonies of the Commonwealth, with sugar beet, grown on farms in the south and east of Britain. So, Europe might have been putting money into Liverpool but it was also taking it away.

The reasons for this particular closure only reinforced the north–south divide in Britain that by this time had become well established and which continues to exist to the detriment of places like Liverpool. In 1990, the closure of the British American Tobacco factory, also in the heart of the city, would further undermine the local economy and increase unemployment, as would the closing of the Garston-based Bryant & May match factory in 1994.

However, working alongside the task force, the Merseyside Development Corporation also made a real impact. One of the MDCs early flagship projects was the complete rebuilding, restoration and redevelopment of the part-bombed and abandoned Albert Dock warehouses and the silted-up dock itself. In 1983, the MDC had set up the Albert Dock Company and work began immediately. The first phase opened in 1984 and the project was completed in 1998. With its apartments and office accommodations and vast range of leisure and cultural attractions, this continued to promote the city as a tourism centre. The Albert Dock complex is now the largest group of Grade I listed buildings in Britain and one of the country's most visited tourist destinations.

Nevertheless, for every two steps forward that the regeneration process was taking, there seemed to be an issue, crisis, or policy decision that forced it to take one step back. One of these major factors, which limited Liverpool and Merseyside's capacity to function, was the shutting down of Merseyside County Council by the Thatcher Government. The county had been created in 1972, and this had brought the disparate local authorities together under one administrative and democratically elected umbrella, which only worked to the region's advantage. While the name of the county was retained, its governing body was not, and when it ceased to exist in 1986, this led to the fragmentation of the region once more.

However, some of the problems that further set Liverpool back had nothing whatsoever to do with economics or politics. It simply seemed that fate was conspiring against Liverpool.

In the five years following the Garden Festival, tragedy would strike at the heart of Liverpool twice and in ways that would scar the city and its people immeasurably. Both of these major incidents were associated with football, which apart from pop music had been the only thing that Liverpool had consistently excelled at since the war.

In 1985, at the Heysel football stadium in Brussels and during a match between Liverpool FC and the Italian club Juventus, violence broke out on the terraces between opposing supporters. This, combined with a crumbling stadium, led to the deaths of thirty-nine Italians under a collapsing wall. The resulting shame and anguish that was felt in the city was palpable, but then came the Hillsborough football stadium disaster.

In April 1989 at this Sheffield ground, ninety-six people, many of them children and teenagers, were crushed to death. Many more were injured, some critically, and the escalating catastrophe was caused directly by police incompetence and ground mismanagement. The press at the time, particularly *The Sun* newspaper, dramatically and completely falsely accused the Liverpool supporters of drunkenness, vandalism and of the looting of the dead as the tragedy unfolded. Even senior police officers went on to blame the same supporters for the disaster and corruptly falsified their records. They also lied on evidence to hide their culpability for the totally preventable loss of life. It would take over twenty-five years for the truth to begin to come out, but during that time, not only the families of those killed but the people of Liverpool and Merseyside shared a very special form of grief and anger.

Then in 1993, the brutal killing of three-year-old Jamie Bulger by two young boys made international headlines. Although this took place in the town of Bootle, immediately to the north of Liverpool, it once again placed the city at the forefront of disaster and tragedy.

As a backdrop to these dreadful events, the region's economy was taking far too long to recover, unemployment continued to rise and the future was looking increasingly bleak. Throughout the 1980s, though, and into the beginning of the 1990s, the regeneration process and the enterprise initiatives, energised and initiated by Michael Heseltine and delivered by the Merseyside Development Corporation, the Merseyside Task Force and others, had indeed begun to have a transformational impact across Merseyside.

Also, in Liverpool particularly, an initially and openly hostile and largely incompetent civic leadership had been replaced by local politicians who were eager to work in partnership with both the public and private sectors. This new breed of civic leader was eager to continue to invest in the rescue and economic rebuilding of their city.

Even so, it was not only government agencies, politicians and the private sector that were responsible for the redevelopment of Liverpool and the region; the ordinary people and their residents' associations, community groups, faith communities and cultural organisations all played their part. They spent money too; what little they had. They also gave of their time, experience and skill, to make significant contributions to the process. Indeed, without the support and encouragement of the people of the region, Michael Heseltine and his teams would have made little headway. But in 2012, Liverpool publicly acknowledged the key role that the former 'Minister for Merseyside' had played in its initial, post-riot regeneration and rehabilitation, by honouring Lord Heseltine with the Freedom of the City.

Throughout the later 1980s though, the regeneration of Merseyside remained a long, slow, grinding process. Indeed, the fate of the site of the International Garden Festival became a barometer for the larger issues that, in some cases, were slowing regeneration and, in others, stopping it completely.

From 1985 to the early 1990s, Tomorrow's Leisure, an independent amusement and entertainment company, attempted to run part of the site as the 'Pleasure Island' theme park, making use of the Festival Hall. Unfortunately, the noise and disturbance to local people, plus the company's failure to attract appropriate

numbers of visitors, doomed the park. The freehold of the whole Garden Festival site transferred from the MDC to the city council in 1997 and in the same year Tomorrow's Leisure was bought by the London-based development company Planestation. Sadly, the new owners did nothing to maintain the site or its buildings either, because they ran out of development capital and government grants were no longer available for such ventures.

The once stunningly beautiful gardens and parkland, including the specially designed garden buildings and the wonderful oriental temples and pagodas, became overgrown. They all reverted to the dereliction and neglect that had been the state of the pre-festival waterfront. The Festival Hall became dilapidated, a dumping ground for waste and refuse and was subsequently demolished and the site left barren. It was as if the International Garden Festival had never taken place at all. The irony of the situation was not lost on Liverpudlians and the apparent absence of long-term investment, maintenance funding, or creative and sustainable development plans made the future of the site uncertain.

This failure was now becoming typical across the region, as the regeneration process lost momentum. This was despite the number of QUANGOS and agencies still operating on Merseyside. The reason for this became increasingly apparent: money from both public and private sources was running out and the Merseyside economy was nowhere near being self-sustainable.

By the end of the 1980s, Britain was entering yet another deep recession. This would see company earnings decline by 25 per cent, unemployment rise by 55 per cent and mortgage interest rates reach a crippling 15.4 per cent. Thousands of people lost their homes and hundreds of thousands more found themselves on the dole again. Naturally, and as if once again blighted by fate, Liverpool and Merseyside were among the parts of Britain that suffered most of all.

There still remained a legion of issues that urgently needed funding and imaginative solutions, but to the surprise of many people, it was Liverpool's very poverty that was to be the cause of its deliverance. Ironically, this would come from Europe, which in so many ways had been responsible for our initial post-war decline.

Liverpool Resurgent

Immediately after the end of the Second World War, Liverpool set about rebuilding itself. One of the symbols of this was the clearing of the totally bombed-out Lewis's department store and the start of work on a completely new building. This opened in 1951 and the huge bronze sculptural group that dominated the front of the new store and which was to symbolise the new beginning for the city was unveiled four years later. When it was finally revealed to an expectant public, it caused a mixture of shock, amazement and delight. This was because it was a very detailed, gigantic, full-frontal, nude male figure, boldly and defiantly standing on the prow of a great ship. Created by Jacob Epstein (1880–1959), the ship's prow weighs 2½ tons and the

figure itself weighs a further 2¾ tons. He stands at 18 feet 6 inches high overall, but I have no information about any other dimensions associated with the figure. While, and for obvious reasons, the Lewis's statue is referred to locally as 'Dickie Lewis', the formal title of the group is 'Liverpool Resurgent' and for equally obvious reasons.

The start of Liverpool's resurgence, however, did not take place until 1994. The Merseyside economy at that time stood at less than 75 per cent of the European average, and so qualified the region for an initial tranche of European regeneration funding, under the Objective 1 Programme. This was distributed through the ERDF (European Regional Development Fund) and the ESF (European Social Fund) and was matched by £700 million from the British Government. However, this barely made a dent in the major urban renewal and economic challenges that the region still faced; the state of health of Liverpool was still 'very poorly'.

Then, in 1998, a bizarre-sounding statement came from the European Parliament, when it declared that Liverpool and Merseyside were actually poorer than Sicily. What, on the face of it, was a depressing announcement actually proved to be quite the opposite, because in 2000 another £928 million of European money followed. It was now as if the city had been plugged into a particularly efficient life-support system that completely revitalised its regeneration. Work to turn around the economy of Liverpool and Merseyside could now continue with greater speed and effectiveness. Between 2007 and 2013, the North West would benefit from a further £700 million injection of capital funding, which kept up this vibrant momentum.

This new money was coming into Merseyside via two government agencies, the North West Development Agency and Government Office North West. Liverpool City Council knew very well that this funding had to be spent strategically, effectively and above all, efficiently. The council had the vision and the will and it now had the skilled professionals to deliver these objectives. Organisations such as the Speke-Garston Development Company, Liverpool Vision, the Liverpool Land Development Company, and Business Liverpool were among the QUANGOS that were also now set up by the council. Also, the Mersey Partnership was created by the private sector to promote tourism and inward investment across the region. Each of these had very specific spending objectives and the European money, together with new rafts of government grants and private sector investment, was divided between them.

Serious investment was now made in education and training, as well as in enterprise development and in targeted job creation. Housing too saw major new investment, as did the urban environment and the infrastructure of the region. Roads, railways and bus services were improved and the construction of new retail, commercial, enterprise and science parks soon attracted serious private sector inward investment. Companies were now setting up on Merseyside because it made profitable, sustainable, economic sense to do so.

European money was also what allowed one of Liverpool's most underdeveloped assets to begin to reach its full potential: Liverpool Airport.

Even though the city suffered dreadful bombing during the Second World War, Speke Airport, which had been a major target, stayed open and fully functional

throughout the conflict and it played a key wartime role. On what was to become the post-war Dunlop factory, adjacent to the airfield, fighter planes had been built and then simply wheeled out onto the runway ready for action. From Speke, not only British pilots, but Polish, Czech and American airmen flew to take on the Nazis.

After the war, businesses were drawn to the airport zone and it was quite busy. However, as the rest of Liverpool declined throughout the 1960s and 1970s, so did Speke Airport. Its surrounding and associated businesses also now began to close or move away. Always under local authority ownership and control, it was recognised that money had to be spent to upgrade the airport. So, in 1986, a new Liverpool Airport terminal and longer runway had been opened to provide a much more modern facility. Largely funded from Europe, this was built half a mile away from the original terminal buildings, which, together with the original runway, now joined the catalogue of redundant buildings in Liverpool that were falling into neglect and decay.

In 1990, the airport was privatised, with British Aerospace (BAe) taking a 76 per cent share, and the remainder staying with the five Merseyside Local Authorities. In 1997, the BAe share was bought by Peel Airports Ltd., part of the Peel Group. This company then invested seriously in the facility, again supported by significant Objective 1 grants. Over the following few years the terminal buildings and facilities increased in size and improved in quality at a phenomenal rate. The airport is now a major source of revenue and prestige, not only for Liverpool, but for Merseyside and the North West.

As part of a major rebranding process and as a tribute to John Lennon (1940–1980), it was renamed 'Liverpool John Lennon Airport' in March 2002, by John's widow Yoko Ono (b. 1933). The new terminal complex was then officially opened in July 2002 by Her Majesty the Queen. She also unveiled the motto of the airport, which is taken from the lyrics of John Lennon's song 'Imagine' and quotes: 'above us only sky'.

In 1996, the airport had handled 500,000 passengers, but the investment in the facility meant that by 2013, 4.2 million people a year were going through its passenger gates. Liverpool JLA is now the twelfth-busiest airport in the UK, with flights to approximately sixty destinations in Britain and across Europe.

Fortunately, as part of the later regeneration of the Speke and Garston districts of Liverpool, the original airport terminal building, which is Grade II listed, was completely refurbished and restored to its original 1930s art deco splendour. In 2001, it reopened as a luxury hotel, which continues to be very successful.

In assessing the best ways to invest in a sustainable economy and continuing growth for the city, Liverpool recognised that it did indeed have some major assets to develop and exploit. The most obvious of these were its association with all forms of art and popular music, especially The Beatles, its internationally renowned football clubs and its outstanding waterfront and docklands, the restoration and redevelopment of which was still underway. Each of these were next to become the focus of major public and private sector development initiatives.

Even so, it was clear that European money was still not getting to some of the most deprived areas of Liverpool and unemployment was still an issue. People

were jaded by the decades that had passed since the riots, without any measurable difference being apparent in their basic quality of life and opportunity. Since the collapse of the economy after the war, most Liverpudlians had become increasingly cynical and jaded about promised change.

Indeed, Liverpool's fall, from being the 'Second City of the British Empire' to becoming a 'commercial has-been and national laughing stock', had been so rapid and humiliating that their self-belief was at an all-time low. While Liverpool's citizens could see new buildings going up all around and there were indeed clear improvements to many other aspects of their environment, they were deeply sceptical about its sustainability.

Within the city council too, there was a sense that the regeneration process, despite the massive injections of cash, was losing focus and running out of steam. However, it then suddenly seemed as if fate had now decided to smile on Liverpool for a change. This was because in 2003, two announcements were made that would ultimately restore the self-confidence of Liverpudlians. These would also re-energise the local authority and its development agencies and partnerships. They would also attract greater private sector investment in the city, as Liverpool's self-confidence put confidence back into the marketplace. Britain and the world would now be forced to acknowledge the genuine resurrection of Liverpool and once again appreciate it as a vital national and international resource.

City of Culture and Heritage

This all began on 4 June 2003, which would prove to be one of the most significant dates in the modern history of Liverpool. On that day at 08.11 a.m., Tessa Jowell MP, then the Secretary of State for Culture, Media & Sport, announced in London that Liverpool had been selected as the nominated British city for the title of European Capital of Culture for the year 2008. That would be Britain's official year to carry the title in the international competition, so this meant that we would definitely be awarded the honour. It also meant that we had beaten the other finalists: Birmingham, Bristol, Cardiff, Newcastle Gateshead, and Oxford – stiff competition indeed.

Liverpool had won the unanimous support of the panel of judges, who had visited the city many times in the lead-up to their final decision. The chairman of the panel, Sir Jeremy Isaacs, said that he had been particularly impressed by Liverpool's plan for an eight-year programme of culturally themed years, leading up to and beyond 2008. What had struck him most though, was that everyone that the judges spoke to on the streets of Liverpool knew all about the competition and all were very enthusiastic. Their universal belief that their city undoubtedly qualified for the title moved and inspired him.

The announcement was broadcast live and I was one of a large number of city professionals who had assembled in the Empire Theatre in Liverpool especially to hear the result. The jubilation was overwhelming and there were tears of joy

and celebration from so many people present. Apart from football trophies, this was the first significant accolade that Liverpool had won since the end of the war. Could this be the 'beginning of the end' of Liverpool's economic woes? At the very least, and to complete Churchill's wartime quotation, it would certainly be the 'end of the beginning'.

The city council now established the Liverpool Culture Company to plan and deliver the themed years. These would begin the following year, when 2004 would be Liverpool's Year of Faith. This was to celebrate the city's many diverse religious faiths and doctrines. It is significant that this should have been the first choice and demonstrates that spirituality, in all its many forms, still flows as an undercurrent throughout Liverpool.

The year 2005 was to be the Year of the Sea, showcasing Liverpool's maritime heritage and legacy, and 2006 would be the Year of Performance, celebrating the arts and performance in all its forms. The Year of Heritage would be in 2007 and as this was going to be the 800th anniversary year of the city's founding by King John, the plan was to have a year-long, city-wide birthday party.

The year 2008 would, of course, be the European Capital of Culture Year itself. This would be the culmination of the celebrations, when the city would show, as its strapline for the year said, that Liverpool really is 'the World in One City'. To keep the momentum and optimism going though and to continue to attract the inward investment that the city was convinced its title would bring, the themes would continue. This meant that 2009 was to be marked as the Year of Environment. This was when the city would proudly emphasise its beauty, elegance, cityscape, parks, waterfront and natural heritage. Finally, 2010 would be the Year of Innovation. At the beginning of that year, the Culture Company made this announcement, 'Liverpool is on the cusp of exciting developments in IT, digital technology, and new technological advances as yet undreamed of. Whatever these may be, this is the year when Liverpool will celebrate them.'

In the four years leading up to 2008, Liverpool spent a great deal of its multi-sourced investment money on what became known as 'the Big Dig'. With hardly any complaints from people at all (except perhaps from delivery vehicles and drivers coming into the city from outside), the town centre was completely and continuously disrupted. Roads were completely resurfaced and sometimes redirected, pavements and street furniture were thoroughly upgraded, new lighting, power and communications cabling was installed and utility services were modernised. Despite the major inconvenience this caused, there was an exciting buzz of expectancy in the city throughout the construction work.

Public transport was upgraded, rafts of new hotels began to open up and new tourism services and attractions began to appear. Liverpool would be on show. The world was coming here and we would make its visitors so welcome that they would want to come back. And it all worked perfectly. In 2008 and in the years immediately following, Liverpool was attracting more than 1,800 extra visitors each day, who were spending an additional £220 million throughout Merseyside

each year. Hotel bookings rose by 60 per cent and the city became a place that remains full of eager, happy visitors, enjoying a traditional Scouse welcome.

With thousands of new jobs being created in the leisure and tourism sector and its supply chains, the Capital of Culture title certainly drew down major benefits to the entire region. Perhaps one of the greatest of these though, was the fact that the people of the city began to take pride in themselves once again. They also now gave themselves permission to begin believing in the future.

All of this was reinforced, when also in 2003 it was announced that Liverpool was Britain's sole nomination to UNESCO (the United Nations Educational, Scientific and Cultural Organization), to be added to their prestigious list of 730 World Heritage Sites in 125 countries. If approved, this would mean that the city would, at long last, be able to reclaim its rightful place as a 'World Class City' and Liverpool certainly had the necessary qualifications.

The then Chairman of English Heritage, Sir Neil Cossons (b. 1939), said that 'Liverpool's historic buildings are a proud reminder that this was a hugely important maritime and mercantile city on the world stage' and that it was, beyond question, one of the great cities of the world. In 2004, Liverpool was indeed declared a World Heritage City and Port, a title that would have even greater and longer-lasting global significance for the city than its Capital of Culture title.

Liverpool's maritime, cultural, architectural and commercial heritage are what qualified the city for the title. These included the waterfront, especially the Pier Head and the Three Graces, the Albert Dock area, Stanley Dock and other surviving original docks, warehouses and boundary walls. Also part of the Heritage Site are the Cultural Quarter, the city's 'Roman Forum' around St George's Hall and William Brown Street, the splendid nineteenth-century commercial buildings around Castle Street and Dale Street, as well as the wonderful town hall and the Georgian Quarter, specifically around Lower Duke Street.

The city's new international accolade meant that Liverpudlians could now also take even greater pride in the fabric and history of their city and enjoy a new level of cultural tourism that this status immediately began to bring. This is because Liverpool now ranks alongside other great World Heritage cities, such as Edinburgh, Bath, Vienna, Venice, Cuzco, Vatican City, Toledo, Istanbul and Paris. The city's heritage now also has just as much cultural significance as other World Heritage Sites like the Great Barrier Reef in Australia, the Great Wall of China, the Pyramids and Sphinx, Cologne Cathedral, the Acropolis, the Mayan City of Chichen-Itza and the Statue of Liberty.

From Pool to Powerhouse

The impact of all of these developments did indeed attract increasing inward investment throughout the city, but the largest and most expensive of these was the wholesale redevelopment of a major area at the retail centre of Liverpool.

Initially known as the Paradise Project, this took its name from the street that runs through the heart of what was to become the largest redevelopment project in Liverpool since the end of the war. Paradise Street runs from the junction of Lord Street and Church Street down towards the riverfront. It follows the route of the original creek that fed the Pool of Liverpool. This, as we have seen, became the world's first enclosed wet dock in 1715 and now lies under the streets of modern Liverpool.

For the last 100 years, this part of the town centre has always been where Liverpudlians come when they are 'going into town to do some shopping'. It is on and around Church and Lord Streets that the larger department stores have generally been located and since the 1950s there had been a number of attempts to revitalise the areas, with varying degrees of success. By the end of the 1990s though, this part of town was looking tired, careworn and lacklustre. In fact, studies undertaken at the end of the decade showed that people who could afford the choice preferred to shop in Manchester, Chester and Southport rather than go to Liverpool. This was not what a World Heritage Site and a European Capital of Culture should be offering to visitors, so a bold new investment plan was needed.

This came in the person of Gerald Grosvenor 6th Duke of Westminster (b. 1951) and his international property development organisation, Grosvenor. Liverpool City Council chose the Duke's company to redevelop its 42 acres of prime retail and commercial district, because it had the successful track record necessary to guarantee the highest standard of delivery. The company also had the commitment to make the project an outstanding success and they had the money needed to pay for it all. As this was to be an entirely private-sector-financed scheme, with no grant funding at all, Grosvenor earmarked £1 billion and created the Grosvenor Liverpool Fund.

They leased the land from the city council for a period of 250 years and as it was an essential stipulation that the entire project be completed ready for the start of the 2008 Capital of Culture year, work began on clearing the land in 2005. Overall, twenty-six different firms of architects would be employed in the creation of this vast development, so mastering the logistics would itself be a major task.

The first phase of the project did indeed open on time in May 2008 with the second phase opening in October of the same year. Now renamed as the 'Liverpool One' development, the new retail, commercial and leisure complex covers thirty-four streets, generated 3,000 construction-industry jobs and has created more than 5,000 new permanent jobs for the local community. It also provides training programmes for young people and commercial opportunities for local businesses.

Liverpool One is made up of six distinct districts, thirty individually designed buildings, 1.6 million square feet of retail space with 165 shops, a fourteen-screen cinema, twenty-five restaurants plus cafés and bars, two hotels, more than 500 apartments, 30,000 square feet of office space, a revitalised 5-acre public park, 3,000 car parking spaces and the Paradise Street public transport interchange.

As the foundations for Liverpool One were being excavated, the original Old Dock was discovered and in an excellent state of preservation. So that a significant portion of this could be saved and made accessible, the plans of the complex were completely redesigned. Now, the dock that from 1715 began the initial rise of Liverpool to world-class status is accessible for visitors to go underground and visit. This is a powerful and moving experience, especially for Liverpudlians who appreciate its true significance.

In 1995, Liverpool was the seventeenth most popular shopping destination in Britain, but with the completion of the entirely pedestrianised Liverpool One, the city has risen to fifth place. Also, research has shown that the shopping footfall of the town centre, not just in Liverpool One, has risen by 22 per cent since 1995. On Church Street alone it has risen by 50 per cent. Because a principal route through Liverpool One is along Paradise Street to the waterfront, this has also helped to increase the visitor numbers at the Albert Dock to around 100,000 each week. In 2013, Liverpool One itself recorded a remarkable footfall of over 26 million people.

Indeed, the whole town centre and the waterfront have been enhanced and energised by the impact of Liverpool One. So have the previously derelict former docklands just south of the Albert Dock at Kings Dock. Now renamed Kings Waterfront, here stands another jewel in Liverpool's modern crown, the Arena & Convention Centre Liverpool (ACCL).

Owned by Liverpool City Council, work began in 2005 on what are actually two distinct, though connected and jointly accessible, facilities. The Liverpool Echo Arena, with almost 11,000 seats, is principally for major international-standard concerts, shows, large-scale entertainment productions and celebrity performances. This is also capable of conversion into an exhibition facility of around 70,000 square feet capacity.

The BT Conference Centre has multiple meeting and breakout facilities in the widest range of sizes, with a dedicated 1,350-seat auditorium and a multi-purpose hall covering 40,000 square feet. The complex is supported by adjoining hotels, apartments and restaurants, set around a large and breathtaking piazza. There is also a 1,600-space car park. Costing £164 million to build, this project was the single largest recipient of Objective One funds, at £50 million.

The ACCL also opened in the Capital of Culture year, during which it hosted over 200 events and welcomed more than 665,000 visitors. Within its first year of operation it had contributed more than £200 million into the local economy. Because of its innovative design, the ACCL is also one of the most environmentally sensitive buildings in Liverpool.

As well as concerts and conferences, the largest-scale exhibitions and trade shows can be held in the Exhibition Centre Liverpool, which opens in 2015 and will adjoin its sister buildings. These will take place in an additional 8,100 square metres of space, in three spacious halls. This entire Kings Waterfront complex now competes for business, and wins, at the very highest international levels.

The iconic central waterfront of the Pier Head in front of the Three Graces also received a major facelift, including a redesign of the public open space connecting this

with the promenade and the Mersey Ferry Terminal building. As part of this, in 2009 a new extension of the Leeds–Liverpool Canal was opened, at a cost of £15 million.

A new Central Docks Channel was cut through previously filled-in docks to link the North Docks with Wellington and Princes Docks. From here it now continues through another new cut in front of the Royal Liver Buildings and the other 'Graces' at the Pier Head. It then links to Canning and Salthouse Docks, to the central waterfront leisure zone at Albert Dock, and then on to Liverpool Marina and the South Docks. This modern engineering marvel now provides a direct waterway between the town centre and Leeds and with the rest of Britain's inland waterways network. This is the newest canal to have been built in the UK.

In 2011, the stunning new Museum of Liverpool opened, as the first purpose-built museum in Britain for over 100 years, and adding another outstanding local resource and tourist attraction to the Liverpool waterfront.

The economic success of the redeveloping Liverpool still draws much from the River Mersey, but now also with an eye on the burgeoning international tourist market. In the port's passenger heyday, towards the end of the nineteenth century right up to the middle decades of the twentieth, international cruise liners regularly sailed in and out of Liverpool's harbours. Great vessels with world-famous names once frequented the port, including *Britannia*, *Mauretania*, *City of Paris*, *City of New York*, the *Empress of Canada*, the *Britannic* (the sister ship to the ill-fated *Titanic*, which never actually sailed from the port) and, of course, *Queen Mary* and the *QEII*. However, and once again because of drastic changes to post-war maritime trade, all this had ended by the 1970s.

The once magnificent floating Princes Landing Stage was demolished, as was the floating roadway that connected it to the land. But, once again, the Port of Liverpool has become a major destination and embarkation point for cruise liners sailing the seven seas of the world, and all because of the building of the Liverpool Cruise Liner Terminal, together with a new floating roadway.

Once again, with the Capital of Culture Year as the target, this brand new facility was opened in 2007 at a cost of over £19 million. Recreating Liverpool's glory days, this 1,150-foot-long floating berth lies adjacent to Princes Dock and the largest and most modern liners are now using the port regularly. Very few ports in the world have liner berths directly at their heart, but Liverpool now rejoins Sydney, New York, Venice and Barcelona as destinations of choice. In fact, over the next few years we shall see an average of between forty and sixty vessels a year sailing from and to the port and this figure will continue to grow.

Ships can dock at Liverpool and their passengers can very soon be dining in some of Britain's finest restaurants, or visiting the cathedrals or the Georgian Quarter. After a short stroll they might perhaps go shopping on Church Street or Liverpool One, or perhaps go dancing in the Cavern Club on Mathew Street. Just ten minutes' walk from their ship they can be touring the Albert Dock and the Tate Gallery, or visiting the Maritime, International Slavery, and Beatles Museums. Even those liners in port for the shortest times can allow their passengers to experience and enjoy the world-famous city.

It is fitting that the site of the original Pool of Liverpool and the riverfront off which it lay should now sit at the heart of the dynamic resurgence of the city. The Mersey waterfront has once again become the powerhouse of Liverpool and remains the lifeblood and inspiration for its current success and future prosperity. To stroll through the city today and down to the river is an exciting way to spend your time as a visitor. But if you are a resident, especially one who remembers the sad, bad days from the end of the Second World War to the beginning of the twenty-first century, then it can be an inspiring and emotional journey to take. Yet, for the city, the port and the region, that journey has really only just begun.

16

The City and the World

Modern Liverpool is a very young city and its economy is still in a fledgling state. This is because, in real terms, it was only in the Capital of Culture year that Liverpool had the opportunity to begin again. The year 2008 truly was Liverpool's rebirth; its renaissance. That was the catalytic year that drove forward the massive turnaround and new growth that Liverpool has led across the Merseyside Region. However, that was also the year when the latest recession began in Britain. This would prove to be the worst global economic collapse since the Great Depression of the 1930s and Britain is only now climbing out of this.

Even so, in 2009, and according to figures from the Office for National Statistics, while the national economy fell by almost 2 per cent, Liverpool's rose by almost 2.5 per cent. Indeed, Liverpool's economy remains one of the fastest growing in the country. However, this is only the case because the city started from such a low point and the European funding it continues to receive has under-pinned the city's capacity to economically regenerate. Indeed, the city still faces some major challenges.

Liverpool still needs to attract at least 4,500 businesses to match Britain's average business density and it also needs 35,000 individuals to be economically active to match the national average. The city also needs an additional 46,200 people in full-time employment, again to match the national average. It also needs to exceed this by turning round the shortfall of 90,000 jobs in its economy. Also, in comparison with the national average, households in Liverpool are worse off to the tune of around £1,700 per person, but this figure is now improving.

Also, the employment market has changed drastically across Merseyside. Over recent decades Liverpool attracted large-scale, local and national public sector employers and more people were employed in this sector across the region than in any other. As a result of huge public sector cutbacks throughout the recession, particularly between 2010 and 2012, employment in this sector fell by 4.3 per cent. However, because of the inward investment that had been drawn into Liverpool during that same period, employment in the private sector rose by 5.8 per cent.

Liverpool's overall employment saw growth of 11.3 per cent, between 1998 and 2012. This outpaced national employment growth by 8.4 per cent. In fact, within Merseyside, Knowsley achieved the largest increase with growth of 34.3 per cent. This bodes well for sustained employment growth in the longer term.

Even so, it is clear that public funding from both Europe and National Government is still essential if the city's economic health is to continue to strengthen. However, one major effect of the recession has been a cutting back of such funding and this remains under threat. Also, the policies and legislation of successive governments can often have adverse effects on poorer regions such as Merseyside. The north–south divide remains a very real issue and despite the glossy speeches of some politicians, it is clear that the rich south-east of the country gets richer, while the much poorer north-west of Britain remains seriously disadvantaged.

Liverpool can also be the plaything of party political ideologies. Liverpudlians have never welcomed political interference, especially if this curtails their entrepreneurial autonomy or cultural independence. The city has an imaginative strategy that is fuelled by a very bold vision and which its leaders are determined to see fulfilled. That is, of course, if they continue to have the essential resources and investment available to do so. Complete self-sufficiency is quite a way off yet, but history has certainly shown what Liverpool can achieve when given the freedom to do so. So, what is Liverpool already putting in place to fulfill its grand plan?

A major step forward took place in January 2009 when a Multi-Area Agreement was signed to redefine Merseyside as the new Liverpool City Region. Although nominally including parts of Flintshire, Cheshire, Warrington and South Lancashire, this is a political and economic area principally made up of the local authority boroughs of Halton (Runcorn and Widnes), Knowsley, Sefton, St Helens and Wirral, with the city of Liverpool as its hub.

On the 1 April 2014, the city region took a further step forward with the establishment of a Combined Authority for Liverpool City Region as a new legal entity. Now under one administrative leadership body, various elements of regional policy-making and strategic planning became more formally combined. Representatives from all the city region local authorities formed a new Strategic Cabinet. Through a series of agencies and committees, they have responsibility for managing key programmes, including Economic Development, Planning, Housing and Land Based Assets, Employment and Skills Development, and Public and Strategic Transport.

The citizens of the city region watch these new developments very carefully, as do all professional sectors and local and national politicians. They all hope that this new process will only work to the advantage of the city region, by streamlining its functions and delivery and by strengthening and increasing social, cultural and economic growth. Bringing together these six local authorities has not been an easy process though, and disagreements will be frequent; the tribalism of the region is still a major factor in its psyche.

Nevertheless, what is certain is that all the constituent parts of the city region understand what is at stake and just how vulnerable the region remains to external financial and political unpredictabilities. At least everyone also recognises that the region is stronger, more influential and more successful when it functions with agreed and clear objectives and speaks with a unified voice.

Liverpool is certainly taking control of its own destiny; its leaders as well as its citizens have a determination to address the poverty and fundamental economic and social inequalities that continue to afflict so many of its people. However, its political, business and community leaders know that to do so, the momentum of Liverpool's economic growth must not be allowed to slow down. The city also pursues its ambition to resume its place on the world stage with just as much resolve and focus. This is why the projects that it now invests in all have clear local, national and global benefits.

Liverpool: The Hub of Enterprise

Liverpool has already re-established its positive international reputation as a place of energy, imagination and opportunity. This can be seen by the number of foreign students that come to the city to study. It is also evident in the number of businesses that are moving or setting up here from across Britain as well as around the world. They are all eager to ride the crest of Liverpool's new commercial wave.

Liverpool's presence at the 2010 World Expo in Shanghai in China was an example of how proactive the city is being in raising its international profile. This important event ran from 1 May to 31 October, had exhibitors from around 250 countries and attracted over 70 million visitors from all over the world. Initially, many British cities had planned to attend. However, as the recession bit more deeply, one by one they dropped out; even London. All, that is, except Liverpool. Britain had a national pavilion, but as independent as ever, it was Liverpool that had seen beyond knee-jerk reactions to the worsening economic situation and did what it has always done and took a calculated risk. As has so often been the case before, this paid off.

As the only UK city at this global event, Liverpool's impressive pavilion attracted 774,724 people. This was three times as many as its rival exhibitors, and beat the previous attendance record held by Japan. It also beat the record for the most visitors in the Expo in a single day, and the Liverpool Pavilion won a total of five awards.

With its theme of 'Better city, better life' and directly as a result of Expo, businesses in Liverpool secured £6.5 million worth of sales and trade with China. By June 2013, a further £16.1 million worth of sales and orders had been secured. Since the Shanghai Expo there have been over twenty-five Chinese delegations to the city and Liverpool University attracted £1.5 million of research investment from a major Chinese engineering firm. The number of Chinese students now attending each of Liverpool's universities has also increased dramatically and Chinese visitors to the Beatles Story Exhibition at Albert Dock rose by 60 per cent in 2013 alone.

In 1999, the city council had twinned Liverpool with Shanghai. The following year, craftsmen from the South Linyi Garden Building Company in the great

Chinese city, under the direction of a Mr Zhang, travelled to Liverpool to erect the largest Chinese Arch outside mainland China. Standing at a height of 44 feet, it is decorated with 200 dragons, twelve of which are pregnant. This is said to bring exceptionally good fortune. The arch stands at the gateway to Liverpool's Chinatown and is a reminder that the city once had the largest, and has the longest-established, expatriate Chinese community in the world. I also like to think that the twinning of the two cities was an example of great foresight on the part of Liverpool's and Shanghai's leaders.

In 2012, the Liverpool City Region Local Enterprise Partnership (LEP) was formed. Led by the private sector, but with political representation from the six city region local authorities, this is the vehicle for delivering the continuing economic growth strategies for Liverpool and the region. It does so in four key areas, which it defines as: tourism, now rebranded as 'The Visitor Economy'; the broadest training and education opportunities, now 'The Knowledge Economy'; environmentally focused social and business opportunities, now 'The Low Carbon Economy'; and logistics, airport, docks and port development, now branded as Super**PORT**.

The visitor economy has now certainly become a principal factor in the growth of the city region, generating around £3.4 billion a year; it also supports over 46,000 jobs. In 2012, 57 million visitors came to the city region and Liverpool itself was the fifth most popular British destination for international visitors and the eighth most popular for domestic visitors. It is also the ninth most popular destination for holidays and for business tourism. Also, Liverpool ranks 134th in the world, out of 363, for international conferences.

Six attractions each drew in over half a million visitors during 2013: the Merseyside Maritime Museum; the World Museum Liverpool; the Museum of Liverpool; the Tate Gallery Liverpool; Liverpool Anglican Cathedral; and the world-famous Mersey Ferries. As well as this, there was a massive increase in visitors and revenue, directly as a result of some of Liverpool's more dramatic and spectacular attractions. These included, in 2008 and at the height of the Capital of Culture celebrations, a 50-foot-high moving mechanical spider, which took up residence in the town centre. Designed and operated by the French street theatre company, La Machine, she was known as La Princesse. The great spider stayed in the city for five days, only to disappear forever into the Liverpool entrance to the Queensway Mersey Tunnel.

Then, in 2012, and as the focus of the 100-year-anniversary commemoration of the sinking of the Liverpool-registered, White Star-owned RMS *Titanic*, a three-day-long outdoor performance event took place across Liverpool. This time presented by Royal de Luxe, this was known as Sea Odyssey. This now featured three mechanical giants, which were a 30-foot-tall Little Girl, her 50-foot-tall Uncle and her dog, Xolo.

An independent report into the impact of Sea Odyssey (known locally simple as 'The Giants') showed that this had been the most successful public event in Liverpool's history, that 800,000 people took part and that the town centre shopping district saw a footfall of 900,000 people. Most significantly of all,

though, is that the event generated around £34 million for the local economy. The Giants returned for Liverpool's First World War commemorations in 2014. If we take into account the vast numbers of visitors who come to Liverpool because of football and the Beatles, and because of the city's music and culture, in all its forms, then it is clear that tourism remains at the very core of Liverpool City Region's economic growth.

In terms of The Knowledge Economy, the city region's educational and training opportunities are among the most respected and popular around the world. The city's three universities are respected and renowned: the University of Liverpool, founded in 1881 and the original 'Red Brick University'; Liverpool John Moores University, founded in 1992; and Liverpool Hope University, the first foundation college of which was founded in 1844. It is not just the excellence of the city's further and higher education establishments, but also the specialist places of learning. These include the Liverpool Institute of Performing Arts (often referred to as The Fame School), the Liverpool School of Tropical Medicine, and the Liverpool Business School, among many others.

The LEP intends to develop this offering to such an extent that it will not only bring in even greater numbers of fee-paying students and trainee professionals, but will also create around 60,000 new jobs by the early 2020s. The sector is also expected to generate £6.4 billion for the region's economy. It will also develop the city region's learning opportunities in other specialist fields, such as life sciences, advanced manufacturing, creative and digital industries and financial and professional services. This exceptionally high standard of academic and professional learning opportunity puts Liverpool on a par with the very best university cities in Europe.

With increasing global awareness of the need to protect and preserve the natural environment, a whole new range of business opportunities have arisen. The Low Carbon Economy led by Liverpool, already places the city region at the forefront of these developments. Currently, there are around 22,700 people employed within the sector, with 8,700 people employed in a very wide range of low-carbon sub-sectors, in hundreds of businesses.

These include: microgeneration; the civil nuclear supply chain; wind, solar, and tidal power; the retrofitting of homes; and the green construction industry. This too can only increase, particularly with the establishment of the region's Low Carbon Economy Action Plan, which is also being driven by both the public and private sectors. It is expected that this sector will generate at least 5,000 new jobs and will add £2.6 billion to the economy.

SuperPORT and the Rebirth of the Docks

Perhaps, though, it is the developments that are taking place in the revitalised docks on both sides of the Mersey, which will have the most long-lasting and globally significant impact for Liverpool City Region and for Britain. There are

four key elements to this rapidly expanding industry: the Freeport, Super**PORT**, Liverpool2 and the Ocean Gateway.

Although the decline of the Liverpool docks during the 1990s was dramatic and catastrophic, it was far from being complete. As part of the efforts by local and national government in the wake of the Toxteth Riots to prevent the collapse of the port in 1984, the Liverpool Freeport Zone had been opened in the North Docks. In 1992, this was extended to cover part of the Birkenhead Dock system.

Winning Freeport status gave the port a significant new lease of life and brought jobs and opportunities to the north of the city and to Bootle. Originally a 600-acre site, this was the largest of the six Freeports created at that time to stimulate trade in areas of special need. The others were the ports of Southampton, London and Felixstowe, as well as the airports at Manchester and Heathrow.

The idea behind Freeports was that they should encourage trade by cutting out several taxes, such as VAT, Import Duty and European Union Agricultural levies, during the period that ships or aircraft remained in the Freeport Zone. Additionally, if incoming commodities were processed in some way within the Freeport boundary and then exported to a non-European Union country, the taxes were also waived.

Liverpool Freeport also includes the Seaforth Container Base, which itself was created from 350 acres of reclaimed land and £20 million was spent on constructing new warehousing and infrastructure. This included, in 1994, the creation of the Euro Rail Terminal at Seaforth Dock, to provide a fully intermodal Freeport Terminal. The Freeport is now acknowledged as being the most successful and fastest-growing such facility in Britain.

In 2005, the former Mersey Docks and Harbour Company and all its docks and properties on both sides of the Mersey had been acquired by Peel Ports. This is another part of the international property organisation Peel Holdings Group, which has investments not only in ports and airports, but also in canals and in retail, industrial, leisure and commercial developments. In 2011, the overall assets of this company were valued at over £6 billion.

It is sometimes said by non-Merseysiders that the only ships that seem to use the Mersey now, apart from the ferries, are those that sail past Liverpool to the Stanlow Oil Refinery, or to connect with the Manchester Ship Canal at Eastham. It surprises them to learn that Liverpool has now regained its status as one of the busiest ports in the world. This is because all of its activity takes place at the far north of the Liverpool waterfront. In fact, since Peel acquired the Mersey docklands and following massive investment, the Port of Liverpool is now busier than at any time in its entire history. The company handles around 40 million tonnes of cargo a year on the Mersey, and, according to government figures, Liverpool now stands in the top ten ports for freight traffic. A major expansion of the entire port facilities and operation is now well underway, and the Port of Liverpool is now the main UK container port for North America.

With £1.8 billion of investment over the next ten years, what has now been named Super**PORT** will further strengthen and grow the city region economy.

It is also predicted to create at least another 20,000 local jobs. It will do so by strategic and significant investment in transportation and logistics, and in Liverpool John Lennon Airport. In addition, there will be a major container-port extension, known as Liverpool2. This is being built out into the river rather than by using existing land and will significantly increase the port's container handling capacity. At a cost of £300 million, the new quay, at almost 3,000 feet long, can accommodate the largest container ships in the world. These include the new generation of massive, 'post panamax' vessels. These are so called because they can sail through the newly widened Panama Canal.

There are currently 34,000 people employed in and around SuperPORT and the now thriving Liverpool docklands, and this will create around 20,000 new jobs and will pump £6.1 billion of GVA into the economy by 2020. This means that, without doubt, Liverpool has now regained its status as one of the most significant and vibrant ports in the world; but the plans do not end with Liverpool2. In fact, the Peel Holdings project, named the Ocean Gateway, should see a further multi-billion-pound investment in the city region over the coming decades. At the heart of this ambitious and controversial project are the Wirral Waters and Liverpool Waters dockland developments.

On the underused and derelict docklands on both sides of the Mersey, new houses and apartments are already being constructed in landscaped waterfront estates. Standing alongside spectacular towering commercial and office buildings, these will be supported by extensive leisure, tourism and retail developments. These will all take full advantage of the unique dock and riverfront locations. Significant architectural features will be preserved to ensure that the industrial and maritime heritage of both waterfronts will be maintained. Wirral Waters will see an investment of around £4.5 billion, while the Liverpool Waters project will receive in the region of £5 billion.

As part of the Liverpool Waters scheme, the idea of constructing an elevated monorail was considered. The proposal was that this should run from Stanley Dock, along the riverside and dock road, all the way to Liverpool John Lennon Airport at Speke. However, this does not form part of the current plans. Perhaps, though, this might be reconsidered. We could then thank Peel Ports for bringing back an overhead railway to Liverpool!

The World in One City

In purely business terms, Liverpool has recently led some outstanding and innovative projects, each of which has generated significant inward investment, as well as consolidating the city region's international reputation as a 'very business friendly' location. In fact, Liverpool is the only British city to have opened its own embassy in London.

It was recognised that if Liverpool was to effectively source new business investments then it needed a very visible presence in the capital. The idea grew

out of the Shanghai Expo and it opened in 2011. Since that time, the Liverpool Embassy in London has generated around £3.8 million of new sales for Liverpool businesses, nearly £3 million of positive PR and over £24 million of new investment in the city.

In 2012, Liverpool voted in its first directly elected city mayor in the person of Labour Councillor Joe Anderson OBE (b. 1958). Leading all of the city's economic development plans and agencies, and working very closely with the City Region Enterprise Partnership with his cabinet of public and private sector representatives, the mayor's election provided a clear strategic framework for Liverpool's continuing successes.

The year 2012 also saw the Global Entrepreneurship Congress (GEC) taking place at Liverpool's Arena and Convention Centre. This was the first time that this global event had ever taken place in Europe and its objective was to provide an opportunity for entrepreneurs and business professionals from around the city, Britain and the world, to meet together to share ideas and opportunities. Lasting only one day, it nevertheless attracted some world-class business minds, among whom were Sir Richard Branson, Sir Terry Leahy, Martha Lane Fox and, of course, Lord Heseltine.

This was such a success that in a subsequent report on strengthening the city region's economy, written by Lord Heseltine and Sir Terry Leahy and drawing on ideas from Liverpool Vision, they suggested that an International Festival for Business (IFB) should be held. They pointed out that to help Britain drive a global, post-recession economic revival, the world should be invited to come to Britain.

Again, ideas and opportunities would be shared, but this would take place over seven weeks, rather than just a single day. In fact, this would be the greatest celebration of British economic and entrepreneurial opportunity and significance since the Festival of Britain in 1951. The coalition government under Conservative Prime Minister David Cameron (b. 1966) and Lib Dem Deputy PM Nick Clegg (b. 1967) agreed. They saw the festival as being a key part of their plan to rebalance the national economy and increase its export and investment opportunities.

Lord Heseltine also said that the IFB should take place outside London, indeed, it should take place in the north of England in Liverpool. This was also agreed; plans were put in place and with greater economic significance than ever before, in the summer of 2004 Liverpool hosted an event of genuinely global importance. Once again the international spotlight focussed on the city on the Mersey and Liverpool was more than ready to take the fullest advantage of this opportunity, while as always making a genuine contribution to the world.

With almost 200 official and fringe events, taking place in over seventy venues across the north of England as well as all around the city region, but with Liverpool as its nucleus, the event was planned around seven broad themes. These were: Cities, Enterprise and Urban Business; Creative and Digital Industries; Financial and Professional Services; Higher and Further Education and Research; Low Carbon and Renewables; Manufacturing, Science and Technology; and Maritime, Logistics and Energy. These plans all took shape against a backdrop of very positive and reassuring economic statistics.

In 2012, Liverpool's GVA grew by £248 million (2.5 per cent), to reach £9,991 million. The GVA of the city region as a whole also grew in the same year by £559 million (2.3 per cent), to reach a total of £25,319 million. The city's medium-term growth between 2008 and 2012 was also strong, exceeding growth in Britain as a whole and that of almost all of the country's other core cities and city region areas. In fact, it grew by 11.3 per cent, compared with a UK average of 5.9 per cent. This all bodes very well indeed for the long-term economic growth and sustainability of Liverpool City Region.

At the beginning of this chapter, I said that the ambitious plans that Liverpool has for its role in the city region, in Britain and in the world will only come to fruition if we have the resources to enable it to do so. That Liverpool has the imagination, energy, the will and the capacity to achieve this is certain. The leaders and the people of the city and of the city region will do everything they can to ensure that nothing stands in their way: the vision they have for their place in the world is too important.

Liverpool is no longer an easy target for the ignorant and stereotypical attacks that parts of Britain and especially some politicians and sections of the media hurled at it in the closing decades of the twentieth century. The nation likes us again now and we are continuing to win greater national respect with each successive year. Abroad, the image of Liverpool has always been positive and its people are welcomed wherever the Scouse diaspora has taken them. This view of us from abroad has been consolidated by our very public achievements, but especially since the Capital of Culture year of 2008.

The story of our rise from the once tiny, insignificant fishing hamlet on the banks of an obscure tidal inlet, to being for 250 years the second city of the British Empire, is a powerful and impressive one. Although we have had our defeats and failures, as this story has shown, we have always bounced back with a resilience that is not only impressive, but which often defies analysis.

Our fall at the end of the twentieth century was almost fatal, but by a combination of luck and belligerent defiance, we survived. In the wake of the riots, the much admired, respected and staunchly Labour City Councillor for the Granby Ward in Toxteth, Margaret Simey (1906–2004), took on Merseyside Chief Constable Kenneth Oxford, Prime Minister Margaret Thatcher and other critics of Liverpool and she generally won all her arguments. Indeed, so angered was she by the ignorance that many establishment figures so often showed towards her city and its people, that she once declared, 'The real problem is that the government keeps making the mistake of believing that Liverpool is part of Britain.' Also a Merseyside County Councillor and Chair of the Merseyside Police Authority, though born in Scotland, Margaret understood her adopted home well.

It was Liverpudlians' innate courage, creativity, arrogance and proud self-belief that ultimately brought the city through. These characteristics also enabled the people of Liverpool to completely reinvent themselves and their beloved city. But our renaissance is just that, a beginning, and our work of rebuilding is far from over.

Indeed, I always delight in saying that Liverpool always was, remains and always will be a work in progress. And is that not wonderful? This means that there will always be opportunities to make a difference, to contribute and hopefully to add value to its continually unfolding story. Built as the city was on immigration and diversity, the people of Liverpool are indeed fiercely independent, as many outsiders have discovered to their cost; you cannot tell Scousers what to do because we already know.

We are a city of individuals who face the future with bold optimism. But we are also a city of sanctuary, a city of hope and a city of dreams and ambitions. Undoubtedly, just as we helped to shape the world, so the world continues to shape us. This exciting place, with its wonderful people, is certainly 'the World in One City', and the best is yet to come.

Acknowledgements

I hope that you have enjoyed this story of the wonderful city and port of Liverpool and its remarkable people. Of course, this work would not have been possible without considerable resources and support. I would therefore like to thank the staff of Liverpool Central Libraries and of the Liverpool Record Office in particular and the librarians and many of my fellow proprietors of the Liverpool Athenaeum. I am always grateful for their encouragement, time and professionalism.

I would like to acknowledge the valuable research resources provided through the Liverpool History Society and especially the late Rob Ainsworth for his always generous expertise, encouragement and friendship.

There are a number of other people who generously provided their knowledge, expertise and resources and without whom this book would not have been possible. So, I would like to extend my special thanks to:

Chris Heyes, head of Liverpool in London, Liverpool Embassy, Liverpool Vision Plc
Cllr Nick Small, Cabinet Member for Employment and Skills, Liverpool City Council
Mike Taylor, former CEO, Business Liverpool
Pam Wilsher, head of tourism, Liverpool City Region Enterprise Partnership
Rt Revd James Jones, former Bishop of Liverpool
Sir Alan Waterworth, former Lord Lieutenant of Liverpool
The Rt Honourable Edward Stanley, 19th Earl of Derby
The Rt Revd Justin Welby, Archbishop of Canterbury,
Tony O'Neill, Head of Business Investment, Liverpool Vision Plc
Ian McCarthy, Director of Programmes, Liverpool Vision Plc
Ged Fitzgerald, Chief Executive, Liverpool City Council
Ken Perry, Chief Executive, Plus Dane Group
Mark Basnett, Executive Director – Key Sectors, Liverpool City Region Enterprise Partnership
Peter Nears, Strategic Planning Director, Peel Holdings (Management) Ltd

I would also like to thank Peel Holdings, Liverpool City Council, Liverpool Record Office and the Athenaeum Library for providing images for reproduction in this book.

Bibliography

Ainsworth, R. and G. Jones, *In the Footsteps of Peter Ellis* (Liverpool: Liverpool History Society, 2013).

Andrew F. Richardson, *Well I Never Noticed That: Parts One And Two* (Liverpool: West Derby Publishing, 1994).

Bailey F. A. and R. Millington, *The Story of Liverpool* (Liverpool: Corporation of Liverpool, 1957).

Brownbill, J. and W. Farrer, *A History of the County of Lancashire* (eds) (Victoria County History, 1911).

Cavanagh, T., *Public Sculpture of Liverpool* (Liverpool: Liverpool University Press, 1997).

Chandler, G., *Liverpool* (London: B. T. Batsford Ltd, 1957).

Charters, D., *Great Liverpudlians* (Lancaster: Palatine Books, 2010).

Chitty, G., *The Changing Face of Liverpool: 1207–1727* (Liverpool: Merseyside Archaeological Society, 1981).

Crick, M., *The March of Militant* (London: Faber, 1986).

Doyle, P., *Mitres and Missions in Lancashire* (Liverpool: The Bluecoat Press, 2005).

Du Noyer, P., *Liverpool: Wondrous Place. Music from Cavern to Cream* (London: Virgin Books, 2002).

Evans, R., 'The Merseyside Objective One Programme: Exemplar of Coherent City-Regional Planning and Governance Or Cautionary Tale?' *European Planning Studies*, 10(4) (Liverpool: 2002), 495–517.

Frost, D., and R. Phillips., *Liverpool '81: Remembering The Toxteth Riots* (eds) (Liverpool: Liverpool University Press, 2011).

Hand, C. R., *Olde Liverpool and its Charter* (Liverpool: Hand & Co., 1907).

Heseltine, M., *Life in the Jungle: My Autobiography* (London: Hodder and Stoughton, 2000).

Heseltine, M., *No Stone Unturned: In Pursuit of Growth* (London: Department for Business Innovation and Skills, 2012).

Heywood, T., *The Moore Rental* (ed.). (Manchester: The Chetham Society, 1847).

Hinchliffe J, *Maritime Mercantile City* (Liverpool: Liverpool City Council, 2003).

Hird, F., *Old Lancashire Tales* (Liverpool: Frank Hird, 1911 and 1918).

Hollinghurst, H., *Classical Liverpool* (Liverpool: Liverpool History Society, 2009).

Hollinghurst, H., *John Foster and Sons – Kings of Georgian Liverpool* (Liverpool: Liverpool History Society, 2009).

Hollinshead, J., *Liverpool in the Sixteenth Century* (Lancaster: Carnegie Publishing Ltd, 2007).

Horton, S., *Street Names of the City of Liverpool* (Birkenhead: Countyvise, 2002)

Howell Williams, P., *Liverpolitania* (Liverpool: Merseyside Civic Society, 1971).

Hughes, Q., *Liverpool City of Architecture* (Liverpool: Liverpool History Society, 2002).

Jackson, J., *Herdman's Liverpool* (Parkgate: The Gallery Press, 1989).

Lane, T., *City of the Sea* (Liverpool: Liverpool University Press, 1997).

Lewis, D., *The Churches of Liverpool* (Liverpool: The Bluecoat Press, 2001).

Littlefield, D., *Liverpool One – Remaking A City Centre* (London: Wiley, 2009).

Liverpool City Council, *Liverpool City Council – The Index of Multiple Deprivation – A Liverpool Analysis* (Liverpool: Liverpool City Council, 2010).

Liverpool City Council, *Liverpool Local Development Scheme: 2006* (Liverpool: Liverpool City Council, 2009).

Liverpool Heritage Bureau, *Buildings of Liverpool* (Liverpool: Liverpool City Planning Dept, 1978).

Merseyside Socialist Research Group., *Merseyside in Crisis* (Birkenhead: Merseyside Socialist Group, 1980).

Moore, J., *Underground Liverpool* (Liverpool: The Bluecoat Press, 1998).

Muir, R., *A History of Liverpool* (London: Published for the University Press of Liverpool by Williams & Norgate, 1907).

Munck, R., *Reinventing the City? Liverpool in Comparative Perspective* (ed.) (Liverpool: Liverpool University Press, 2003).

Murden, J., 'City of Change and Challenge: Liverpool Since 1945', in J. Belchem (ed.), *Liverpool 800; Culture Character and History* (Liverpool University Press, 2006), 393–485.

Noel-Stevens, J. and M. Stevens, *The Hidden Places of Lancashire And Cheshire* (Guernsey: M & M Publishing, 1991).

Parkinson, M., *Liverpool on the Brink*. (Oxford: Policy Journals, 1985).

Pearce, J., *Romance of Ancient Liverpool*. (Liverpool: Philip, Son & Nephew, 1933).

Picton, Sir J., *Memorials of Liverpool* (London: Longman, Green & Co, 1873).

Power , M., *Liverpool Town Books 1649–1671* (ed.) (Stroud: Sutton Publishing Ltd, 1999).

Sheppard, D., *Steps Along Hope Street: My Life in Cricket, the Church and the Inner City* (London: Hodder & Stoughton Ltd, 2002).

Sheppard, D., and D. Worlock, *Better Together* (London: Hodder and Stoughton, 1988).

Stonehouse, J., *The Streets of Liverpool* (Liverpool: Hime & Son, 1907).

Thomas, H., *The Slave Trade: History of the Atlantic Slave Trade, 1440–1870* (New York: Simon and Schuster, 1997).

Various Contributors, *A Guide to Liverpool 1902* (London: Ward, Lock & Co., 1902).

Various Contributors, *Liverpool History Society Journal 2002* (Liverpool: Liverpool History Society, 2002).

Various Contributors, *The Mersey Tunnel* (Liverpool: Charles Birchall & Sons, 1934).

Whale, D., *Lost Villages of Liverpool: Part One* (Prescot: T. Stephenson & Sons, 1985).

Whitworth, R., *Merseyside at War* (Liverpool: Scouse Press, 1988).

Ken Pye FRSA: A Biography

Born and bred in Liverpool, Ken Pye is the managing director of The Knowledge Group and is in great demand across Europe as a business-development mentor, programme and conference facilitator and as a very well-informed, inspiring motivational speaker at major conferences and business events. Ken is also an Honorary Fellow at Liverpool Hope University and a Fellow of the Royal Society of Arts.

In a varied career spanning over forty years, Ken has experience in all professional sectors. This includes working with profoundly disabled youngsters, as a youth and community leader, as the community development worker for Toxteth, the north-west regional officer for Barnardos, the national partnership director for the Business Environment Association, and senior programme director with Common Purpose.

Ken is also the managing director of Discover Liverpool, and as such is a recognised expert on the past, present, and future of his home city. Ken is a frequent contributor to journals, magazines and newspapers, and is also a popular after-dinner speaker. He is also a regular broadcaster for both radio and television.

Ken is also well known across Merseyside and the north-west as the author of the acclaimed books *Discover Liverpool* and *The Bloody History of Liverpool*, (both of which are now in their second editions). He is also the writer and presenter of the series of *Discover Liverpool* DVDs, the third edition of which has recently been issued!

He was also a principal contributor to the popular *Scousers*, and the author of *A Brighter Hope* – about the founding and history of Liverpool Hope University, which is published by Liverpool Hope University Press.

Having also completed two private writing commissions for the Earl of Derby, as well as *Liverpool: The Rise, Fall and Renaissance of a World-Class City*, Ken is now working on his new series of books called *Tales of Merseyside*. These are

Ken Pye.

accompanied by a series of audio CDs, which are already proving to be very popular.

On a personal basis, if pressed (better still, if taken out to dinner), Ken will regale you with tales about his experiences during the Toxteth Riots, as a bingo caller, as the lead singer of a pop group and as a mortuary attendant.

Ken is married to Jackie, and they have three children: Ben, aged twenty-seven, Samantha, aged twenty-four, and Danny, aged eighteen.

Ken Pye
Liverpool 2014.

The Pye family.

Index